# Picasso
## The Last Years, 1963–1973

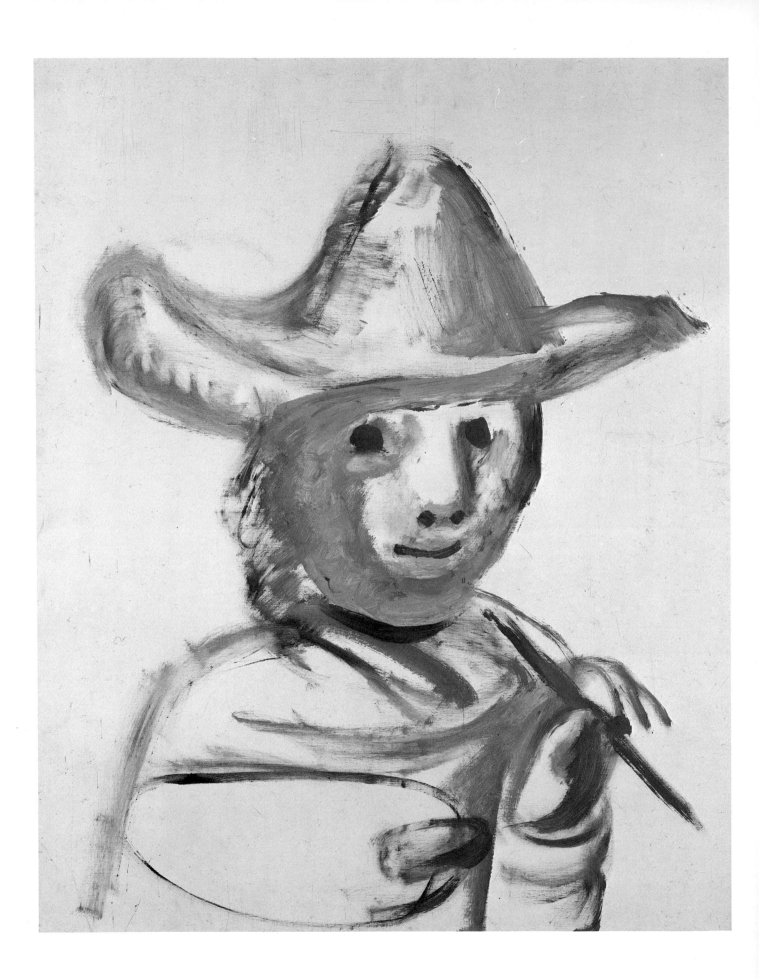

# Picasso
## The Last Years, 1963–1973

by Gert Schiff

**Solomon R. Guggenheim Museum, New York**

Published by

**George Braziller, Inc., New York**

in association with the

**Grey Art Gallery & Study Center, New York University**

This publication was prepared in conjunction with the exhibition, **Picasso: The Last Years,** organized by Gert Schiff for the Grey Art Gallery and Study Center, New York University, and shown at the Solomon R. Guggenheim Museum, New York. The exhibition and accompanying publication have been made possible in part through funding from the National Endowment for the Arts, Washington, D.C., a federal agency, through a bequest from the Abby Weed Grey Trust and support from The Merrill G. and Emita E. Hastings Foundation.

George Braziller, Inc., One Park Avenue, New York, New York 10016
in association with the Grey Art Gallery and Study Center, New York University.

**Library of Congress Cataloging in Publication Data**

Schiff, Gert.
    Picasso, the last years, 1963–1973.

    Bibliography: p.
    Includes index.
    1. Picasso, Pablo, 1881–1973.  2. Artists—France—Biography.  I. Picasso, Pablo, 1881–1973.
II. Grey Art Gallery & Study Center.  III. Title.
N6853.P5S34  1983     709'.2'4 [B]     83-19724
ISBN 0-8076-1089-5
ISBN 0-8076-1088-7 (pbk.)

Designed by Katy Homans
Printed in the United States of America by Eastern Press

First Edition

Front cover illustration: **Self-Portrait,** June 30, 1972, cat. 115.
Frontispiece: **The Young Painter,** April 14, 1972 (III), cat. 107.

## Photographic Credits

In addition, the following photograph credits are noted: Alinari/Art Resource, fig. 2; Fogg Art Museum, Cambridge, Mass., fig. 82; Galerie Beyeler, Basel, fig. 25; Gøteborgs Konstmuseum, Gøteborg, fig. 53; courtesy Egbert Haverkamp-Begemann, fig. 43; Jacqueline Hyde, pls. 3, 7, 14, 24; Kunsthaus, Zürich, fig. 92; Kunstmuseum, Basel, pls. 33, 46, figs. 40, 121; Robert E. Mates, figs. 32, 36; Musee Condé, Chantilly, fig. 1; Musée National d'Art Moderne, Centre Georges Pompidou, Paris, fig. 7; Musée National du Louvre, Paris, figs. 3, 89, 90, 109; Musée Picasso, Paris, fig. 88; Museo Picasso, Barcelona, fig. 127; Museo del Prado, Madrid, fig. 9; The Museum of Modern Art, New York, fig. 94; National Gallery, London, figs. 46, 57 (with the kind cooperation of Egbert Haverkamp-Begemann); The Pace Gallery, New York, pls. 50, 52, figs. 56, 117, 119; Christian Poite, pls. 12, 13, 54, figs. 22, 118; Rijksmuseum, Amsterdam, fig. 47; John D. Schiff, pl. 21, fig. 33; SEF/Art Resources, fig. 54; Service de documentation photographique de la Réunion des Musées Nationaux, pls. 45, 55, 58, 59, figs. 3, 7, 88, 89, 90, 109, 120, 125 and frontispiece; Staatliche Kunstsammlungen, Dresden, Gemäldegalerie Alte Meister, fig. 39; Staatsgalerie, Stuttgart, fig. 49 (with the kind cooperation of Egbert Haverkamp-Begemann); Steven Tucker, pl. 17, figs. 108, 112; Wallace Collection, London, fig. 63 from *Picasso 347,* by Pablo Picasso, graphic arts copyright © 1969, 1970, by Pablo Picasso, reprinted by permission of Random House, Inc., figs. 64, 72.

# Contents

# Acknowledgments

Picasso: The Last Years, 1963–1973 came to the Guggenheim Museum through a sequence of unforeseen circumstances. Planned originally by the Grey Art Gallery & Study Center of New York University, it became evident that the financial means for so ambitious an undertaking were unavailable and that the project commissioned by Robert R. Littman, the Grey Art Gallery's director, and so carefully prepared by Professor Gert Schiff would have to be abandoned. Fortunately, sufficient flexibility in the Guggenheim's schedule and some reserves in our exhibition budget allowed us to come to the rescue of this valuable project to present it here during the spring months of 1984.

The preservation of Picasso: The Last Years in exhibition form, however, was not primarily motivated by samaritan impulses. First and foremost the decision was based on the Guggenheim's enthusiasm for a much misunderstood phase in Picasso's oeuvre and on confidence in Professor Schiff's ability to authoritatively deal with issues related to it. From the time Picasso abandoned the engaging Blue and Rose Periods of his youth in favor of a demanding transition to Cubism, the majority of his admirers were left behind in uncomprehending puzzlement. Throughout the decades that followed, the recurrent theme of Picasso's alleged decline was sounded with monotonous persistence, usually to be conceded years after each phase, now no longer recent, had been digested and added to the gathering evidence of the artist's overwhelming achievement. Unreformed and uninstructed by such revisions, however, nonbelievers and detractors continued to brand the most recent periods as declines.

The present show to our minds is visual proof contradicting this negative judgment, as well as a rich and moving testimony to Picasso's irrepressible originality and his volcanic creativity, which remained with him to his last breath. We are grateful therefore for the privilege of showing Picasso: The Last Years at the Guggenheim and indebted above all to Professor Schiff for selecting the works and providing us with a valuable catalogue text.

The funds and the copies of the catalogue transferred to the Guggenheim by New York University as well as the generous emergency sponsorships extended by Frank S.M. Hodsell, chairman of the National Endowment for the Arts, and by The Merrill G. and Emita E. Hastings Foundation enabled us to step into the breach at the time the show was about to be cancelled.

Finally, I wish to associate the Guggenheim Museum with Professor Schiff's acknowledgments to those who aided in the realization of the exhibition in its formative stage, as well as to the lenders who, in the end, determine the success or failure of such manifestations.

**Thomas M. Messer, Director**
**The Solomon R. Guggenheim Foundation**

It is a deep pleasure to thank all those many admirers of Picasso's late works, both here and abroad, who have helped me in preparing this exhibition and this publication. My warm thanks go to Robert Littman, director of the Grey Art Gallery, for initially providing me with the opportunity to curate this show. I am deeply indebted

as well to Thomas M. Messer, director of The Solomon R. Guggenheim Foundation, for arranging for the presentation of the exhibition at the Guggenheim Museum after its showing at the Grey Art Gallery was cancelled.

To start with our helpers overseas: my warm thanks go to Dr. Christian Geelhaar, director of the Kunstmuseum Basel, who liberally shared with me both the experience and the documentation of his own trailblazing 1981 exhibition, *Pablo Picasso, Das Spätwerk—Themen, 1964–1973*. No less generous were the director of the Musée Picasso, Dominique Bozo, and its conservator, Michèle Richet, who, in spite of many concurrent requests, granted the loan of five important works from the artist's own legacy. That the Galerie Louise Leiris, thanks to the sympathetic support of its director, Maurice Jardot, made the lion's share of loans will surprise no one. It should be mentioned, also, that we received through the good services of Galerie Louise Leiris a privately owned and rarely seen work, our catalogue number 21. We have been lucky in engaging the participation of four members of the Picasso family: Mme. Maya Ruiz Picasso granted our requests at the recommendation of our distinguished colleague, Brigitte Baer; Marina Picasso lent three major paintings through the intermediary of her ever-helpful representative, Jan Krugier; Paloma Picasso-Lopez, whose collaboration was engaged by Arnold B. Glimcher, gave us her amicable support instantly; and Javier Vilató who must be singled out for his special kindness.

Picasso has always had a devoted following in Switzerland; hence, a large number of the works exhibited come from that country. We are especially indebted to the generosity of such major promoters of late Picasso works as Ernst Beyeler of Basel; Jan Krugier of Geneva; Siegfried Rosengart and Angela Rosengart of Lucerne. It is also gratefully acknowledged that, thanks to the efforts of Mr. Rosengart, the authorities of the city of Lucerne agreed to lend a major painting, *Rembrandt-like Figure and Cupid* (cat. 55), which is part of Mr. Rosengart's donation of works by Picasso to his home town. Another Swiss contributor is Thomas Ammann, who shares his enthusiasm for late Picasso works with the artists of his own generation. The director of the Kunsthaus Zürich, Dr. Felix A. Baumann, agreed to lend one of the cornerstones of his museum's collection of works by Picasso, the *Grand Nude* of 1964 (cat. 9).

An unexpected windfall came from Susumu Yamamoto, director of the Fuji Television Gallery in Tokyo, and his collaborator Masami Shiraishi, who enabled us to include fifteen drawings as well as the moving last *Self-Portrait* (cat. 115).

In the United States, a considerable portion of our thanks is due to Arnold B. Glimcher, president of The Pace Gallery, New York; himself the author of an important exhibition of Picasso's works from 1968–1972, he has been tireless in establishing contacts with lenders and his enthusiasm proved incendiary. We received loans from the following individuals and their New York galleries: William Acquavella of Acquavella Galleries; Aldis Browne of Aldis Browne Fine Arts; Jody Robbins of Reiss-Cohen; Mrs. Daniel Saidenberg of Saidenberg Gallery; Edward Sindin of Sindin Galleries. Mr. and Mrs. Saidenberg were also kind enough to part with several outstanding works from their private collection. Douglas G. Schultz, director of the Albright-Knox Art Gallery in Buffalo, obtained the approval of the Art Committee of its Board of Directors to loan a major painting, *The Artist and His Model* of 1964. That we were able to include a masterwork such as *Rape of the Sabines* (cat. 1) is due to the collaboration of Alexandra Murphy, assistant curator of the Museum of Fine Arts in Boston, and to the generosity of its Board of Trustees.

In addition, I want to express my sincere gratitude to the following private lenders: Mr. and Mrs. Morton L. Janklow, Owen Morrissey, Mr. and Mrs. Mike Moses, all in New York; Mr. and Mrs. Raymond D. Nasher in Houston, Texas; and A.L. Levine in conjunction with The Metropolitan Museum of Art and its curator of Twentieth-Century Art, William S. Lieberman.

I must also thank those students who—during the spring semester of 1983—took my seminar on late Picasso art at the Institute of Fine Arts, New York University, all of whom helped me in shaping the ideas expressed in this catalogue. The special contributions of Marie Busco, Janie Cohen, and Cindy Mack are acknowledged in the appropriate places. For the initial editing of my essay I am indebted to David Rattray, poet and polyhistor. A close reading by Richard Martin helped me greatly in giving it its definitive form. I am further indebted to Charles Miers of George Braziller, Inc., and Deborah Weiss for their careful attention to minutiae of organization and wording. Lastly, my greatest personal debt is due to my assistant, Isa van Eeghen, who compiled catalogue entries and bibliography, conducted much of my correspondence and corrected many of my own errors. Without her commitment, the work would never have been concluded in time.

A dark shadow was cast over the work of completing this catalogue by the death of Alberto Raurell, director of the Museo Rufino Tamayo in Mexico, and originator of the 1982 exhibition *Los Picassos de Picasso en México*. I dedicate this exhibition to the memory of this much-valued colleague and friend.

**Gert Schiff, Professor of Fine Arts**
**Institute of Fine Arts, New York University**

At a time when practicing artists and a group of scholars look to Picasso's late paintings with renewed interest and pleasure, it is expected that this exhibition and accompanying publication will contribute to the objective assessment of the paintings and prints from 1963 to 1973 and will help determine their place in the Picasso canon. It may eventually be determined that Picasso was never as fervently creative as in the last years of his life.

For his original impetus to this project our thanks to the designer, Christopher Scott, as well as to William Rubin and Robert Rosenblum for taking time to discuss its various ramifications. Their suggestions and encouragement are much appreciated.

Generosity, scholarship and talent come to nought without the funds that pay for seeding the idea. It is thus to our sponsors that we are indeed grateful: the National Endowment for the Arts and the Abby Weed Grey Trust in addition to funding from The Lila Acheson Wallace Fund, no. 2, The Rudin Family Fund and The Benjamin and Frances Benenson Foundation, Inc. We also appreciate the insight and connoisseurship of Thomas M. Messer and the hospitality of the Guggenheim Museum.

**Robert R. Littman, Director**
**Grey Art Gallery & Study Center, New York University**

# Introduction

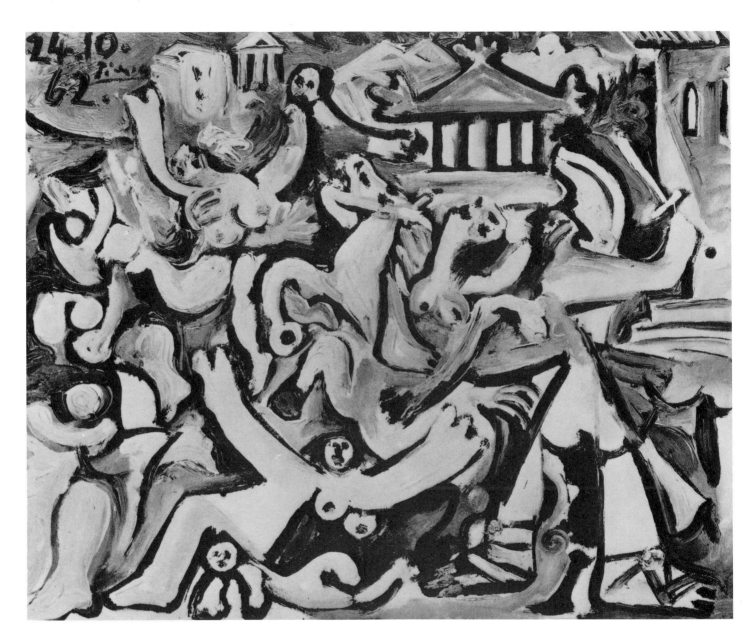

**Fig. 1**
Picasso, *Rape of the Sabines*
Oil on canvas, October 24, 1962
Zervos XXIII, 6

# The Musketeer and His *Theatrum Mundi*

Avignon, summer 1973. Picasso had died on April 8 at the age of ninety-two, but in the Grand Chapel of the Palace of the Popes he was still holding sway, shaking his contemporaries out of their aesthetic and moral indolence, as he had done for three quarters of the century. In front of the paintings and drawings of his last three years bourgeois were rubbing backs with hippies, workers with scholars, schoolgirls with neatly dressed matrons—all in a state of agitation. The sheer intensity of the visual experience brought some close to a state of panic. They found themselves confronted by a Baroque pageant: seventeenth-century cavaliers in splendid array, toreadors, nude couples embracing, heads of old fishermen, painters, prophets—all painted impetuously, hastily, in explosive colors or muddy greys, with coarse black brushstrokes outlining grim distortions and brusque disruptions of faces and bodies. How did these paintings compare with Picasso's last drawings, works of unsurpassable linear perfection which were classical in style but not in content? The drawings depicted an incredible comedy of manners, with frequent forays into hitherto unexplored regions of sexual passion. Were they the works of a nonagenarian? Where was the wisdom of old age in this outcry of a desperate lust for life? How could one reconcile the meticulous control of the drawings with the frenzy of the large canvases? Why did the most advanced pictorial genius of the era, this embodiment of modernism, immerse himself in a past age which had served as inspiration only to the most hackneyed academicians of the past century? What brought this tireless explorer of *form* into that most outmoded field of pictorial creation, Romantic narrative?

Angry outcries and imploring questions were raised by the Avignon exhibition, but then embarrassed silence took over. Hardly discussed in scholarly literature, poorly represented in exhibitions, commercially unpopular, the works of Picasso's last period—which we shall see as beginning in 1963—were all but hushed up, since no one found answers to the questions they raised.

The truth is that all through his career Picasso was ahead of his audience by just one "period." The time has now come for a dispassionate assessment of his ultimate achievements.

Today we can see that the apparent carelessness of execution in many of his last paintings contained a pictorial shorthand rich in the most striking expressive values and even the most "sloppily" painted pictures reveal an unfailing formal control. Furthermore, we realize that Picasso's exploration of *simultaneity* continued to trigger the most unexpected solutions. By constantly re-inventing the human form he continued to teach us ever new truths about ourselves. If we are willing to sustain his attacks on our visual nerves, we will be rewarded by a considerable expansion of our visual sensibility. As long as we remain civilized, that is, conscious of our own cultural legacy, we will be grateful for his re-creations of art history in a language akin to our feeling.

Picasso was a genius. He was also a man endowed with an ardent soul, with passions and drives stronger and more persistent than those of most ordinary humans. To the last, he poured all his impassioned humanity into his art. Thus, his last works teach us something that cannot be deduced from the more detached works of other giants in their old age. By pushing the limits of our self-awareness a little further, Picasso undermines our moral complacency in the name of his own

honest and fearless humanism. Quite often, he does so with disarming naiveté and exquisite humor.

For all these reasons, his last period has a special place within his development. It is not a "swan song," but the apotheosis of his career. On the following pages, this shall be demonstrated analytically. The pictures, of course, will justify our interest on their own.

## Notre Dame de Vie

Picasso's last ten years were spent in magisterial creativity. Notre Dame de Vie is a spacious eighteenth-century farmhouse surrounded by cypresses and olive trees, with a view extending down to the Bay of Cannes. The artist's wife Jacqueline organized his life for him. She provided him with unlimited time for his work—and with inspiration. Biographers count 70 works (paintings, drawings and graphics) that included her image in 1962[1] and 160 in 1963.[2] If these numbers appear astounding, one must understand Picasso's exceptional productivity during his ninth decade: he made 347 etchings between March 16 and October 5, 1968; 167 paintings between January 1969 and the end of January 1970; 194 drawings between December 15, 1969 and January 12, 1971; 156 etchings between January 1970 and March 1972; 172 drawings between November 21, 1971 and August 18, 1972; and 201 paintings between September 25, 1970 and June 1, 1972. Beyond this, there are more still, works that have never left Notre Dame de Vie.

Picasso's eightieth birthday was honored by a major retrospective in Paris, which for the first time showed the full scope of his accomplishments as a sculptor. On his ninetieth birthday, eight of his key works were temporarily installed in the Grande Galerie of the Louvre, an honor never before bestowed upon a living artist. Picasso had made generous donations to the museum founded in his name by his friend Sabartés in Barcelona. To The Museum of Modern Art in New York he had given the epoch-making *Guitar* of 1912 and the wire construction that had been intended as a monument to Guillaume Apollinaire.[3] Chicago received the maquette for the *Monument* at its Civic Center.[4] Monumental versions of his metal cutouts (heads of Sylvette David and Jacqueline) were put up in Sweden, in Amsterdam and on the grounds of New York University's Silver Towers near Washington Square. Picasso's productivity was interrupted but once between October 1965 and spring 1966, and then only because of an illness. He worked to the very end of his life, personally selecting the 201 paintings that were shown in the Palace of the Popes in Avignon from May through September 1973.

Picasso's was an output unparalleled in the history of art, made possible by his unique physical strength and health, motivated by a creative urge that impelled him to go every day beyond his previous achievement; motivated, on the deepest level, by his desire to ward off death. As long as he worked, he lived. He saw many friends of his early days go before him: in 1963, Georges Braque and Jean Cocteau; in 1966, André Breton; in 1968, Sabartés, his confidant; in 1970 the Zervoses, authors of the complete catalog of his work. In spite of his busy working schedule, he saw visitors from all over the world: museum officials, collectors, dealers, writers, photographers and especially Spaniards, including Manuel Pallarés, a painter whom he had befriended at the art school in Barcelona when Picasso was fifteen; Rafael Alberti, an Andalusian poet who later published the so-called Avignon paintings;[5] and Roberto Otero, filmmaker and adventurer, to

whom we owe records of some of Picasso's most quizzical conversations.

If the old Picasso was troubled by anything other than purely personal sorrows, it was the fact that younger painters no longer had any use for his art and that his late works were not appreciated by the public at large. In the very worst instances he found himself attacked not for his art but for his age. Today, he would no longer have to worry about the response of artists: his works have been received with enthusiasm by artists as diverse as David Hockney, Julian Schnabel and Malcolm Morley. One can also trace the influence of his last works in the work of Italian neo-expressionists as well as abstract or figurative artists such as Elizabeth Murray or Rafael Ferrer. As for that elusive body, the "public at large," in modern art it has often followed the judgment of artists and has thereby always been well advised.

### Rape of the Sabines

They sat together in the studio of Notre Dame de Vie, Picasso, his wife Jacqueline, the painter Édouard Pignon and his wife, Hélène Parmelin, to whom we owe an account of that evening in October 1962.[6] The lights were turned off and on one wall appeared a slide projection of Poussin's *Massacre of the Innocents* (fig. 2). For several hours the group discussed every detail of this severe masterpiece, which conveys the whole horror of its subject through the interaction of only four figures. Later that same night they also looked at David's *Sabines* (fig. 3). At first sight this crowded composition seemed to compare poorly with Poussin's condensed image. Yet at closer inspection, it too revealed its strength. Picasso and his friends spent the evening "in a delirium of painterly enthusiasm."

This experience inspired Picasso to paint a series of antiwar paintings. He had begun to think of the subject when Pignon invited him to contribute to the 1963 exhibition of the Salon de Mai, traditionally a reunion of veterans of the French Resistance and their friends. Quite often the organizers of the Salon proposed a common theme for their exhibitions. This time they suggested that the paintings submitted should be related to Eugène Delacroix's *Entry of the Crusaders into Constantinople*. Picasso, however, chose to base his contribution upon the two paintings he had studied during the slide session, using in addition the Louvre version of Poussin's *Rape of the Sabines* (fig. 4).

The first painting, executed on October 24, 1962 in Picasso's *Rape of the Sabines* series depicts barbarians carrying off women in attitudes closely related to the work by Poussin (fig. 1).[7] Yet it was clear from the outset that Picasso did not intend to paint mythological paintings but rather to indict war and violence in our time. This explains why he pursued through several of these mythologically based paintings and drawings the anachronistic motif of a young woman fallen from her bicycle (fig. 5). She has the face of Marie-Thérèse Walter, Picasso's love of the early 1930s,[8] and is being trodden under foot by the soldier from Poussin's *Massacre of the Innocents*. Four other works, titled *Warrior*, followed, in which the Warriors' heads are monstrously compounded with their antique helmets. In one of the most horrifying paintings (November 2 and 4), a woman with pathetically extended arms is run over by a ghostly rider (fig. 6). This woman is derived from the figure of Hersilia who, in David's *Sabines*, intervenes between the combatants and pleads for an end to the bloodshed. Her pleading gesture is transformed into one of surrender and horror.

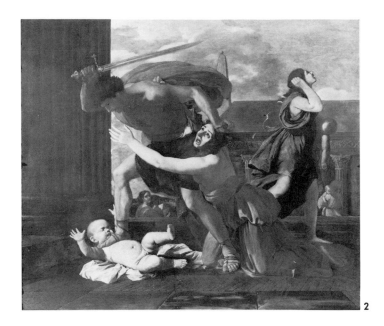

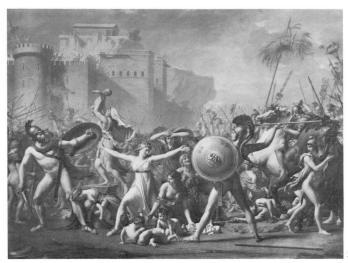

Fig. 2
Nicolas Poussin, *Massacre of the Innocents*
Oil on canvas, c. 1628
Chantilly, Musée Condé

Fig. 3
Jacques-Louis David, *Sabines*
Oil on canvas, 1799
Paris, Musée National du Louvre

Fig. 4
Nicolas Poussin, *Rape of the Sabines*
Oil on canvas, c. 1635–1637
Paris, Musée National du Louvre

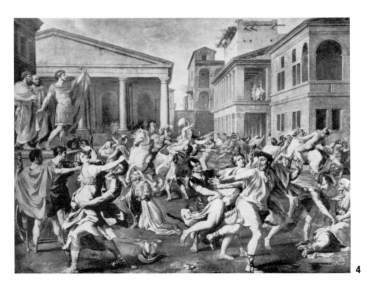

During the early days of November 1962 Picasso wrought elements of all the preceding paintings into a vast panorama of violence (fig. 7). One sees, surmounted by a bullring, a Greek temple and modern tenement buildings, a vast plane seething with convulsed bodies: mothers lamenting their children, women carried off by horsemen, men fleeing in panic, a lancer charging an unseen target. The figures have dotted faces and bloated, boneless bodies. A giant with an executioner's sword dominates the carnage. A mother with a dead child, like the one facing the bull in *Guernica*, screams at him. The giant is a savage caricature of the Romulus figure in David's *Sabines*.

What is the meaning of this "cynical" transformation? Whatever we make of it, it points at a painful ambiguity pervading this picture. Victims and assailants look too much alike; they are all treated with equal cruelty by the painter. For instance there is the radically foreshortened figure in center foreground, an almost evil-minded travesty of a well-known art historical formula, as exemplified in Mantegna's *Dead Christ*[9] or in the corpse in Rembrandt's *Anatomy Lesson of Dr. Deijman*.[10] With a pitiful smile he looks up to the hoof that will crush his face. Pierre

14

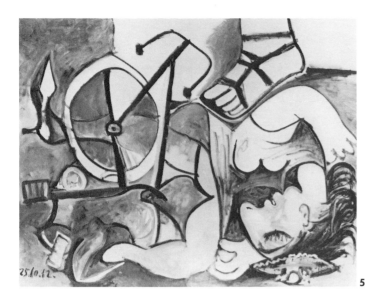

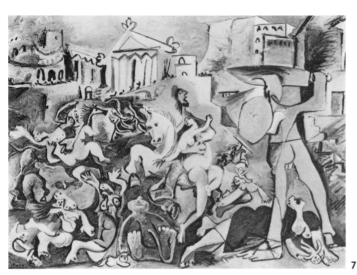

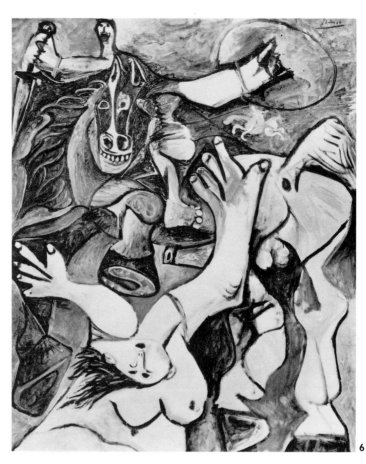

Fig. 5
Picasso, *Rape of the Sabines*
Oil on canvas, October 25, 1962
Zervos XXIII, 7

Fig. 6
Picasso, *Rape of the Sabines*
Oil on canvas, November 2, 4, 1962
Zervos XXIII, 71

Fig. 7
Picasso, *Rape of the Sabines*
Oil on canvas, November 4, 8, 1962
Paris, Musée National d'Art Moderne, Centre
   Georges Pompidou
Zervos XXIII, 69

Cabanne concludes that Picasso "cannot but record the strength, exalt the violence of the warriors. As in the cruel encounters in the arena, he is for matador and bull at the same time."[11]

This unresolved conflict may well have been the reason why Picasso, groaning under the weight of his self-imposed task, put the subject to rest until January 9, 1963. On February 7 he finished a large canvas which resolved the contradiction. As if he had exorcised the cruelty in his own soul, Picasso was now capable of creating one of the most moving statements against war and violence ever painted (fig. 8).

The figures are selected from the right half of the preceding picture and are monumentalized like the four figures in Poussin's *Massacre of the Innocents*. A lancer and a hoplite assail one another above the figures of a dying mother and her child. The hoplite, as tall as his antagonist and his horse together, puts his foot upon the dying woman. The Cubist interaction between figure and environment has rarely been used as effectively as in the way this Moloch inscribes himself into the peaceful land. One of his greaves lacerates the tilled soil; his giant toes scar

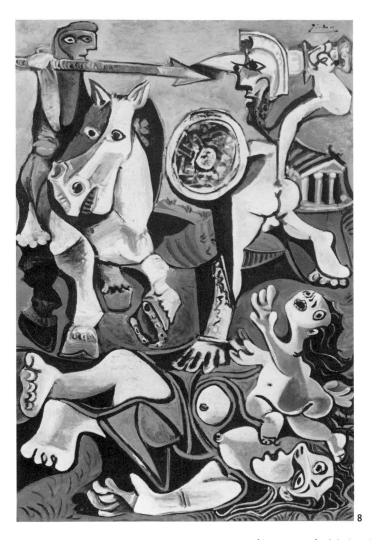

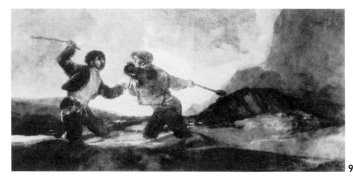

Fig. 8
Picasso, *Rape of the Sabines*
Oil on canvas, January 9, February 7, 1963
Cat. 1. (Plate 1)

Fig. 9
Francisco de Goya, *Dos Forasteros* (Quinta del Sordo)
Oil on canvas, 1821–1822
Madrid, Museo del Prado

the green field; his hideously mangled head plants itself triumphantly upon the distant temple roof. Indeed, the two warriors fight with the same stupid and reckless fury that is displayed in one of Francisco de Goya's "Black Paintings" (fig. 9) from the Quinta del Sordo, in which two men, both sunk knee-deep in a morass, are battering each other's heads with clubs. The savage horse is ready to crush the expiring woman whose defenseless body offers no resistance. The child screams as it helplessly attempts to escape. There could be no better example of the perfect necessity of deformation than the way its body is treated. The twist that conflates its front, side and rear views conveys with the child's stumbling movements the convulsion that shakes its body. This is one of those children which news photographers single out on the battlefields and in the bombed- and gassed-out villages of the wars of this century; such snapshots have been eagerly seized upon by the international press and used by all sides for political propaganda, as they break everybody's heart.

Thus, the final painting in the series is free of ambiguity. It derives its power from the contrast between the hideousness of the combatants and the human dignity of their victims. Poignant also is that the slaughter takes place on a lovely summer day. There remains, however, the question posed by the hoplite who, again, is derived from the figure of Romulus. Here, with the last trace of caricature removed, he is on a par with his proto- and antitype, as pure an incarnation of evil as Romulus is an incarnation of humanism and progress.

As always, Picasso is great at making the like unlike. The transformation of Hersilia in figure 6 poses a similar problem. Why has the pacifier been turned into a helpless victim of violence? Leo Steinberg provides an answer: ". . . to accuse the atrocity of a warring world, [Picasso] holds up to it the brutalization of what was made to be loved. The degradation of a cherished perfection becomes an index of the general sink."[12]

According to Pierre Daix, Picasso's biographer, cataloger and one of his closest friends during his later years, the Salon de Mai was only the external stimulus for these paintings. What directed Picasso's thoughts toward war and violence even before he was asked to participate in the show was the Cuban missile crisis and its threat of a new world war.[13] However, the variations on the *Rape of the Sabines* were to be Picasso's last paintings dictated by universal human or political concerns. They mark the conclusion of a line which includes *Guernica* (1937), *The Charnel House* (1944–45), *Massacre in Korea* (1951), and *War and Peace* (1952). That Picasso clad his message in a language derived from Baroque and Neoclassical sources was to him only natural; for a long time, and increasingly with deepening age, the artist had considered it his mission to be, in a very personal way, the keeper of the pictorial legacy of the West. Nobody will deny that the outcome, as exemplified by the masterpiece just discussed, of *Rape of the Sabines* was not historicism but an immensely powerful statement "for life against death"[14]—timeless, yet born out of our time. Picasso himself saw it so; and he was only half joking when he commented on the French Communist party's lack of comprehension about his work: ". . . what I have accomplished in painting was truly Socialist Realism, and 'they' simply didn't realize it."[15] Corroborating all writers who had first-hand knowledge of Picasso, Daix stresses the fact that Picasso remained politically informed and "engagé" to the end of his life. "Nobody who didn't know him was aware of it, but Picasso followed passionately the events of Spring 1968 in Prague and Paris; he read *L'Aveu*, shuddering with indignation at what happened in Spain, but also at that which likened the U.S.S.R. to the despotism of the Franco regime."[16]

As a painter, however, Picasso was to dwell thereafter exclusively on personal concerns and private fantasies.

**Artist and Model**

The day after he finished his great antiwar painting, Picasso embarked upon a subject which would keep him busy all through 1963 and intermittently throughout his remaining years, *The Artist and His Model*.[17] For a long time he would not dwell upon the anecdotal, or even the erotic potential of the theme. Nor was he to paint "autobiography." For, contrary to the painters in his pictures, he never used an easel, but laid the canvas flat upon a table or, if it was very big, stretched it out on the floor. More importantly, he hardly ever worked from live models.[18] Thus, he used *The Artist and His Model* as a metaphor for the conceptual nature of his art, for the transformation of the thing seen into a sign, for the paradoxical relationship between artistic and pragmatic truth.

Picasso initially explored the subject in a series of twenty-nine drawings.[19] The setting is always a studio with a high window (fig. 10). To the left a painter is seated in front of his canvas while a nude model lounges on a couch opposite him. However, the two figures are never rendered in the same idiom. If the model is

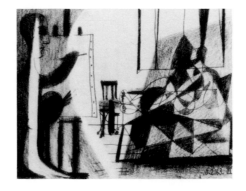
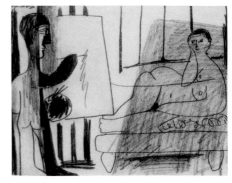
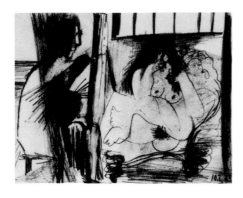
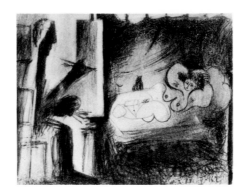
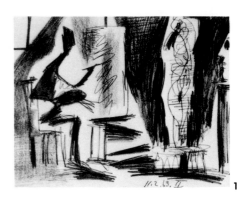

**Fig. 10**
**Picasso,** *The Artist and His Model*
**Pencil, February 10 (II–V), 11 (I, II), 1963**
**Zervos XXIII, 122–127 (XXIII, 126: colored
    crayons)**

given fully rounded corporeality, the painter is a mere matchstick figure. If the painter has a Greek profile and a solid body, the model becomes an abstract ideogram. Thus, visible and conceptual reality are treated as being interchangeable. We are rarely allowed a glimpse of the nascent painting, for the canvas is either seen edgewise, or empty or filled with a mere blotch of color. This is as it ought to be, for the process of transformation has been transposed into the figures of the painter, who enacts it, and the model, who undergoes it.

Evidently, Picasso was probing the nature of his artistic practice. The first two paintings after the completion of the sketchbook (figs. 11 and 12) have an almost monastic atmosphere. They show the painter engaged in a sober exercise: he is painting a sculpted head. In the first version there is a perfect equation between the painter's face, the bust and its image: all of which are treated as in children's drawings. In the second one, where the studio is suddenly illumined by a ray of light, the relationship has changed. The sculpture is treated more realistically, its surface flickering in the sunlight. The painter, however, has received a multiple, abstracted profile. Moreover, throughout the series, his chair has been removed from the easel and his body is treated to suggest how he is moving back and forth, sighting the subject from varying distances.

In the ensuing works, a nude model replaces the sculpture and the studio brightens up. Figure 13 represents a great many variations, in which Picasso always treats his theme with the most lighthearted virtuosity. Here also painter and model are each treated quite differently. The painter's body, again at a mobile distance from the subject, is structured as if it were the scaffold supporting his own canvas. The model is a green cotton swab kneaded into a lush arabesque. As if by miracle, every inflection of her body is there. In a later work, a quick improvisation in mother-of-pearl colors (fig. 14), the painter has disappeared and the model has become completely conceptualized. The canvas remains blank, as if to indicate

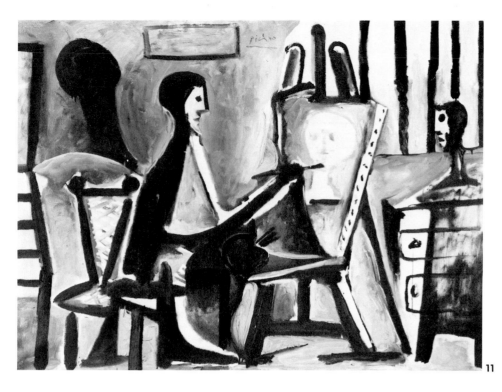

11

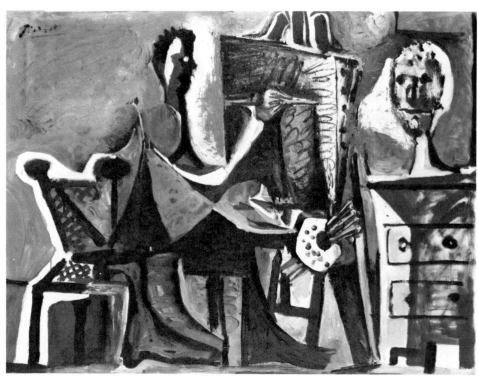

Fig. 11
Picasso, *The Artist*
Oil on canvas, February 22, 1963
Cat. 3.

Fig. 12
Picasso, *The Artist in the Studio*
Oil on canvas, February 22 (II), September 17,
  1963
Cat. 4. (Plate 3)

12

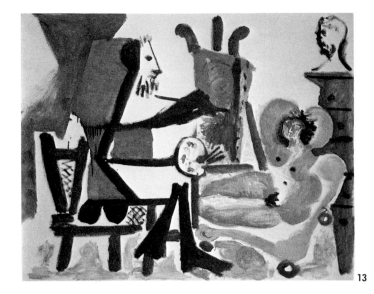

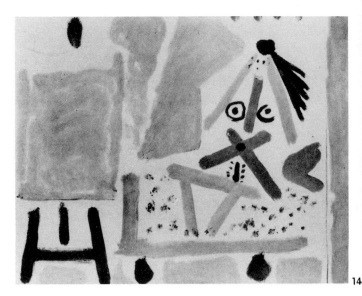

13

14

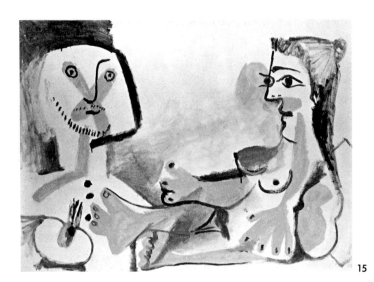

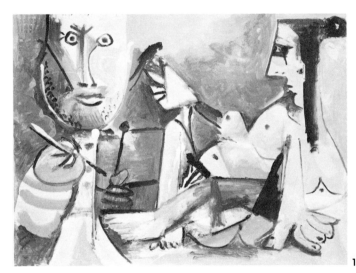

15

16

that there is a point beyond which conceptualization cannot be carried. The body is reduced to a triangle, a vertical axis and two crossed diagonals above a trapezoid. This diagram, however, is inscribed with a minimum of an impish face and summary indications of female attributes. These signs carry the weight of make-believe—they make the figure live. Maybe this is what Picasso meant when he said, "I want to say the nude. I don't want to do a nude as a nude. I want only to *say* breast, *say* foot, *say* hand or belly. To find the way to say it—that's enough. I don't want to *paint* the nude from head to foot, but to succeed in saying. . . . For you, one look and the nude tells you what she is, without verbiage."[20]

Many works from *The Artist and His Model* series deal with the scrutiny that enables the painter to "say the nude." If Picasso does not depict the model transformed, he will render her as the professional she is, posing indifferently, erotically neutral, almost reified. Yet he also dwells upon her interaction with the painter. Figures 15 and 16 belong to a series which, seen as a whole, unfolds like a cinematographic sequence, mirroring the painter's consternation and growing anger at his lack of success with his picture, while the model by turns assuages,

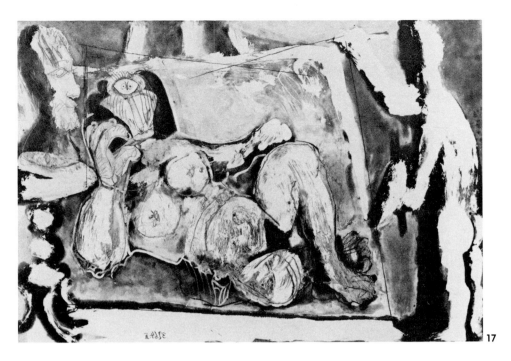

17

Fig. 17
Picasso, *Artist at Work*
Aquatint and drypoint, February 3, 1964 (III)
Cat. 129.

Fig. 18
Picasso, *In the Studio*
Aquatint and drypoint, March 14, 1965 (II)
Cat. 132.

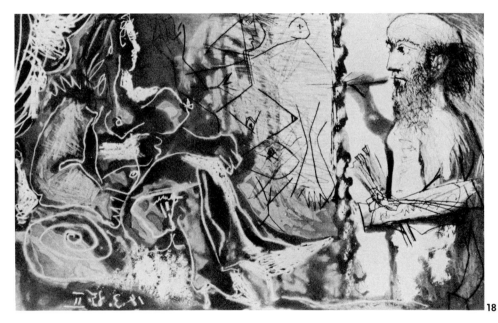

18

sustains, mocks and teases him, until she grows impatient and angry also.

A graver and more philosophical approach to the subject can be found in some etchings of 1963–65. Little known,[21] nevertheless these are among the finest Picasso ever did. They are boldly experimental in their technique and intensely revelatory about his artistic concerns. Mixed application of aquatint and aquafortis with drypoint allows Picasso, in an example such as figure 17, to envelop the studio in a twilight that turns the painter into a translucent ghost, while the reclining nude on the canvas receives a maximum of solid corporeality. Her body is Rubensian; her head, a cross between an owl and the Chicago *Monument*. Figure 18 carries the juxtaposition of different modes of representation one step further. The painter, a distant relative of Paul Cézanne's, is treated like a portrait. The model,

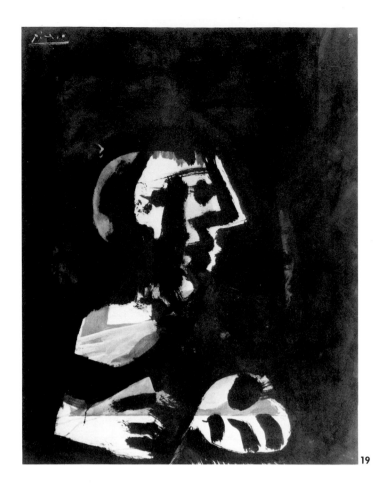

19

Fig. 19
Picasso, *The Artist*
Gouache and India ink, on a reproduction of a
    painting of March 30, 1963; October 10, 1964
Cat. 12. (Plate 8)

Fig. 20
Picasso, *Artist and Model*
Ink and chalk on green paper, January 25, 1971
Cat. 86.

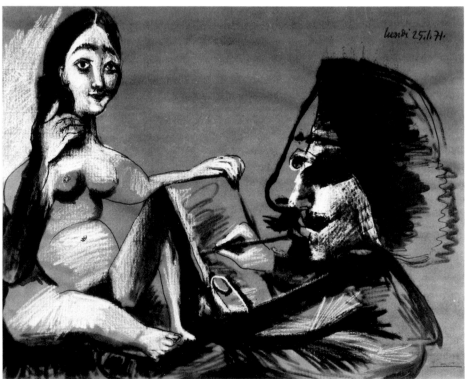

20

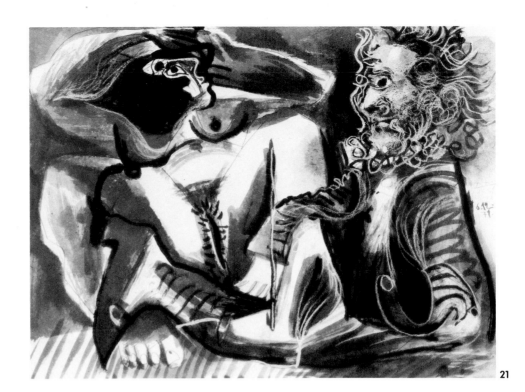

Fig. 21
Picasso, *Nude and Seated Man*
India ink, crayon and chalk, December 1–6,
  1971
Cat. 100.

21

outlined in white, dissolves and dematerializes as a consequence of a skillfully used technical accident. On the canvas, however, she is geometricized and firm as a rock.

In both these prints, we sense the atmosphere of Honoré de Balzac's *Chef-d'oeuvre inconnu*, the novella Picasso illustrated in 1927. It deals with an imaginary seventeenth-century painter, Frenhofer, who wants to incorporate all his art and wisdom in an ultimate masterpiece, a life-size female nude. He keeps the painting hidden from everyone: the nude is his "creation," his "beloved"; to expose her to profane eyes would be blasphemy. Yet, when the young Poussin and another artist are finally admitted to his studio, they find the painter, gone mad, in front of a canvas covered with senseless lines and blots of color. Picasso liked this story because the process by which Frenhofer transforms his originally naturalistic nude into a labyrinth of "senseless" lines corresponds in a certain way to his own definition of a painting as a "sum of destructions."[22]

Presently he was to combine *The Artist and His Model* theme with a variation on Rembrandt's *Self-Portrait with Saskia*.[23] Then again he painted painters alone in front of their canvases, intellectual artists, idealistic artists—and even a haunted one, literally groping his way in the dark (fig. 19). The latter was painted with gouache and India ink over a reproduction of an earlier, much brighter painting. Picasso would continue to make drawings of painters with their models: classical ones, Baroque ones (fig. 20), and finally one who could say with Baudelaire, "I have felt the wind of the wings of madness pass over me" (fig. 21).

Then there were the nudes: a great outpouring occurred early in 1964, between January 9 and May 11. Figure 22, left in a purely diagrammatic state, shows Picasso at his most experimental in reshuffling parts of the female body. He would develop this solution through several more stages. What with its fragility of delineation and the immateriality of its salmon pink border, this painting has something of the tenderness of certain vegetal fantasies of Paul Klee.

23

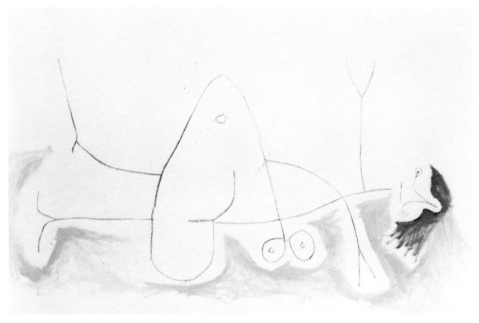

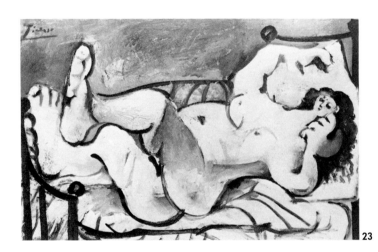

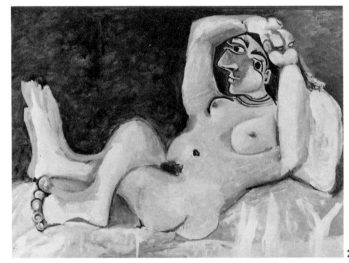

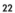

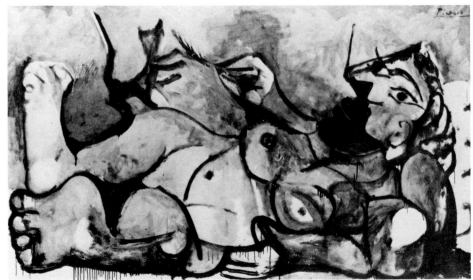

Fig. 22
Picasso, *Reclining Nude*
Oil on canvas, January 29, 1964 (I)
Cat. 8.

Fig. 23
Picasso, *Reclining Nude*
Oil on canvas, January 9, 18, 1964
Cat. 7. (Plate 5)

Fig. 24
Picasso, *Grand Nude*
Oil on canvas, February 20–22, March 5, 1964
Cat. 9. (Plate 6)

Fig. 25
Picasso, *Reclining Woman Playing with a Cat*
Oil on canvas, May 10, 11, 1964
Basel, Galerie Beyeler. Zervos XXIV, 145

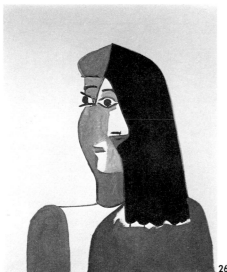

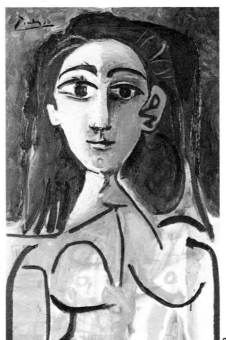

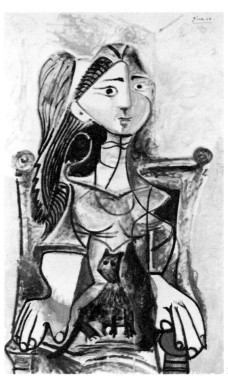

26

27

28

29

Fig. 26
Picasso, *Head of a Woman*
Oil on canvas, January 3, 1963
Cat. 2. (Plate 2)

Fig. 27
Picasso, *Portrait of Jacqueline*
Oil on canvas, April 22, May 30, 1963
Cat. 6.

Fig. 28
Picasso, *Seated Woman with Cat*
Oil on canvas, February 27 (I), March 22, 1964
Cat. 10.

Fig. 29
Picasso, *Seated Woman*
Etching, drypoint and aquatint, October 26, 27, 1966 (IV)
Cat. 136.

Figure 23 is the perfect visualization of a physiological fact: it shows how an individual, upon awakening, sheds the remnants of sleep. She flexes her biceps and kicks the air with her feet—her limbs are largest where she feels heaviest. The *Grand Nude* (fig. 24), on the other hand, shows a woman wide awake, with sharply modeled features, a strongly rounded body and only one evanescent foot. Note how brilliant the coloring is, with its highly unusual modulation from flask green via yellow to blue and pink. Finally, there is the bigger-than-life-size *Reclining Woman Playing with a Cat* (fig. 25). Devoid of coloristic refinement, brushed monochromatically in gray-green, the picture preserves the whole fury of the painterly process, whereby both pentimenti and exaggerations of limbs become as many ways of conveying the musculature of a strong body reacting to the quicksilver movements of a feline plaything. "The extraordinary, Picasso said, would be to make with all the most liberated means a picture that would incorporate itself into reality. . . . The opposite of a photograph. . . . A painting that contained everything of [a particular] woman and yet would not look like anything known about her."[24] It is perhaps in pictures like this that Picasso comes closest to such a paradoxical accomplishment.

It has often been noted that the image of Picasso's wife Jacqueline is diffusely omnipresent in *The Artist and His Model* series as well as in most of the nudes.[25] Her portraits range from idollike abstractions (fig. 26) through serene evocations of her youthful self (figs. 27 and 28) to that moving masterpiece, the etching of October 26 and 27, 1966 (fig. 29). In the latter, Jacqueline is portrayed twice. Frontally seated in an armchair, she appears hypersensitized, "all feeling," with, as it were, every nerve laid bare. On the left margin her profile is sculpturally consolidated and invested with the beauty of an unnamed sadness.

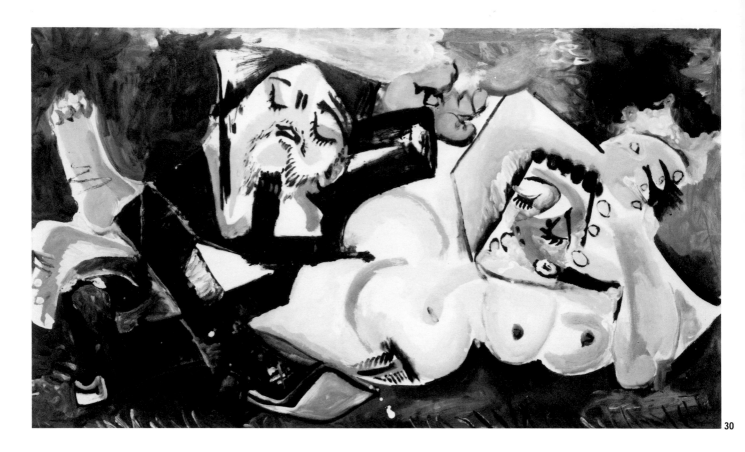

Fig. 30
Picasso, *The Sleepers*
Oil on canvas, April 13, 1965
Cat. 20. (Plate 7)

### Arcadia

Bucolic imagery was to loom large in Picasso's work between 1966 and 1968, although not in the anemic manner of one of his early heroes, Puvis de Chavannes. As always, the vision is rooted in reality—witness *The Sleepers* (fig. 30). The nakedness of the woman must be understood as poetic license; the figure of the man, however, sweating and snoring in his black Sunday best, designates the couple as peasants, or petits bourgeois from the suburbs on a country outing.

There are more paintings, and especially drawings,[26] of couples disporting themselves in the country; but in the latter, ideal nudity replaces all remnants of contemporary reality. In more than a hundred drawings, Picasso celebrates the joyful and peaceful life of a primeval Arcadia. There are hoary elders drinking wine or conversing with well-built youths; mothers tenderly receiving the caresses of their cupid sons; fishermen; children riding donkeys and goats or playing with tame hawks and buzzards; boys lolling on the beach, playing pipes and eating melons. Many times Picasso paraphrases an ideal triad: the loving mother, the providing father, and the adolescent son playing an antique oboe. Then again, as in figure 31, he portrays a father with his two sons. The father carries a sheep slung around his neck; it is not destined to be sacrificed, as in Picasso's famous sculpture on the town square in Vallauris,[27] but to serve as a playmate for the children before it fulfills its inevitable destiny on the family dinner table.

Finally, in some of the most breathtaking drawings, the artist concentrates upon the figure of a woman, always ripely portrayed, and a young lad serenading

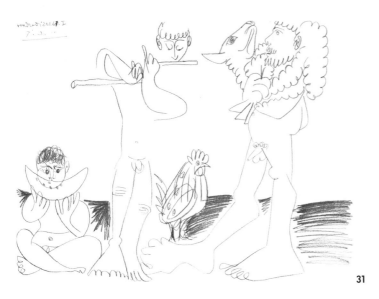

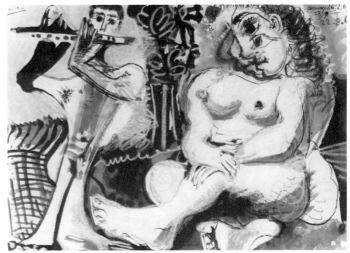

31

32

Fig. 31
Picasso, *Man with Lamb, Musician, Cock and Child with Watermelon*
Colored crayons, January 20 (I), 1967
Cat. 27.

Fig. 32
Picasso, *Seated Nude and Flute Player*
Ink and colored crayon, February 26, 27 (I), August 22, 1967
Cat. 29.

Fig. 33
Picasso, *Seated Nude and Flute Player*
Ink and colored crayons, February 26 (VI), 27, 1967
Cat. 30.

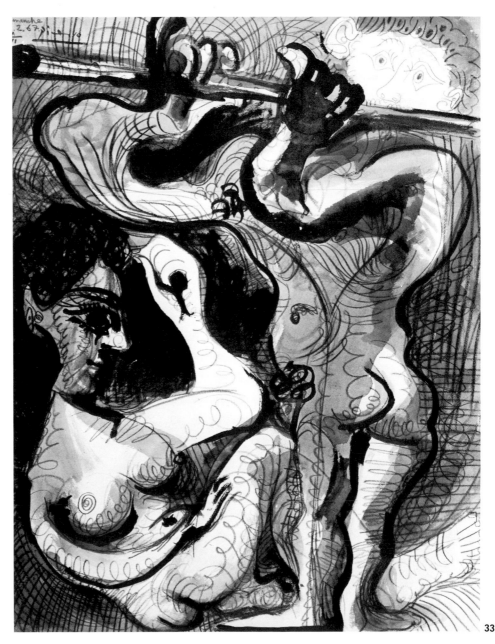

33

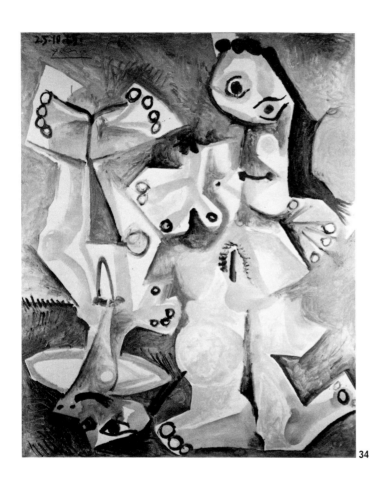

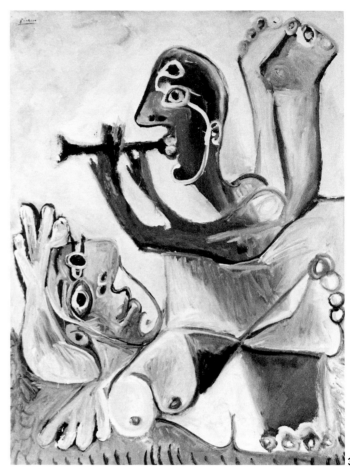

Fig. 34
Picasso, *Nude Man and Woman*
Oil on canvas, October 25, 1965
Cat. 23. (Plate 14)

Fig. 35
Picasso, *The Aubade*
Oil on plywood, June 18, 1967
Cat. 34. (Plate 18)

her on his flute. In figure 32, the boy's wiry body is tautened so that it resembles some of Picasso's sheet-metal sculptures. The woman, a Gaea Tellus (Earth Mother), listens dreamily. The placement of both her eyes in her left profile emphasizes her rapt expression. In figure 33, the flautist's body is twisted so that its upper part faces the viewer. His arms branch out mightily as his fingers belabor the instrument; his wide-eyed face realistically reflects the actual strain and elation of performance. The woman is so caught up in the rhythm that she snaps her fingers and wiggles to the music in her seated position.

Here the old artist revives one last time that dream which Paul Gauguin had impressed so forcibly upon his generation: the flight from civilization. To think there are whole peoples who lie in the sand and pipe upon bamboo canes![28] To think that it should be possible to rid oneself of all norms and necessities of modern life, of the curse of individuality—to live a life without memory, hence without

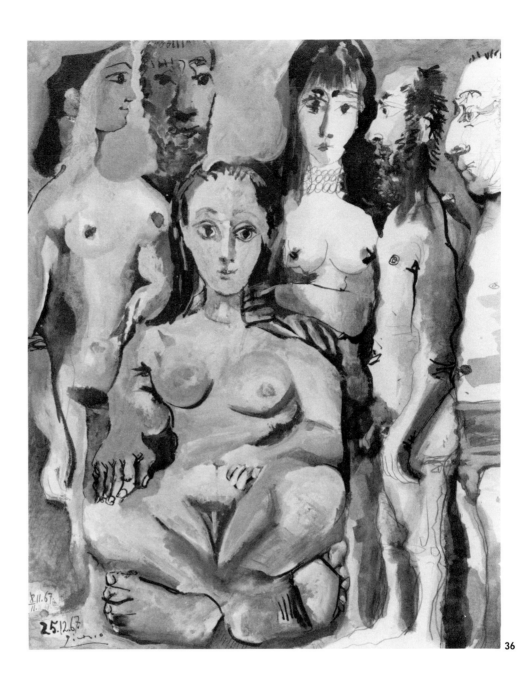

36

death; to come into being and disintegrate like a plant and to spend the interim safely embedded in the mythical collective of a primitive society. Could it be that the brain itself is the result of a faulty development?[29] This question seems to lurk behind those large paintings like figures 34 and 35, in which Picasso transforms his bucolic figures into budding primeval giants.

Alas, the answer to all those fantasies can only be no. At least, this seems to be the message of that very beautiful drawing (fig. 36), which shows the pastoral characters all suddenly world-weary and worn out by the experience of centuries.

The remaining themes of the drawings of 1966 to 1968 belong to civilization: the circus, variations on Ingres's *Turkish Bath*,[30] a sultan with his odalisques (derived, oddly enough, from the movie *The Lives of a Bengal Lancer* (1935), seen on late-night television at Mougins),[31] and scenes involving a new cast of seventeenth-century characters. It is to these latter ones that we now turn.

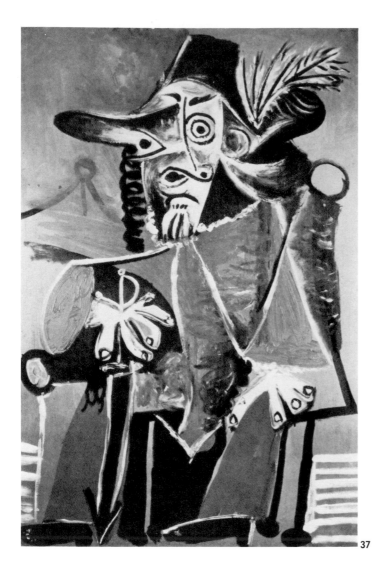

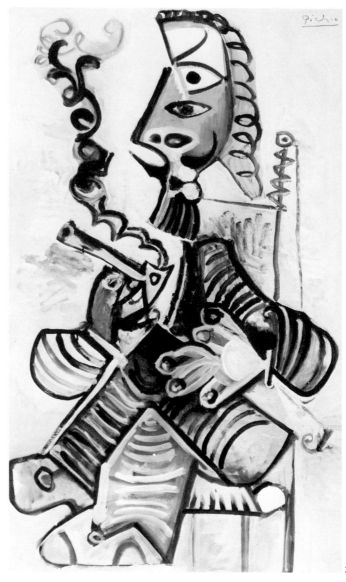

Fig. 37
Picasso, *Man with Sword*
Oil on canvas, July 19, 1969
Cat. 58.

Fig. 38
Picasso, *The Smoker*
Oil on canvas, November 22, 1968
Cat. 51. (Plate 27)

## Musketeers

In December 1966 an army of seventeenth-century soldiers invaded Picasso's pictorial world. These—soldiers of fortune, soldier-adventurers, Spaniards of the Golden Age—he referred to colloquially as "musketeers." The first contingent, mostly heads and busts, had austere faces surrounded by long hair, ruffs and collars. Soon, however, Picasso was depicting his musketeers as full-length figures sporting swords, sabres, muskets, or even the big lances with which cavalrymen of the 1600s were armed. At this point, we see them clad in doublets, fancy hose, belts in vivid colors, embroidered with gold and silver, and hats adorned with multicolored plumes.[32]

What fabulous monsters they are, these musketeers! Preposterous, to be sure, yet quite as believable as Picasso's most grimly distorted portraits of real people. And distorted they are. Their wide-brimmed hats hardly manage to contain faces in which giddy eyes dance under eyebrows shaped like ears of corn, and a bearded chin is appended like a tassel to a twisted nose. In the *Man with Sword* (fig. 37) the man's left eye is shaped like a bull's-eye and his right one shoots like a

bullet from the brim of his hat. For all his comic fury, he is rooted, nay transfixed, to his armchair. Or that other "musketeer"—in actual fact none other than Picasso's friend and printer Piero Crommelynck (fig. 38)—whose Quixote-like head is another instance of Picasso's restless experimentation with the human face. An upper profile, agitated and pale, is pushed into a lower, more sedate and blue one. The nose points to the left, but the chin with the blubber lips points to the right and the two halves of the mustache camouflage the trick.

There are faces drawn in a straightforward manner and others with widely dislocated noses and nostrils shaped like the ∞ sign. Certain heads are divided as if by a single slash of the sword. They all have big, hypnotic eyes: eyes brim with fury or eyes that know of terrible secrets; quirky, melancholic, or hungry eyes; eyes of blackguards; eyes of soldiers-turned-mystics. In the most iconic faces, two eyes are even encased in one socket.

These are very large canvases. They are painted with increasing rapidity and dispatch, with a great deal of black and white amid the garish colors. Pentimenti or difficult transitions are simply covered by brushwork, gray as tobacco smoke. The figures have the flatness of playing cards—André Malraux called them "tarots."[33] In his striving for flatness, Picasso avoids foreshortening. Hence, in seated figures he paints the legs and feet in a childlike manner, either parted or parallel. The drawing is often coarse. The musketeers' hands resemble "Picasso croissants," the pride of the bakers of Vallauris (one remembers the photograph of Picasso at the breakfast table, with those baked hands in front of him.)[34] Mere dots and squiggles indicate curly wigs, ruffs, and chains; striations in red, yellow, or green mark doublets and sashes. Picasso practices an against-the-grain historicism: with pictorial means that are light-years removed from the Baroque, he creates a Baroque pageant more exuberant and "genuine" than any of the studied historical reconstructions of the nineteenth century.

Once the first battalion had been assembled, Picasso and the Pignon-Parmelin couple met again and engaged in a new game, ascribing a character to every musketeer. "With this one, you'd better watch out. That one makes fun of us. That one is enormously self-satisfied. This one is a grave intellectual. And that one, Picasso said, look how sad he is, the poor guy. He must be a painter, somewhere."[35] And indeed, as soon as the "musketeer" type had been established, he endowed a great many of them with palette and brushes, thus adding to his gallery of "painters" a new class of courtly or martial seventeenth-century masters.[36]

Where did Picasso's musketeers come from? Apart from a lifelong love of masquerade, they came out of childhood memories. Returning to his beginnings as he did in so many ways at the end of his life, Picasso may have remembered certain drawings that he had done in 1894, at the age of twelve, after his first visits to the theater. These show "the typical sort of cloak-and-dagger character that might be used to illustrate many of the works of Lope de Vega."[37] Furthermore, musketeers belonged to the stock-in-trade of bourgeois historical genre painting around 1900, both in Spain (followers of Fortuny such as Domingo Marqués, Sanchez Barbudo or Pinazo) and in France (followers of Meissonier).[38] However, their immediate source was disclosed by Jacqueline in conversation with Malraux: "They came to Pablo when he'd gone back to studying Rembrandt."[39]

The extent to which reminiscences from Rembrandt pervade Picasso's work of his last years and, especially, the years following the long period of illness and convalescence in 1965–66 has hardly been recognized.[40] To quote only a few

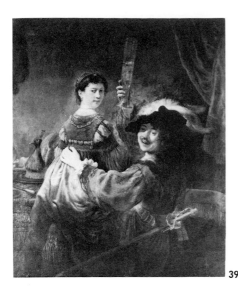

39

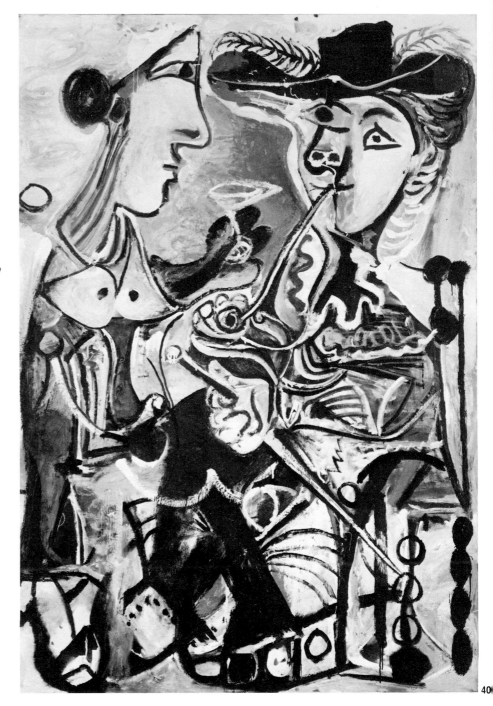

40

Fig. 39
Rembrandt, *Self-Portrait with Saskia*
Oil on canvas, c. 1636
Dresden, Staatliche Kunstsammlungen, Ge-
 mäldegalerie Älte Meister

Fig. 40
Picasso, *The Couple*
Oil on canvas, June 10, 1967 (II)
Basel, Kunstmuseum, Gift of the Artist, 1967.
 Collection of the Community of the City of
 Basel

instances: Rembrandt's *Self-Portrait with Saskia* (fig. 39) in Dresden again trig-
gered a series of transformations. One from June 10, 1967 (fig. 40), is fairly close to
its prototype, with both figures in full dress.[41] An earlier one, however, painted on
February 22 and 28 and March 1, 1967 (fig. 41), shows Saskia nude in the arms of
an older Rembrandt with what Picasso called his "elephant's eyes." Seen in this
context, the painting of November 10, 1968 (fig. 42), likewise reveals its derivation
from *Self-Portrait with Saskia*.

Rembrandt's *Danaë* in Leningrad (fig. 43) charmed Picasso's imagination. In
a drawing of July 6, 1969 (fig. 44), he transformed her into an earth goddess with
an enlarged right hand.[42] In a nude of 1968 (fig. 45) we still recognize her in spite of

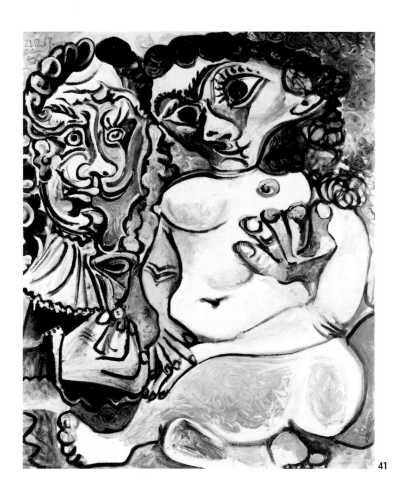

Fig. 41
Picasso, *Man and Nude Woman*
Oil on canvas, February 22, 28, March 1, 1967
Cat. 28.

Fig. 42
Picasso, *Nude and Smoker*
Oil on canvas, November 10, 1968
Cat. 50. (Plate 26)

41

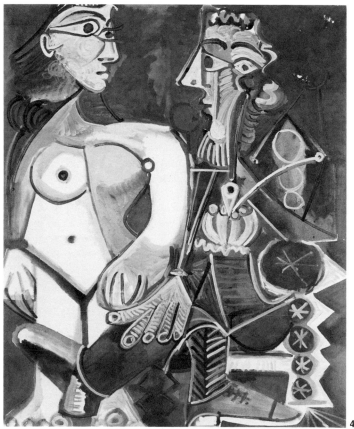

42

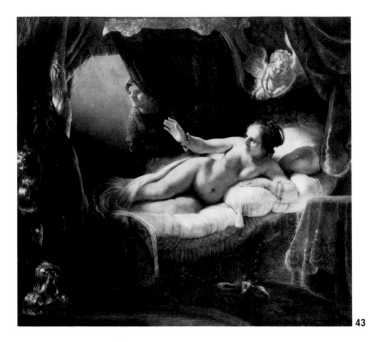

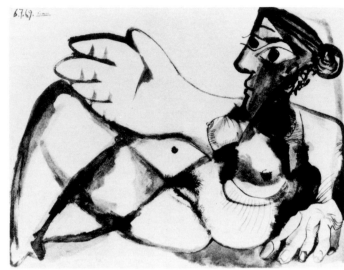
43

44

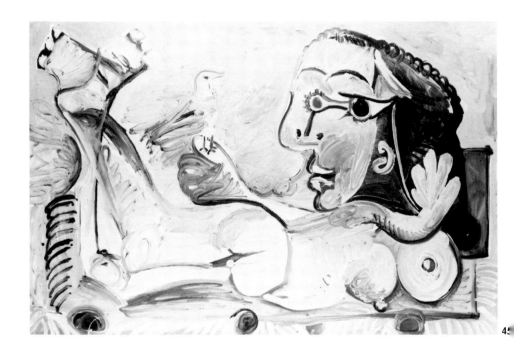

Fig. 43
Rembrandt, *Danaë*
Oil on canvas, 1636
Leningrad, Hermitage

Fig. 44
Picasso, *Reclining Nude*
Ink, July 6, 1969
Zervos XXXI, 304

Fig. 45
Picasso, *Nude Woman with Bird*
Oil on canvas, January 17, 1968
Cat. 41.

45

the twist given to her body as a consequence of the conflation of front and rear views.[43] The *Bather* (fig. 46) in the National Gallery, London, also prompted a transformation by reference to Rembrandt's etching *Woman Making Water* (figs. 47 and 48), with comic emphasis upon animal relief.[44]

In a more serious mood, Picasso painted several variations of Rembrandt's *St. Paul in Prison* (fig. 49). The painting of June 28, 1971 (fig. 50), shows a writer pausing in the middle of a sentence. He is deep in thought, or perhaps full of wrath, instead of being struck by the terror of spiritual illumination like his model. Proof

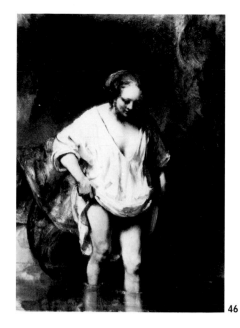

46

47

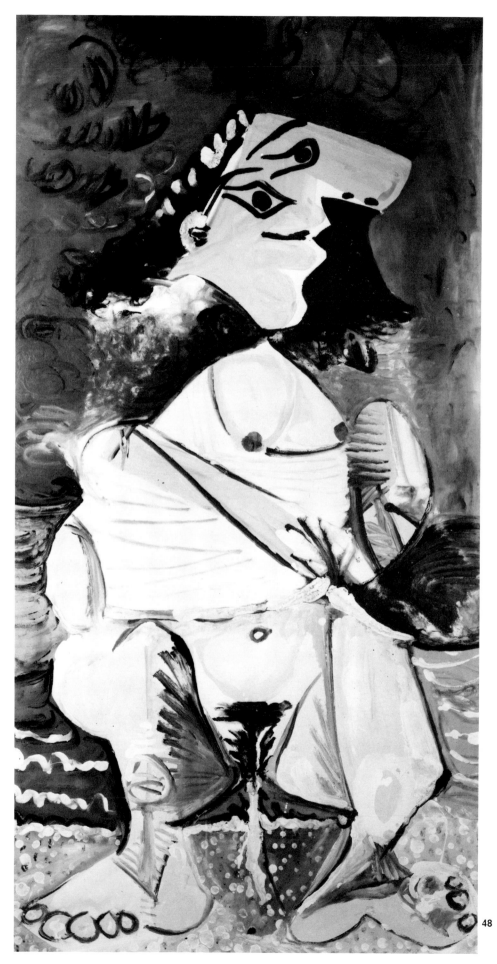

48

Fig. 46
Rembrandt, *Bather*
Oil on wood, 1655
Reproduced by courtesy of the Trustees of the
    National Gallery, London

Fig. 47
Rembrandt, *Woman Making Water*
Etching, 1631
Amsterdam, Rijksmuseum

Fig. 48
Picasso, *Woman Making Water*
Oil on canvas, April 16, 1965 (I)
Cat. 21.

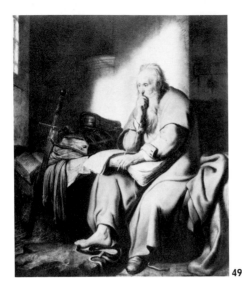

49

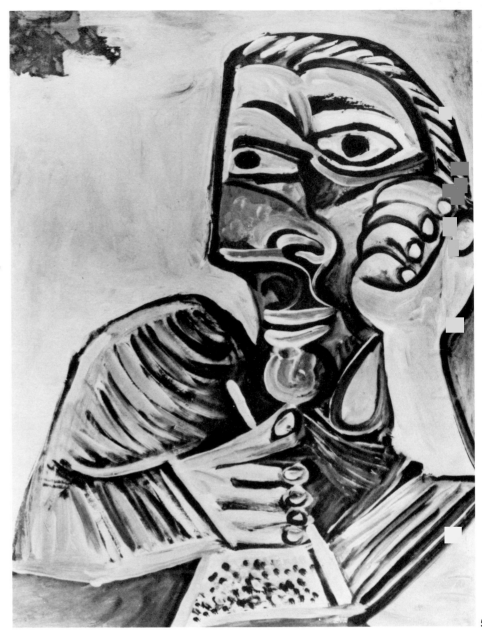

5

for the derivation can be found in the fact that Picasso's figure has two right hands: the "wrong" one, that is, the one that is attached to his left arm, is the same hand with which Rembrandt's saint holds his chin. In a later version of July 7, 1971 (fig. 51), the terror of illumination is fully revealed by the stare of one giant eye. Note also how Picasso transcribes the wind-swept fringe of St. Paul's hair.

Finally, as we return to the musketeers, there is the extraordinary *Character with a Bird* (fig. 52), painted on January 13, 1972, but reworked by Picasso shortly before his death. (It was thus the last painting he touched.)[45] Its prototype is Rembrandt's *The Falconer* in Gøteborg (fig. 53). Picasso transforms the watchful gaze of *The Falconer* into the frightening stare of an idol and pushes the left eye of his figure into the brim of the hat. He slashes the compound of head and hat in such a way that it appears—quite fittingly in view of the Dutch model—like the wings of a windmill.

Many of these musketeers are in a general way related to portraits by

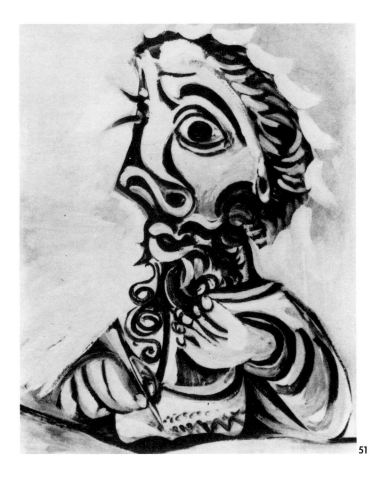

51

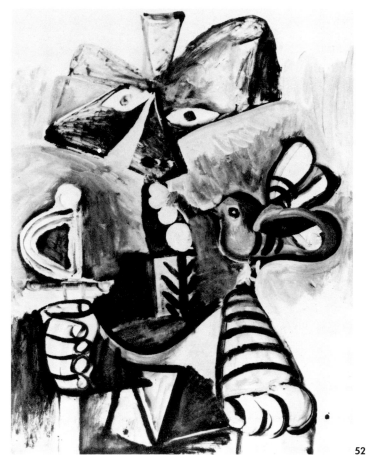

53

52

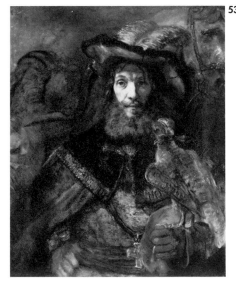

**Fig. 51**
Picasso, *Bust of a Man Writing*
Oil on canvas, July 7, 1971 (II)
Zervos XXXIII, 92

**Fig. 52**
Picasso, *Character with a Bird*
Oil on canvas, January 13, 1972
Zervos XXXIII, 274

**Fig. 53**
Rembrandt, *The Falconer*
Oil on canvas, 98.5 × 79 cm, 38¾ × 30⅞ in.
Gøteborg, Gøteborgs Konstmuseum

Rembrandt, even if it is not always possible to point to specific prototypes. What remains of the models is often merely something of the lineaments of a furrowed face, a searching look, a disheveled head of hair and beard, or the play of light and shadow. However, not many musketeers remain recognizably "Dutch." In most the spiritual climate is closer to El Greco, Velázquez, Murillo or Antolinez. Even the most diagrammatic ones are imbued with Spanish fervor, are *hidalgos* rather than *staalmeesters*.

Among Velázquez's works, Picasso painted some variations on his portrait of *Sebastian de Morra* (fig. 54), the dwarf at the court of Philip IV. Of the two examples in this exhibition, the *Adolescent* (fig. 55) retains the attitude of the model whose feet are stretched forward, with the soles facing the beholder. Yet Picasso's figure is less firmly rooted in the environment, whose coloration shifts from crimson via purple and yellow to green. His noble and perplexed features are slanted in anguish—a "Child Consecrated to Sorrow."[46]

Quite different is the *Man with Sword and Flower* (fig. 56). To a child's body is joined the enormous scarred and weather-beaten face of an old man with grim eyes and flaring nostrils. His forehead crowned with a wreath of flowers, he bristles in his narrow cell, like a mastiff in his kennel; the court jester dreaming he is a general.

The series further includes variations of well-known portraits of Cardinal Richelieu (figs. 57 and 58) and Louis XIII,[47] leading us to ask whether Picasso might

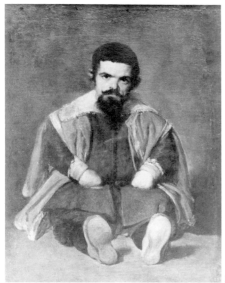

54

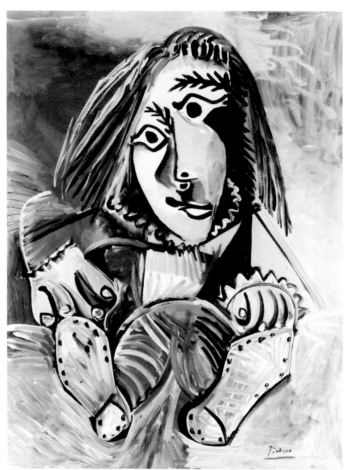

55

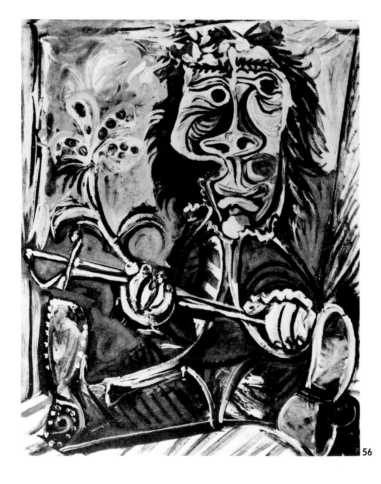

56

Fig. 54
Diego Rodríguez Vélazquez, *Sebastian de Morra*
Oil on canvas, c. 1645
Madrid, Museo del Prado

Fig. 55
Picasso, *Adolescent*
Oil on canvas, August 2, 1969
Cat. 59. (Plate 30)

Fig. 56
Picasso, *Man with Sword and Flower*
Oil on canvas, August 2 (II), September 27, 1969
Zervos XXXI, 449

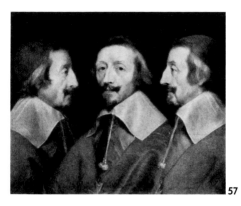

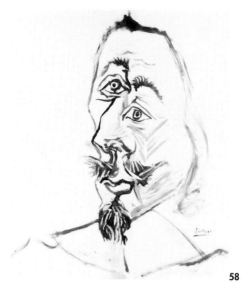

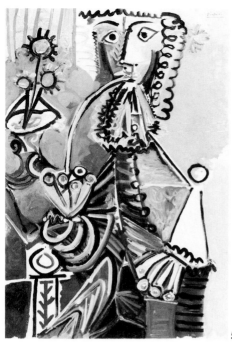

57     58     59

Fig. 57
Philippe de Champaigne, *Triple Portrait of the
  Head of Richelieu*
Oil on canvas, n.d.
Reproduced by courtesy of the Trustees of the
  National Gallery, London

Fig. 58
Picasso, *Head of a Man*
Oil on canvas, March 27, 1969 (III)
Cat. 56.

Fig. 59
Picasso, *Musketeer with Pipe and Flowers*
Oil on canvas, November 5, 1968
Cat. 49. (Plate 25)

Fig. 60
Picasso, *Head of a Man*
Oil on canvas, July 31, 1971 (II)
Cat. 92.

Fig. 61
Picasso, *Man with Sword* (detail)
Oil on canvas, July 19, 1969
Cat. 58.

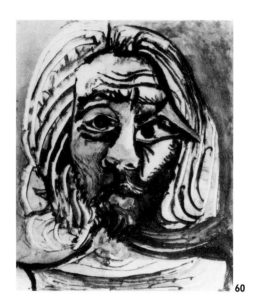

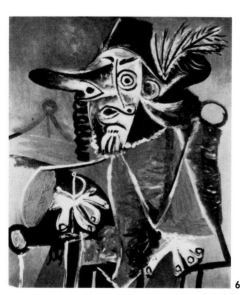

60     61

also have thought of Alexandre Dumas's *Three Musketeers*. Among the pictures in
the present exhibition, we recognize an ideal embodiment of Aramis, half-
musketeer, half-abbé: it is that most gentle of courtiers, the *Musketeer with Pipe
and Flowers* (fig. 59). The *Head of a Man* (fig. 60) corresponds to Athos, the
disenchanted moralist. Finally Porthos, the bragging, irascible, slightly dumb
fellow of irrepressible vitality: he could be found in the above-mentioned *Man
with Sword* (fig. 61), who, incidentally, is a distant relative of Rembrandt's *Warrior*
in the Thyssen-Bornemisza collection.[48]

    There is one attribute of Picasso's musketeers that he could not find prefigured
in Rembrandt: the long clay pipes which so many of them smoke. Men and
occasionally also women smoking such pipes can be found in paintings by
Adriaen van Ostade, David Teniers, Jan Steen, Frans Hals, Frans van Mieris,
Gabriel Metsu, but never in portraits by Rembrandt. Again, we have to seek the

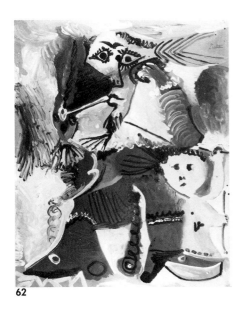

62

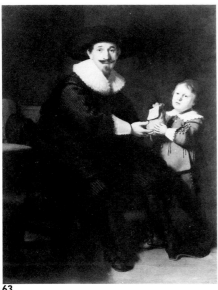

63

Fig. 62
Picasso, *Rembrandt-like Figure and Cupid*
Oil on canvas, February 19, 1969
Cat. 55. (Plate 28)

Fig. 63
Rembrandt, *Portrait of Jan Pellicorne and His
    Son Caspar*
Oil on canvas, c. 1635–1637
Reproduced by permission of the Trustees, the
    Wallace Collection, London

origin of the motif in Picasso's early life. "Picasso was a lover of pipes and knew a great deal about pipe lore . . . in his youth Picasso was a great pipe smoker. . . . There are all sorts of pipes in his early pictures—things with long Javanese stems and so on."[49] In his painting *Vase of Flowers* (fall 1907) some of his long-stemmed, gambier pipes hang from the chimney.[50] Of more sinister import is the inclusion of a pipe in the *Still Life with a Skull* of 1908. According to Theodore Reff's quite plausible conjecture, this painting reflects Picasso's reaction to the suicide of an artist friend, the German painter Wiegels, "just as the long opium pipe beside the skull may allude to the reputed cause of Wiegels' depression."[51] Picasso himself had for some time smoked opium with his friends, but he gave it up under the impact of the suicide.[52]

Yet during his last years when he had finally renounced even tobacco, the memory of its soothing effect was still on his mind. His smoking musketeers invariably have a wistful expression, as if musing upon some lost or inaccessible happiness. Characteristically, this holds also for those who smoke their pipes in the presence of voluptuous women. Was Picasso thinking of the words of the Psalmist: "For my days are consumed like smoke . . . "? Or was he aware of an emblematic tradition, flourishing in the Netherlands and well known to those seventeenth-century artists who painted smokers? This tradition treats tobacco smoke as a symbol of the futility and fleetingness of love, or else as a remedy against a lover's sorrows.[53]

A series of four paintings from 1969 shows sorrowful pipe-smoking musketeers accompanied by cupids, or genies of youth. Figure 62 was called by Picasso himself *Personnage rembranesque et Amour*.[54] I find its source in Rembrandt's *Portrait of Jan Pellicorne and His Son Caspar* (fig. 63). If my understanding of Picasso's transforming or appropriating works of others is at all correct, this is a prime example of how he proceeded (perhaps not even with the reproduction beside his canvas). What he remembered was the pudgy face of the child and the fine scepticism in Pellicorne's eyes, which are widened, with raised eyebrows, as though in an unspoken question. Both these features are translated almost verbatim into Picasso's idiom. Other recognizable details are Pellicorne's beard and lace collar, his cuffs, the striation of his costume, the rosettes on his shoes and even the twisted chair legs. Those are the materials from Rembrandt which Picasso welds into an altogether different conception.

Picasso had used dissonant combinations of red and yellow similarly in some of his variations on *Las Meninas*.[55] Here the tension is heightened by the addition of purple; and an element of restlessness is introduced by the nervously brushed areas in black, white and gray. Furthermore, color is used independently of its representational function. Red, generally reserved for the man's dress, also fills the area between his profile (with the characteristic right-left twist), his pipe and the vertically rising pipe smoke. Yellow covers the corresponding area between his cheek and left arm and his right arm is purple. The man's body is contracted in the torso, blown up in the grotesquely outspread extremities and entirely dominated by the twisted, sorrowful face. In a striated shape which may represent the brim or plume of the hat, his sorrows seem to radiate like brain waves from a troubled mind. Hectic brushwork imparts this mood to the entire surface. Only the cupid appears calm. He brandishes an arrow, yet trustingly nestles up against the man's body, a comforter rather than a tormentor.[56]

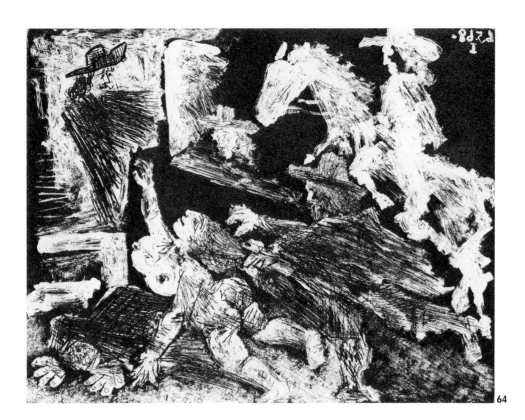

Fig. 64
Picasso
Aquatint, etching, May 16, 1968 (I)
Bloch No. 1572 (L. 92)

### Suite 347: Innocence

One would hardly do justice to the musketeers' iconographic complexity without taking into account a secondary meaning of the Spanish word *mosquetero*, which refers to those nonpaying spectators who stood in the back of the theaters of Spain's Golden Age.[57] José L. Barrio Garay, who was the first to connect this linguistic fact with Picasso's musketeers, concludes: "As if Picasso were now himself a spectator of his life and oeuvre, or as if his images had acquired the volition to create their own spectacle in his art, he has in recent years portrayed a fantastic circus and theater-like universe."[58]

This observation—it is of great consequence and we shall return to it—is clearly corroborated in the following incident: Picasso was showing some guests a few etchings from the evolving *Suite 347*.[59] One of these (fig. 64) attracted special attention. It shows a group of cloaked cavaliers, one on horseback, chasing a nude prostitute and her procuress, the archetypal La Celestina,[60] through a street with sketchily indicated, whitewashed houses. Picasso points with a roguish laugh at La Celestina, who has fallen on the floor and lost her money. Then he tells his company how such stories grow under his hand: "I spend hour after hour while I draw, observing my creatures and thinking about the mad things they're up to; basically, it's my way of writing fiction."[61]

Within that great outpouring of narrative fantasy which is *Suite 347*, scenes of cavaliers chasing prostitutes form a class by themselves. The pursuit starts with cloaked gentlemen meeting women accompanied by their *dueñas* (fig. 65). The girls sport the attitudes and allurements of Goya's *majas*, though Picasso hardly ever bothers to dress them in more than high-heeled shoes and the *tapada*, or veil,

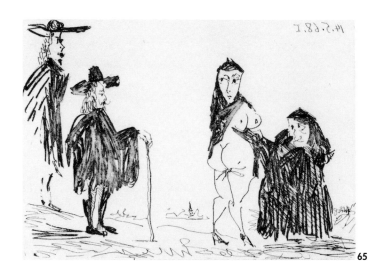

65

66

67

Fig. 65
Picasso
Etching, May 14, 1968 (I)
Bloch No. 1563 (L. 83)

Fig. 66
Picasso
Etching, May 14, 1968 (III)
Cat. 148.

Fig. 67
Picasso
Aquatint, May 15, 1968 (II)
Cat. 149.

slung around head and neck. The *dueña* is always La Celestina. Who are the cloaked cavaliers? Are they musketeers, noble soldiers of Their Most Catholic Majesties? Or are they "picarized" noblemen, by day leading the life of beggars and robbers and hiding under an ample cape clothes made of filthy rags? In some of the designs it is hard to tell whether the girl is being chased or whether she is dragging the cavalier. In a few moonlit and stagelike scenes (figs. 66 and 67), La Celestina takes the lead and their common goal is the *putería*, the whorehouse. In others, fierce horsemen carry off more or less unwilling females who wince under their abductors' rough grasp and throw up their arms as they are being swept away. Picasso paraphrases the theme in a variety of techniques, from detailed drawings in drypoint to ghostly materializations in aquatint or *manière noire* (figs. 68 and 69). Each time the pained contortions of the women strike us as a déjà vu, traceable, through Picasso's antiwar paintings of the winter of 1962–63, to its source: Poussin's *Rape of the Sabines* (fig. 3).[62] Nothing could be more indicative of Picasso's retreat into a private fantasy world than this transfer of the abduction

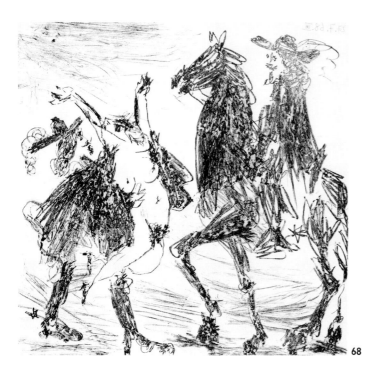
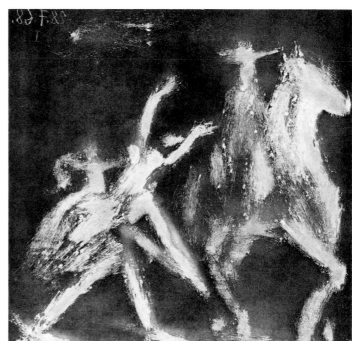

Fig. 68
Picasso
Etching, July 27, 1968 (III)
Cat. 159.

Fig. 69
Picasso
Aquatint, July 28, 1968 (I)
Cat. 160.

theme from one of his most enraged statements "for life against death" into the sphere of bawdy, picaresque comedy.

Throughout *Suite 347*, it is Picasso's private self that revels in fantastic disguises and ominous travesties. The first etching, however, includes his first *realistic* self-portrait after the lapse of some sixty-five years (fig. 70). He depicts himself as aged, frail and dwarfed by the performers in a darkened circus arena. The humble veracity of this self-image takes on splendid irony when he reappears in a later plate at the village photographer in an archetypal Spanish village (fig. 71). Strolling actors have arrived. A monk, a musketeer, and a street urchin gather around their cart. While harlequin and columbine—well-known characters from some Blue Period paintings—engage in a dialogue with the girls at the well, Don Pablo with a black cloth over his head and an antediluvian camera, photographs the lovely drawers of water. What's the difference? He does what he has always done—he transposes the image of naked beauties onto a two-dimensional surface. (One must not forget Picasso's contempt for photo-realism in painting!)[63]

In another etching (fig. 72) we see him sad and dwarfed alongside a gaudy musketeer who rubs his hands in happy anticipation at the sight of healthy female flesh. Here the artist puts himself into the picture a second time, now as a superannuated child, a putto with a wrinkled face who, although sitting in a Buddhalike pose in the presence of women, is, nonetheless, ridden with youthful appetites.[64] (It is not for Picasso to suppress any part of the truth.) Carrying on the self-deriding tendency of the *Human Comedy* series,[65] Picasso also appears in some circus scenes as a tiny clown. Obviously, these are only so many ways of telling us how age has caught up with him.

That marvelous circus of Picasso's! Where else in modern art has the excitement of the circus ring been evoked with so much gusto? Picasso's circus includes equestriennes and acrobats building their human pyramids on the back of a giraffe; swimming acrobats in a transparent tank; giants, midgets, wrestlers,

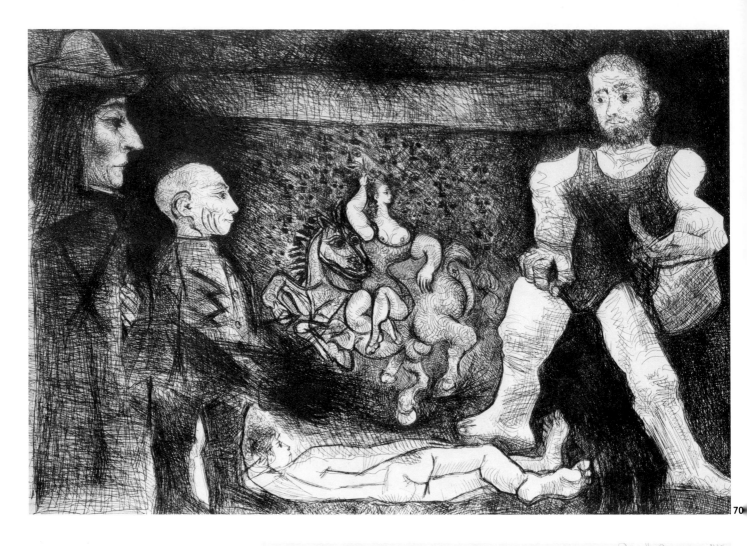

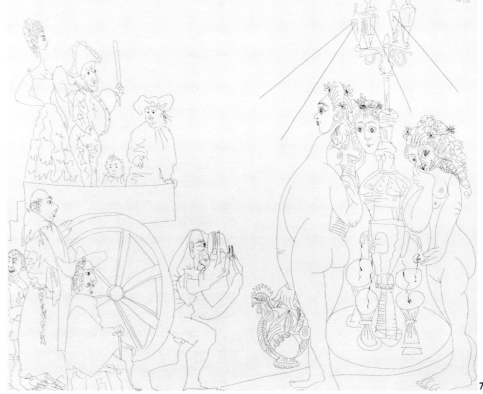

Fig. 70
Picasso
Etching, March 16–22, 1968 (I)
Cat. 138.

Fig. 71
Picasso
Etching, May 13, 1968
Cat. 147.

Fig. 72
Picasso
Etching, March 25, 1968
Bloch No. 1488 (L. 8)

Fig. 73
Picasso
Etching, April 11, 1968 (II)
Cat. 142.

Fig. 74
Picasso
Aquatint, etching, June 4, 1968 (II)
Bloch No. 1622 (L. 142)

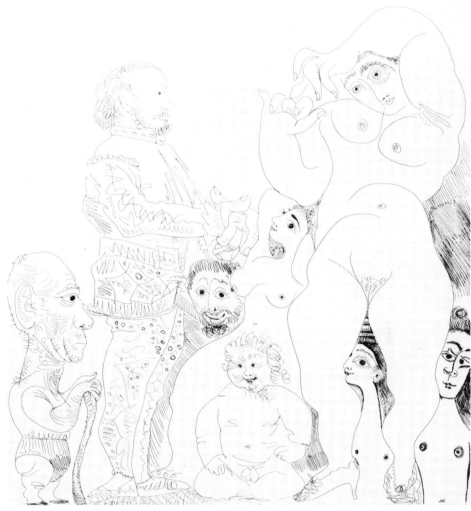

72

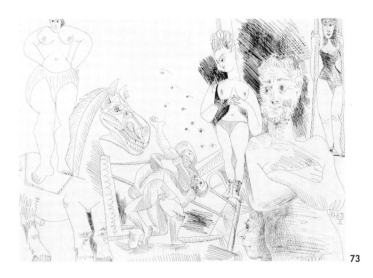

73

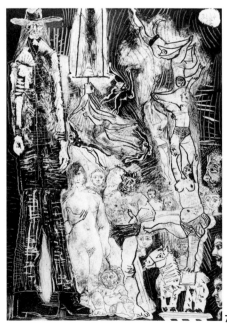

74

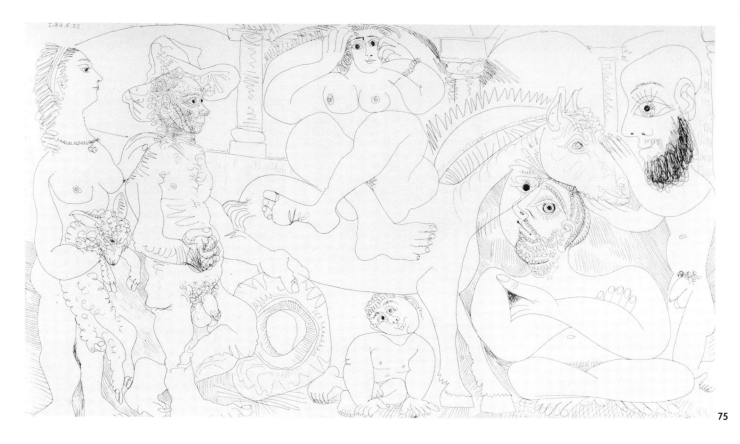

75

Fig. 75
Picasso
Etching, March 22, 1968 (I)
Bloch No. 1483 (L. 3)

Fig. 76
Picasso
Aquatint, May 28, 1968
Cat. 152.

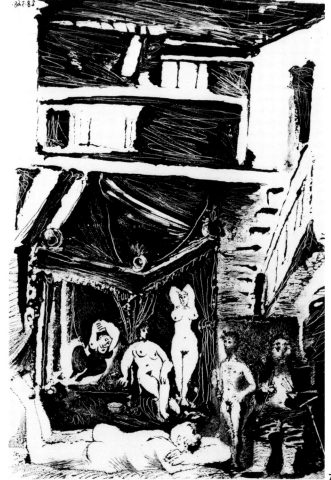

76

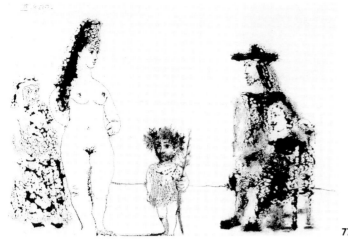

77

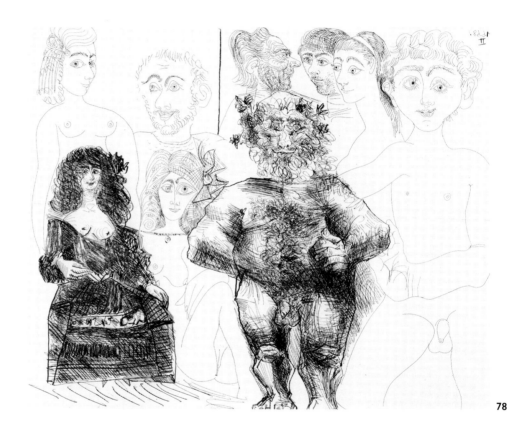
78

Fig. 77
Picasso
Aquatint, May 25, 1968 (III)
Bloch No. 1591 (L. 111)

Fig. 78
Picasso
Etching, June 1, 1968 (II)
Cat. 154.

tightrope walkers, and that most daring of female athletes who, high up in the tent, spins around an axis which she holds between her own teeth (figs. 73 and 74).

The imagery of *Suite 347* is characterized by a commingling of times and cultures: musketeers appear in the circus; harlequins in Homeric Greece; Amazons cavort like acrobats on antique chariots; an equestrienne officiates at the primordial sacrifice of a lamb (fig. 75), the scene of Velázquez painting the Infanta is transformed into a bordello (fig. 76). As time shifts backward and forward, Picasso sees himself as a child prodigy, attended by the specters of Velázquez and Rembrandt, and by Woman, that other source of his inspiration (a majestic mantilla-draped nude, led by La Celestina [fig. 77]). There are images in which he appears as a king of life, with the virility of a silenus by Rubens; nowhere more

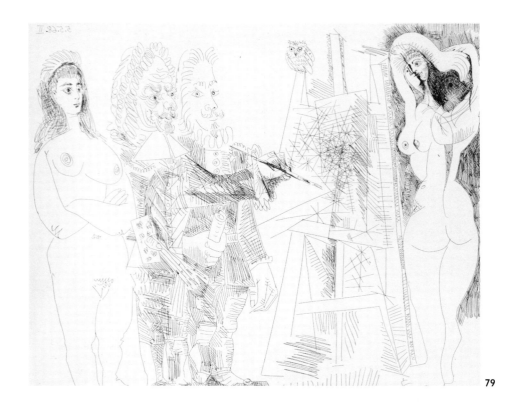

79

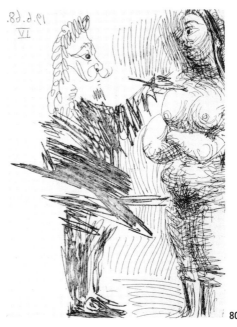

80

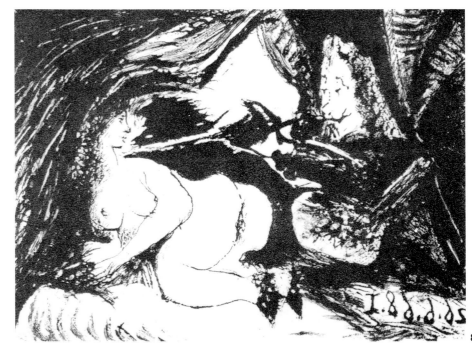

81

Fig. 79
Picasso
Etching, May 5, 1968 (II)
Cat. 146.

Fig. 80
Picasso
Etching, June 19, 1968 (IV)
Bloch No. 1646 (L. 166)

Fig. 81
Picasso
Aquatint, June 26, 1968 (I)
Cat. 157.

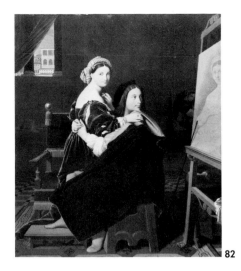

82

83

Fig. 82
J.A.D. Ingres, *Raphael and La Fornarina*
Oil on canvas, 1814
Cambridge, Mass., Fogg Art Museum

Fig. 83
Picasso
Etching, August 29, 1968 (I)
Cat. 165.

beautiful than in that plate where he, a hoary, ivy-crowned satyr, is led by the genius of Youth amid a group of bacchanalian revelers and *majas* (fig. 78). Thus, the comforter of lovesick musketeers sustains him also.

Other inventions tackle the problem of pictorial representation, the antinomy of artistic versus pragmatic truth. In figure 79 Picasso depicts a painter who, like the hero of Balzac's *Chef-d'oeuvre inconnu*, has transformed what we assume was originally a realistic nude into a web of incomprehensible lines. Moreover, the model who poses for him "in the flesh" is already, in the conflation of front and rear views, a typical "Picassoid" hybrid. Then there are those plates which deal with the theme, likewise related to Balzac's novella, of the artist's infatuation with the beautiful woman he has painted, and with his wish to bring her to life. In such plates (figs. 80 and 81), Picasso finds a disarmingly simple formula for the Promethean creativity of the painter: he omits the canvas and shows the artist working directly on his model. In one (fig. 80) he adds a touch to the coloration of her bosom; in the other (fig. 81) his brush glides lovingly around her neck and shoulders. The Pygmalion dream is a wish-fulfillment fantasy of which Leonardo da Vinci once wrote, "If the painter wishes to see beauties which will make him fall in love with them, he is a lord capable of creating them."[66]

This argument is carried to its conclusion in a series of twenty-four variations on Ingres's *Raphael and La Fornarina* (fig. 82). Picasso explained them to Roberto Otero:

> And there is one series that is quite innocent—I mean, quite natural. Well, you can imagine what they are about: Raphael and La Fornarina—his famous model—making love. Well, there's no need to exaggerate—it's not all sex, Raphael is painting in many of them, too—but Michaelangelo is also there, spying on them from behind the draperies and under the bed. And sometimes the Pope is peeping through the keyhole, or some other important character is lurking about. Anyway, they have to do with certain facts—I would call them historical facts.[67]

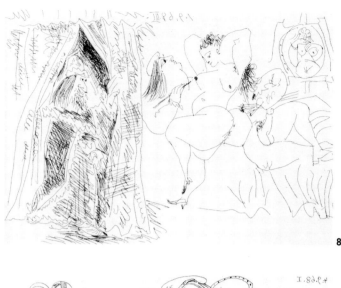

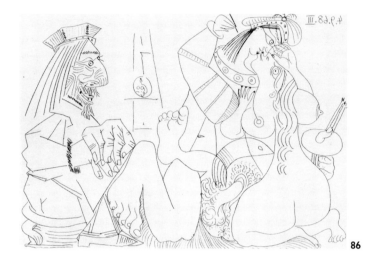

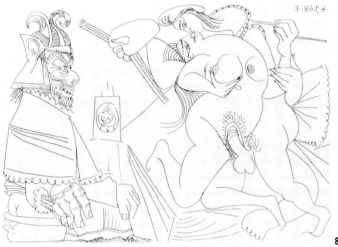

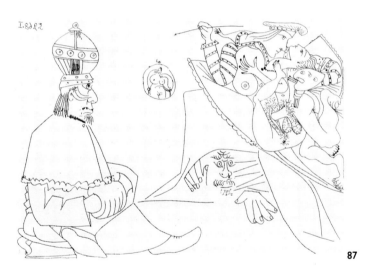

**Fig. 84**
Picasso
Etching, September 1, 1968 (III)
Cat. 166.

**Fig. 85**
Picasso
Etching, September 4, 1968 (I)
Cat. 167.

**Fig. 86**
Picasso
Etching, September 4, 1968 (III)
Cat. 168.

**Fig. 87**
Picasso
Etching, September 5, 1968 (I)
Bloch No. 1794 (L. 314)

Picasso was nothing if not a master of understatement. This "innocent" series contains not only a primal scene—the male child possessing the mother while Papa looks on—it is also the most fervent celebration of all the amorous conquests of Picasso's long life, a dizzying sequence of climaxes leading from foreplay into the ecstasies of consummation (figs. 83–87). The lovers appear as contortionists, their bodies writhe in simultaneous views to make sure the "important characters" do not miss any detail of their shared raptures. Yet in almost every print the painter retains palette and brushes in his hand. He goes on painting, on the Fornarina's body or merely in the air. Thus painting, lovemaking and "creation" (in Leonardo's sense) become one.

A year later, during the winter of 1969–70, a similar mood overcame Picasso. This time he painted kissing and copulating couples, all larger than life. Once more he empathized with one of his artistic forebears and depicted Douanier

Fig. 88
Picasso, *The Kiss*
Oil on canvas, October 26, 1969
Paris, Musée Picasso.
Zervos XXXI, 484

Fig. 89
Henri Rousseau, *Portrait of the Artist with Oil
    Lamp*
Oil on canvas, 1902–1903
Paris, Musée National du Louvre (Donation
    Picasso)

Fig. 90
Henri Rousseau, *Portrait of the Second Wife
    of Rousseau*
Oil on canvas, 1902–1903
Paris, Musée National du Louvre (Donation
    Picasso)

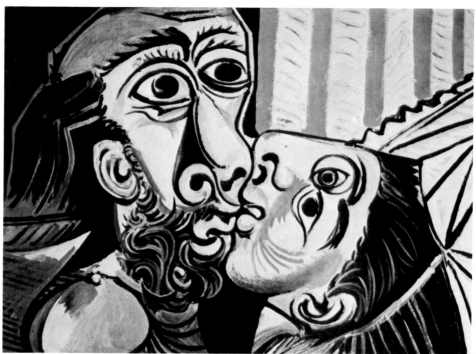

88

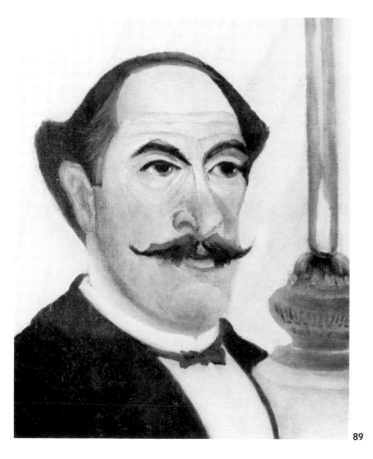

89

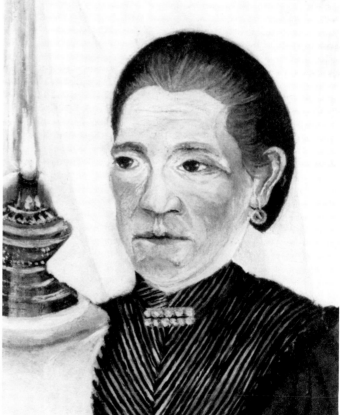

90

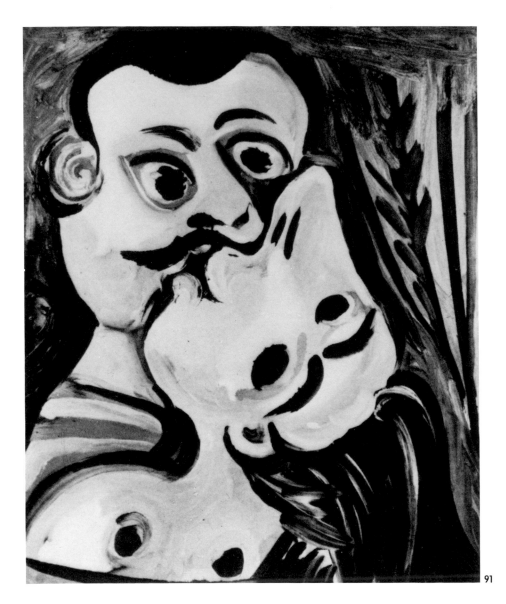

91

92

Fig. 91
Picasso, *The Kiss*
Oil on canvas, December 1, 1969 (IV)
Zervos XXXI, 534

Fig. 92
Henri Rousseau, *Portrait of Pierre Loti*
Oil on canvas, 1891–1892 (repainted about
   1910)
Zürich, Kunsthaus Zürich

Rousseau, a friend of his youth, embracing his second wife (fig. 88).[68] Picasso portrays the aged couple at a high pitch of emotion. The inspiration came from their portraits (figs. 89 and 90), painted by Rousseau himself, and which Picasso owned.[69] In another painting, *The Kiss* (fig. 91), the man is Pierre Loti as painted by Rousseau (fig. 92).[70] Thereafter he imagined the embraces of rustic couples. Figure 93 shows how Picasso at this point in his career eventually fell back upon much earlier works of his own—it is derived from the *Sleeping Peasants* of 1919 (fig. 94) in The Museum of Modern Art.[71] In spite of the lapse in time and difference in style, the later work appears as a sequel to the former. The couple has awakened and the man pulls the woman up to himself in order to continue their lovemaking which, as William Rubin puts it, is "primal in nature, more procreative than erotic." The humor in the depiction of the long-nosed female in her goggle-eyed ecstasy is related to Picasso's drawings of elephantine ballerinas, also of 1919.[72] Everything is primal in this series of paintings—ferocious unions of nude couples in nighttime gardens (fig. 95), as well as lyrical evocations of maternal divinities communing with little birds (fig. 96).

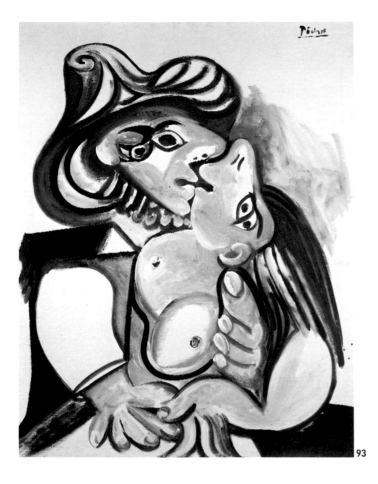

93

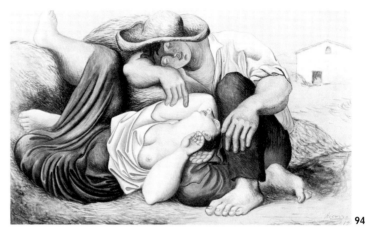

94

Fig. 93
Picasso, *The Kiss*
Oil on canvas, December 1, 1969 (II)
Cat. 69. (Plate 38)

Fig. 94
Picasso, *Sleeping Peasants*
Tempera, watercolor and pencil, 1919, 31 × 48
  cm, 12¼ × 19¾ in.
New York, Collection of The Museum of Mod-
  ern Art, Gift of Abby Aldrich Rockefeller.
Zervos III, 371

Fig. 95
Picasso, *The Embrace*
Oil on canvas, November 19, 1969 (II)
Cat. 68. (Plate 37)

Fig. 96
Picasso, *Woman with Bird*
Oil on canvas, January 14, 1970 (II)
Cat. 75. (Plate 42)

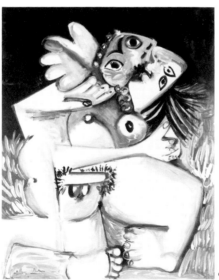

95

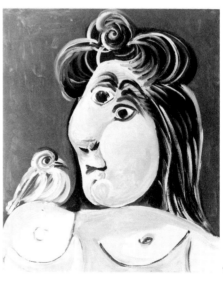

96

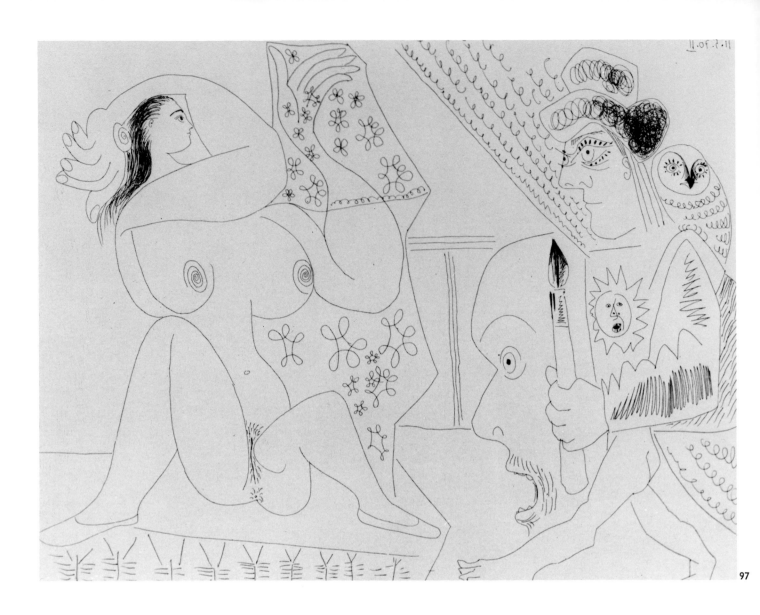

97

**Fig. 97**
**Picasso**
**Etching, May 11, 1970 (II)**
**Cat. 176.**

### *156 Last Etchings:* **Experience**

The series of couples was accompanied and finally superseded by less affirmative images whose protagonist is, once more, the musketeer but now in his role as spectator. What I have in mind are those many etchings and drawings in which the musketeer gazes, transfixed, at a woman exposing herself.

In this series several strands of Picasso's imagination intertwine. The musketeer's amatory melancholy has deepened as old age has forced him into the role of a mere "observer." The painter's scrutiny of his model (as we have seen, many musketeers are also painters) has been reconverted into that infantile curiosity which, according to psychoanalytical theory, played a crucial part in the formation of his artistic personality. Sometimes, it seems, he even reexperiences the infantile horror at the sight of the "mutilated" organ (fig. 97). In his countless variations on this theme Picasso creates an encyclopedia of male frustration. Only James Joyce has dealt with the subject as frankly and as exhaustively.[73]

Obviously, these works are rooted in Picasso's own condition. They are the works of a ninety-year-old man, a man, moreover, who all his life had been an

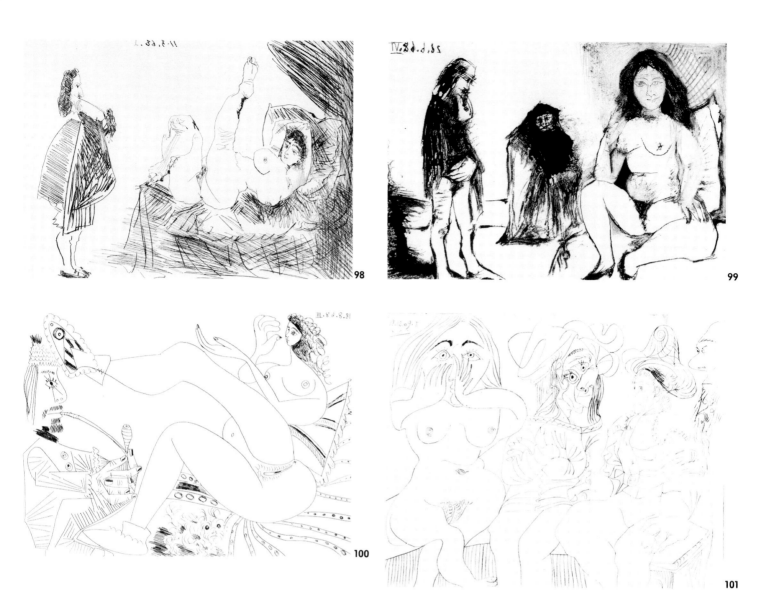

Fig. 98
Picasso
Etching, May 11, 1968 (I)
Bloch No. 1554 (L. 74)

Fig. 99
Picasso
Aquatint, drypoint, June 26, 1968 (VI)
Cat. 158.

Fig. 100
Picasso
Etching, August 18, 1968 (III)
Cat. 163.

Fig. 101
Picasso, *Seated Nude and Three Figures*
Crayon, December 18, 1969 (I)
Cat. 71.

obsessed lover of women and was now reduced to inactivity in the company of a loving and beautiful woman much younger than himself. Not surprisingly, these images betray a dogged refusal to sublimate. They give reality its due (after that last outburst described above, there were no more depictions of frantic embraces, no more Raphaels consummating their love with their muses); but the fixed stare transmits the unrepressed drive in all its despairing frenzy, a frenzy whose expression is as free of shame as it is undiluted by self-pity. The proud musketeer has become an old geezer at a peep show for whom the glorious stage of the world has narrowed into a dark-centered cleft of flesh.

Time and again, in *Suite 347* one encounters these hapless musketeers holding on to those penis substitutes, their pipes (fig. 98), or nervously twitching their mustaches in front of inviting females. Singly or in groups, they are introduced by La Celestina to some stately member of her harem. The women expose themselves with the bored mock solicitude of professionals (fig. 99). Sometimes they grow impatient at the suitor's hesitation and hit his forehead with a big foot in a slipper (fig. 100). In a gentler mood they imitate jilted girls, mawkishly hiding their faces

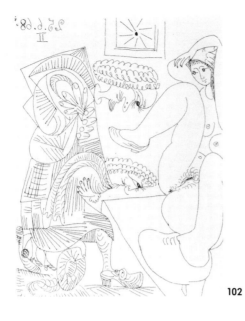

102

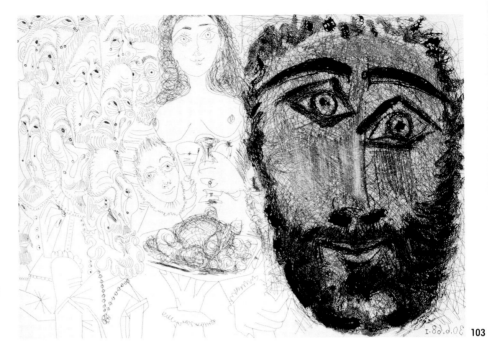

103

Fig. 102
Picasso
Etching, June 25, 1968 (II)
Bloch No. 1664 (L. 184)

Fig. 103
Picasso
Aquatint, etching, June 30, 1968 (I)
Bloch No. 1676 (L. 196)

Fig. 104
Picasso
Etching, June 25, 1968 (IV)
Bloch No. 1666 (L. 186)

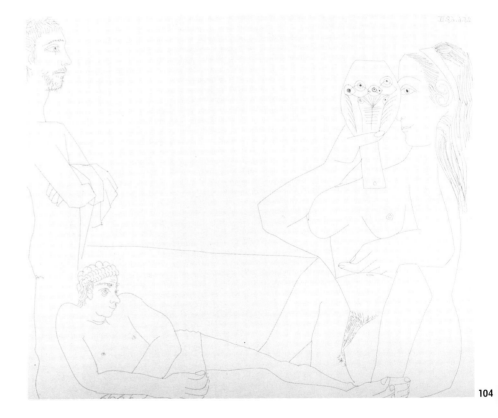

104

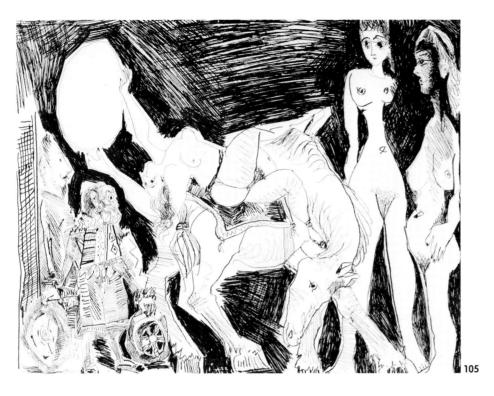

105

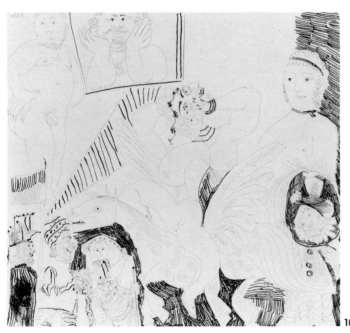

106

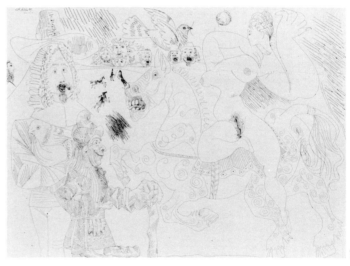

107

Fig. 105
Picasso
Etching, April 20, 1968
Bloch No. 1523 (L. 43)

Fig. 106
Picasso
Etching, April 14, 1970
Cat. 174.

Fig. 107
Picasso
Etching, April 19, 20, 1970
Cat. 175.

(fig. 101). Yet the clients are there only to look. A comic travesty of Spanish etiquette is enacted—unwittingly, it seems—by some haughty seventeenth-century grandees from the court of Philip IV. They bend down in front of the girls, intent only upon their inspection. Yet their attitude is that of the most reverential bow (fig. 102). There are aged lovers whose frustration paints itself in a mien of cosmic pessimism (fig. 103); there are younger ones whose desire remains equally goal-inhibited (fig. 104). At one point, the scene of inspection and exposure is transposed to the circus arena. The equestrienne's gyrations twist her sex into a beautiful ornament.

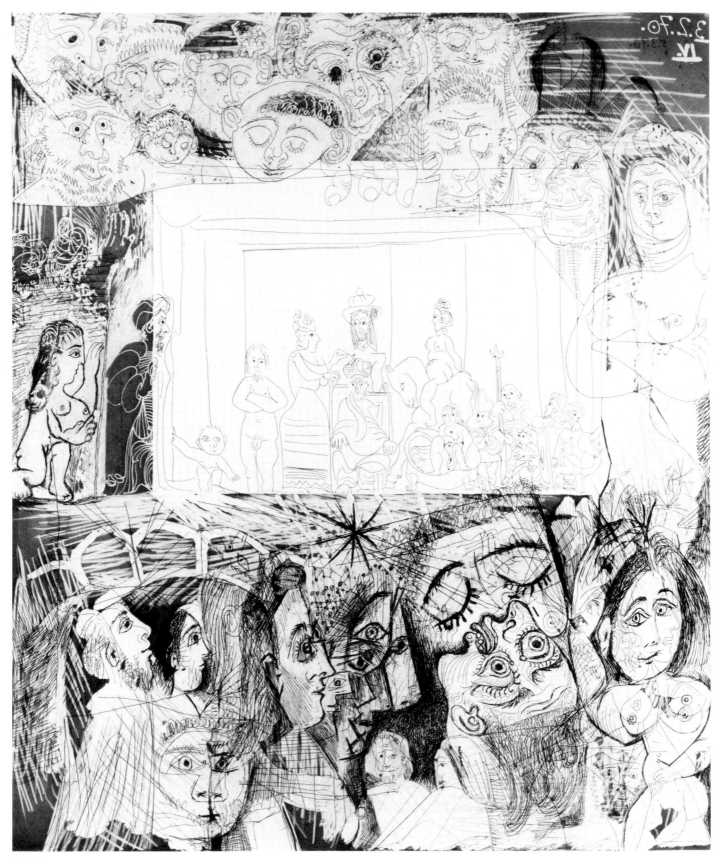

Fig. 108
Picasso
Etching, aquatint, scraper, February 3 (II),
  March 5, 6, 1970
Cat. 171.

109

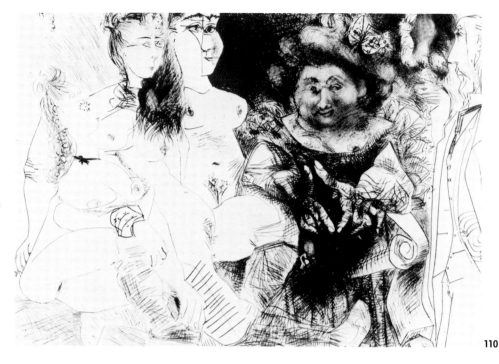

110

Condescendingly and cruelly, she offers herself to the view of clowns, dwarfs and misfits (figs. 105–107).

The *mosquetero* as "odd man out" recurs in the later series of *156 Etchings*, done between January 15, 1970, and March 25, 1972. In one remarkable invention (fig. 108) musketeers flock around a stage upon which a *Gran Teatro del Mundo* is being performed.[74] They are peering down from the gallery while the paying spectators in the tiers engage in amorous pursuits. However, the play is not an *auto sacramental*. An atheist,[75] Picasso forgoes Calderón's idea of putting God center stage as the great artist-creator, modeled upon the Baroque prince who in a lavish feast celebrates his might and splendor. Instead, he depicts an aged king perplexed by the pageant surrounding him.

In the middle of the series, the arch voyeur Edgar Degas makes his entrance. The inspiration for the forty plates with Degas as protagonist is well known. Picasso owned eleven monotypes by Degas depicting scenes in a bordello. Early in 1971, while looking at them with William Rubin, he asked, "What do you think he was doing in those places?" In order to answer this question for himself, he etched these forty compositions.[76]

Picasso's answer was: Degas came only in order to watch. Hence, in each of these etchings he portrays Degas as a mere onlooker, a wallflower. His hands in his pockets, or crossed behind his back, Degas stares at revelry which he does not dare to join. Even when, in the only scene which Picasso derived directly from Degas's series (fig. 109),[77] the girls celebrate the birthday of the *patronne*, he remains the outsider (fig. 110). On the other hand, Picasso makes him *see* much

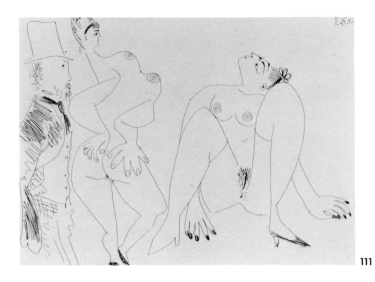

111

Fig. 111
Picasso
Etching, April 1, 1971 (II)
Cat. 182.

Fig. 112
Picasso
Etching, April 4, 1971
Cat. 183.

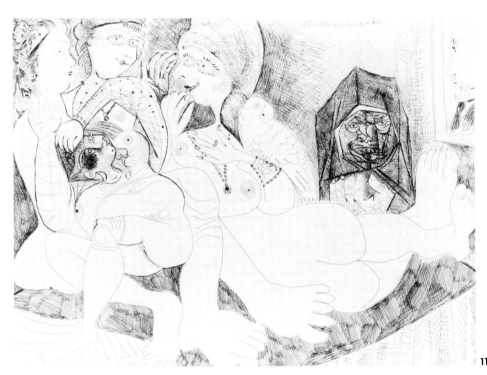

11

more than Degas himself jotted down in his monotypes. Degas depicts a typical petit-bourgeois bordello with plump middle-aged prostitutes lolling naked on plush sofas or catering drowsily to their clients. In Picasso's etchings, however, the brothel becomes to Degas what it became to Bloom in Joyce's *Ulysses*: a theater of hallucinations where, in constantly shifting scenes, all the hero's secret wishes and fears take shape. Degas asks two prostitutes to perform a lesbian wedding dance (fig. 111). Soon all the girls join in a Sapphic orgy, sneering at the voyeur (fig. 112). Then again those frightening women are transformed into monstrous African witches, with tribal scarifications on their faces and bodies (fig. 113). They cavort lasciviously among commedia-dell'arte characters or huddle under the thumb of La Celestina. They tease the helpless man mercilessly, degrading him through the exposure of their own debased flesh. Yet such is the power of wish-fulfilling vision that, in a transformation worthy of Rimbaud, the whorehouse appears to Degas as

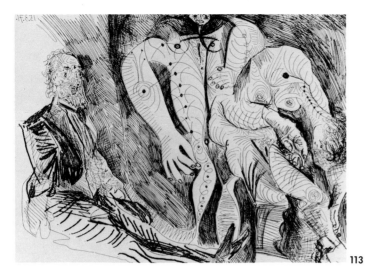

113

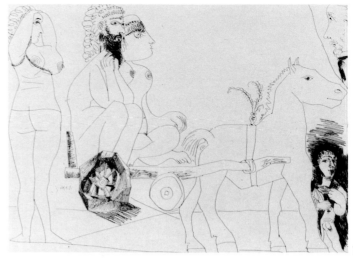

114

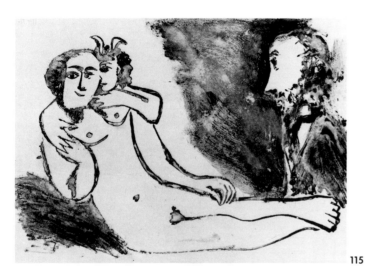

115

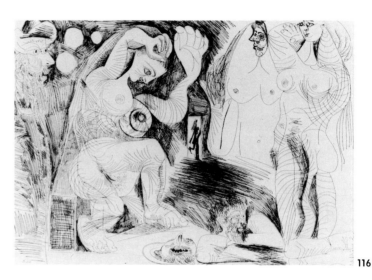

116

Fig. 113
Picasso
Etching, March 15, 1971
Bloch No. 1939 (L. 84)

Fig. 114
Picasso
Etching, April 11, 1971
Cat. 185.

Fig. 115
Picasso
Aquatint, April 11, 1971
Bloch No. 1969 (L. 114)

Fig. 116
Picasso
Etching, June 6, 1971
Bloch No. 2000 (L. 146)

an ideal Hellas (fig. 114) and one of the prostitutes presents herself to him as an Arcadian deity dallying with an infant faun (fig. 115). In the end, with all the trappings of civilization removed, he sees the *maison close* as a haunt of primeval humanity.

Throughout these transformations, "Degas"—this projection of Picasso at ninety—remains alone with his dreams and fears. "He would have kicked me in the fanny, Degas would, if he had seen himself like this," Picasso remarked to Pierre Daix.[78] He had a way with his forebears: Rembrandt, Velázquez, Raphael, Degas—he paid homage to all of them in the same spirit of affectionate mockery. Eventually, Picasso could make fun of his own obsessions as well. Witness his superbly witty depiction of Salome's dance: as she steps around the silver platter, skittishly raising her legs, the Baptist's severed head opens one eye to catch a glimpse of that sacred vessel which in life he had rejected (fig. 116).

In the remaining paintings and drawings, the musketeers become more and more ghostlike and the scenes of inspection ever more diagrammatic.[79] It is in subjects such as toreros, Arcadian figures, family groups and self-portraits that Picasso's art moves to new heights.

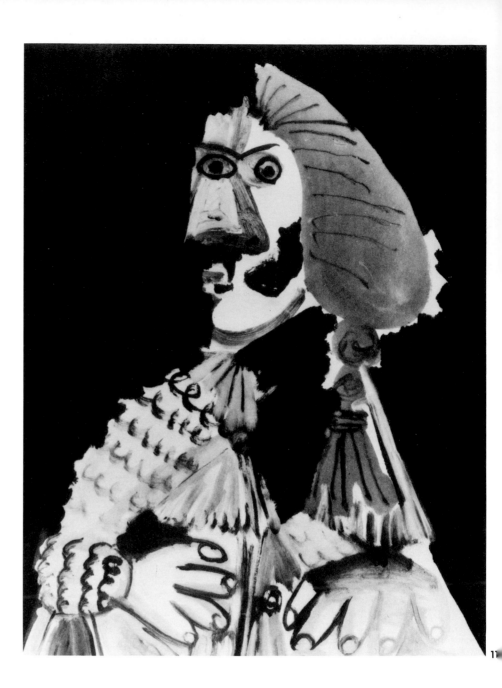

### *Puer Aeternus* and Self-Portrait

Next to painting and women, the bullfight was the greatest passion of Picasso's life. He carried the bulls in his heart and remembered proudly how a famous matador, a friend of his father's, had taken him on his knee when he was a small boy.[80] Later, when attacking a new canvas, he would compare himself to the torero entering the arena. In his last paintings of toreros he endeavored to bring out their bravery, the heroism of their souls, the pride they take in their women. According to Rafael Alberti, these are not the bullfighters of today but "romantic toreros, elegant and beautiful fellows dear to Goya."[81] Picasso therefore imbues them with a fairy-tale radiance that darts from their fierce eyes and glitters on the embroideries of their costumes (fig. 117). He also painted a different class of bullfight characters, not so proud and resplendent. These are the picadors, and

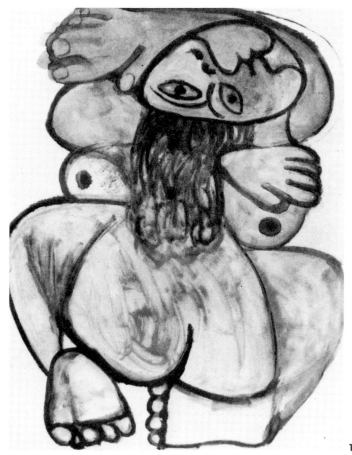

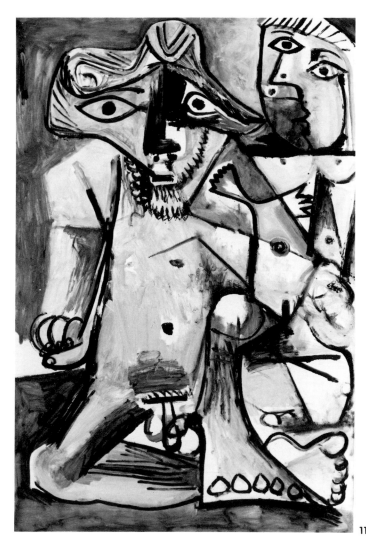

118

119

Fig. 118
Picasso, *Crouching Nude*
Oil on canvas, July 26, 1971 (II)
Cat. 91.

Fig. 119
Picasso, *Man and Woman*
Oil on canvas, August 18, 1971
Cat. 93. (Plate 50)

even the humble *peones*, handymen of the arena, with tasseled hair nets framing their leathery faces.[82]

The familiar race of primeval shepherds and shepherdesses reappears. Somewhat mellowed, their giant limbs reduced to human shape, they pipe and loll and disport themselves in untrammeled freedom. On a formal level the remarkable *Crouching Nude* (fig. 118) presents the most plausible solution to Picasso's lifelong problem, the simultaneous depiction of front and rear. On the expressive plane, with her arms slung around her neck, the halves of her split profile kissing each other, she portrays a human being in the ecstasy of being alive.

Many of the last paintings deal with the subject of parenthood—mothers with small children, fathers with older ones, family groups, including one in which part of the subject got lost in a web of pentimenti: *Man and Woman* (fig. 119). Once more, the man's head is compounded with his yellow straw hat. Such is the radiance of his wide-eyed stare that he appears like a sun, as the woman beside him appears like a crescent moon. The man's body is easy to read: he squats with his left knee raised, his right hand forming a fist. The woman's body is divided into arbitrary "Cubist" segments and remains largely undecipherable. However, part of the jigsaw puzzle can be resolved if one focuses upon a lozenge-shaped form in

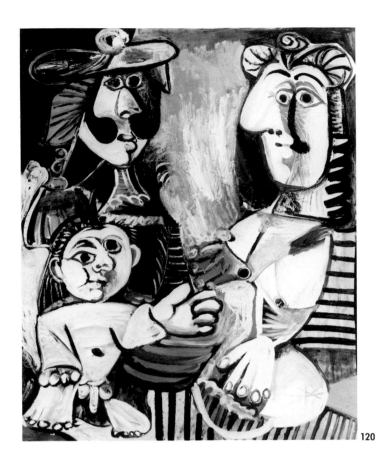

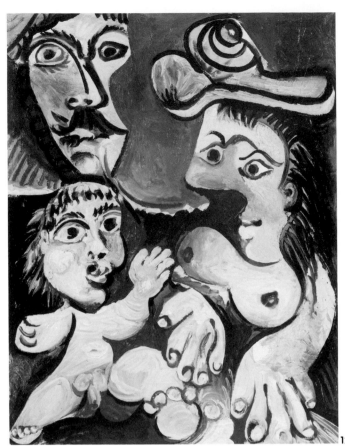

Fig. 120
Picasso, *The Family*
Oil on canvas, September 30, 1970
Cat. 82. (Plate 45)

Fig. 121
Picasso, *The Family*
Oil on canvas, September 30, 1970 (II)
Cat. 83. (Plate 46)

front of her body, partly overlapping with a red wedge. This form has two fanlike extensions that can be read as the spread arms of a child; a navel and a schematic indication of the female sex can also be recognized. One also notices the man's other hand, half wiped out, which was meant to hold the child on his knee. But the child's head and legs could not be fitted into the composition. Hence, Picasso dropped the idea and left part of his painting as a magma of undefined forms. The picture is therefore an instance of the artist's growing unconcern with finish. This was due not to a loss of control on Picasso's part but to a willing acceptance of the compulsion that drove him from one painting to the next. A couple as sun and moon—he had said what he wanted to say and could leave it at that. He had developed a new kind of *non-finito* whose impassioned urge defies rational analysis and aesthetic gourmandise.

The two family groups painted on September 30, 1970, are more elaborate (figs. 120 and 121). They belong to those paintings in which some critics detected a reemergence of the Blue Period. However, the blue here is not the color of dreamy world-weariness. It conveys the vitally reassuring warmth of Mediterranean summer nights, well known from Picasso's Vallauris nightscapes of 1951.[83] Nor do the figures bear any resemblance to the ascetic sufferers of the Blue Period. They are parents, watching with pride and concern the willfulness of their offspring as he leaps from one to the other, ever ready to run away from their charge. This *puer aeternus* figures in a great many of the later works as, for example, in drawings (figs. 122 and 123), where he appears again as an emblematic companion of

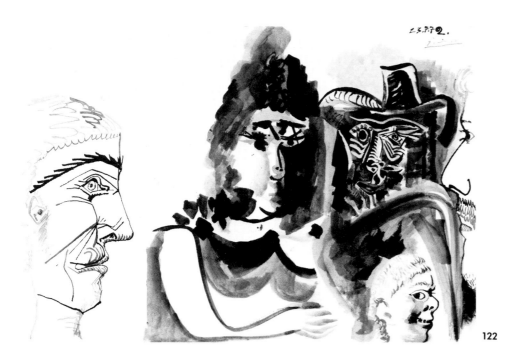

122

Fig. 122
Picasso, *Bust of a Woman and Four Male Heads*
Ink and gouache, July 23, 1972
Cat. 117.

Fig. 123
Picasso, *Three Figures and Dog*
Ink and gouache, July 24, 1972
Cat. 118.

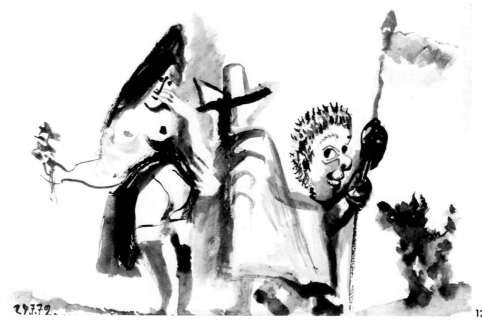

123

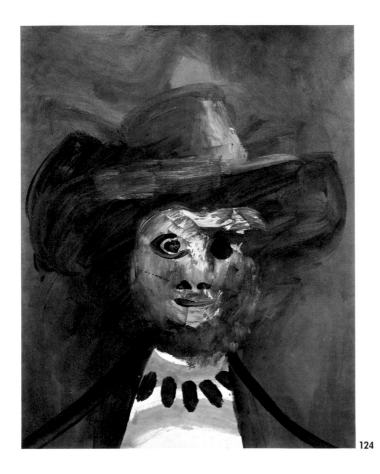

124

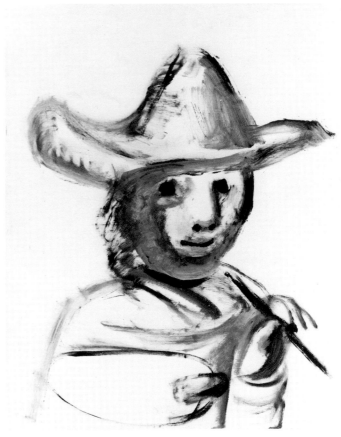

1

Fig. 124
Picasso, *Man with a Big Hat*
Oil on canvas, November 23, 1970
Cat. 84. (Plate 47)

Fig. 125
Picasso, *The Young Painter*
Oil on canvas, April 14, 1972 (III)
Cat. 107. (Frontispiece)

Fig. 126
Picasso, *Self-Portrait*
Crayon and colored crayons, June 30, 1972
Cat. 115. (Plate 60 and cover).

126

amorous musketeers. The *puer aeternus* is in fact an ultimate incarnation of Picasso's stance "for life against death."

Finally, there are the moving symbolic self-portraits. The earliest, *Man with a Big Hat* (fig. 124), is a virtuoso piece. It was modeled with a black brush out of a fiery red ground and subsequently touched up with some white on the palette knife. Lastly, Picasso gave it its spectral face with a few black dots. This head seems to materialize out of hellfire, ready to be consumed again in a flash. Was Picasso hinting here at the inexorable burning of his life energy? Or did he sardonically picture himself haunting his survivors as a revenant?

He presents an entirely different image of himself in *The Young Painter* (fig. 125), an almost ethereal image as it is sketched in the barest outlines with a dry brush in ocher, blue, and purple on the blank canvas. Here for once Picasso reveals his humility which—witness his constant and often reported self-doubts[84]—was the reverse of his reckless passion and hubris. Picasso portrays himself as age-old but having become a child again. Shy, as if bidding forgiveness for the persistence of his creative urge, hesitant, like one who for the first time performs a particularly high and demanding office, he raises his hand to put the first touches of paint onto an invisible canvas.

A skull, outlined like a broken shard, sickly colored and staring in frozen horror—this is how Picasso appears in his ultimate self-revelation (fig. 126). Pierre Daix has related the story of this work: "On June 30, 1972 he drew himself, looking his death in the face. A portrait drawn in the same colors he had used in the *Still Life with a Bull's Skull*, thirty years earlier when he received the news of the death of Gonzalez: greenish blue, mauve and black." The following day, Daix had a long visit with Picasso, who with great liveliness answered all his questions concerning the catalog of his cubist works. Finally, "he led me through his studios and when we passed the one adjacent to the living room which was left half in the dark as usual, he told me casually: 'I have made a drawing yesterday, I think there I have touched upon something. . . . It is unlike anything I have ever done. . . .' The drawing was half-rolled up on a chair. When he unrolled it I saw emerging the fixed and anguished look, the look of Picasso as I had never seen it. He held the drawing side by side to his face, then put it back without saying anything." Three months later, at the end of Daix's next and last visit, Picasso led him again to the self-portrait. "I understood he wanted me to tell him what I felt, and that I should not feign anything. I told him that these were the colors of the still life after the death of Gonzalez. He heard it without wincing. Suddenly I had a feeling that he was facing his death point-blank, as a good Spaniard."[85]

## Notes

1. Daix 1977, p. 385.

2. H. Parmelin as quoted by O'Brian 1979, p. 572.

3. See Rubin/Esterow 1973, p. 42; New York 1980, p. 148, 267, 268.

4. See Otero 1974, "The Chicago Monument," Chapter 3.

5. These are the paintings from 1969 to 1972 which were exhibited in the Palace of the Popes in Avignon in 1970 and 1973; they are published in full color in Alberti 1971 and 1974.

6. Parmelin 1980, pp. 73–76.

7. The whole series, including drawings, is reproduced in Zervos XXIII, 6–71, 119–121. For color reproductions of the paintings see Parmelin 1966 (I).

8. Observation by O'Brian 1979, p. 547.

9. Andrea Mantegna: The Dead Christ (Cristo in scurto), Milan, Brera. See Bellonci and Garavaglia, L'opera completa di Mantegna, (Milan, 1967), colorplate LX–LXI.

10. Abraham Bredius, Rembrandts Gemälde, 630 Abbildungen (Vienna, 1935), no. 414.

11. Cabanne 1977, p. 514.

12. Leo Steinberg, "Who Knows the Meaning of Ugliness?" in Steinberg 1972, quoted from Schiff 1976, p. 138.

13. Daix 1977, p. 385.

14. In November 1950 Picasso attended a peace congress in Sheffield, England, and said at the end of his brief address: "I stand for life against death; I stand for peace against war." Penrose 1959, p. 329.

15. Otero 1974, p. 184.

16. Daix 1977, p. 397.

17. Most of these works are listed in Zervos XXIII and XXIV. For color reproductions see Parmelin 1966 (I). For a particularly illuminating discussion see Leiris 1973.

18. Leiris 1973, p. 249.

19. Zervos XXIII, 122–150.

20. Parmelin 1966 (I), pp. 151 f.

21. See, however, the thorough discussion in Daix 1977, pp. 392–393.

22. Ashton 1972, p. 38.

23. Zervos XXIII, 171. Parmelin 1966 (I), colorplate on p. 41.

24. Parmelin 1980, p. 82.

25. Leiris 1973, p. 249.

26. These drawings are reproduced in Feld 1969 and Zervos XXV and XXVII.

27. This has been pointed out by Robert Burge, in "Picasso's Man with a Sheep," to be published in Source, spring 1984.

28. Adapted from Gottfried Benn, "Ithaka," in Gesammelte Werke, no. 6, 1975, p. 1473.

### CATULI ET MARTIALIS EPIGRÁMMATA

#### AD SE IPSUM DE ADVENTU VERIS (Ep. VII. Cat.)

Jam ver gélidos refert tepores,
Jam coeli furor aequinoctialis [1]
Jucundis Zéphiri silescit auris.
Linquantur Phrigii, Catule, campi,
Nicaeaeque ager uber aestuosae.
Ad claras Asiae volemus urbes.
Jam mens praetrépidans [2] avet vagari,
Jam laeti studio pedes vigescunt.
O dulces cómitum valete coetus,
Longè quos simùl a domo profectos
Diversè variae viae reportant.

#### AD M. T. CICERONEM. (Ep. VIII. Ibid.)

Disertíssime Rómuli nepotum,
Quod sunt, quotque fuere, Marce Tulli,
Quotque post aliis erunt in annis;
Gratias tibi máximas Catullus
Agit, péssimus ómnium poeta;
Tantò péssimus ómnium poeta
Quantò tu óptimus ómnium patronus.

#### AD QUINCTILIANUM. (Ep. VI. Mart.)

... ne, vagae moderator summe [3] juventae,
velut si pá...
por mur... Romanae, Quinctiliane, togae;

1—coeli furor aequinoctialis.., las tempestades del equinocio se calman.

2—jam mens praetrépidans.., ya el espíritu fatigado anhela distracciones.

3—moderator summe, el mejor maestro.

Fig. 127
Picasso, Croquis de Mosquetero
Pen and ink on paper, 1892–1893
Barcelona, Musée Picasso, courtesy of the director, Mrs. Mayte Ocaña

29. Ibid., p. 1475: the quote is "Das Gehirn ist ein Irrweg."

30. Feld 1969, nos. 344–354. Compare also Leiris (Suite 347), nos. 289, 290; Leiris (156 Last Etchings), nos. 49, 63.

31. Otero 1974, pp. 169, 170 (January 8, 1968.)

32. For color reproductions of a great number of Picasso's musketeers, see Alberti 1971 and 1974.

33. Malraux 1976, p. 77 and passim.

34. Photograph by Doisneau Rapho, Cabanne 1977, p. 412.

35. Parmelin 1980, p. 87.

36. Many examples in Zervos XXV, between nos. 280 and 364.

37. Palau i Fabre 1981, p. 51 and pl. 35. Conceivably Picasso's earliest drawing of a musketeer can be found on the margin of the Latin textbook which he used when at school in La Coruña between 1891 and 1895. This drawing was brought to the author's attention by Victoria Combalía Dexeus in a letter to the author, August 2, 1983. Museo Picasso Barcelona, inv. no. 110.930 (Fig. 127)

38. Victoria Combalía Dexeus, letter to the author, April 12, 1983.

39. Malraux 1976, pp. 4, 86. When Picasso told Daix (1977, p. 395, n. 17) that the musketeers had been suggested by Daix's request for a portrait of Shakespeare, this was certainly no more than a sly attempt at covering up his tracks.

40. See, however, Janie L. Cohen, "Picasso's Exploration of Rembrandt's Art: 1967–1972," to be published in Arts Magazine, October, 1983.

41. This has been noticed before by Geelhaar 1981, p. 36.

42. Observation by Janie Cohen.

43. See also Alberti 1974, 33, Femme nue couchée, October 31, 1970.

44. Leiris 1973 describes this picture as follows: "Equally comic, yet simultaneously of resounding grandeur, is the imposing figure dated 16 April 1965 of a kind of monumental goddess in classical draperies, who hitches up her clothing in order to empty her bladder into the sea, a frothing mass which one is tempted to believe she has created herself."

45. Malraux 1976, p. 86.

46. This is the title of a gouache by Paul Klee, 1935, Albright-Knox Art Gallery, Buffalo, see C. Giedion-Welcker, Paul Klee (London, 1952) part 3, pl. 104.

47. As noted by Marie Busco (Institute of Fine Arts Seminar Report of May 12, 1983), Head of a Man, March 27, 1969, is based upon Philippe de Champaigne's Portrait of Richelieu, National Gallery, London; see Bernard Dorival, Philippe de Champaigne, 1602–1674, II (Paris, 1946), pl. 213. The painting (Zervos XXXI, 194, Buste d'homme lauré, May 11, 1969), is based upon Simon Vouet's allegorical portrait of Louis XIII between France and Navarre, in Versailles; see William R. Crelly, The Painting of Simon Vouet (New Haven and London, 1962), pl. 43.

48. Bredius, op. cit., no. 132.

49. Rubin/Esterow 1973, pp. 42, 43.

50. Rubin 1972, p. 44 (with reproduction.)

51. Theodore Reff, "Themes of Love and Death in Picasso's Early Work," in Penrose and Golding 1973, p. 45.

52. Fernande Olivier, Picasso et ses amis (Paris, 1933), p. 89. Penrose 1959, pp. 133, 134. According to Picasso himself in conversation with Penrose, "It was not only the suicide of Wiegels that put a stop to [his use of opium]. While under the influence of the drug Picasso found that his imagination and his vision became more acute but that his desire to paint what he saw diminished seriously."

53. See Seymour Slive, Frans Hals, I (London, 1970), p. 77. The quote is from Psalms 102:4. Janie Cohen brought to my attention an interesting collection of sources for the emblematic meaning of tobacco smoke: Joh. Feinhals, Tabak in Kunst und Kultur (Cologne, 1911).

54. Siegfried Rosengart, Lucerne, in conversation with the author, July 28, 1982.

55. Fifty-eight paintings dating from August to December 1957, reproduced in full color in Jaime Sabartés (ed.), Picasso, Variations on Velázquez's Painting "The Maids of Honor" and other recent works (New York, 1959).

56. Already in Picasso's very first drawing of this series, December 29, 1966, I (Zervos XXV, 246), this musketeer is accompanied by a little cupid. Although there is only the slightest of possibilities that Picasso knew it, I should like to mention an emblem, reproduced on p. 77 of Slive, op. cit. Under the heading Fumo pascuntur amantes (Smoke is the Food of Lovers), it shows Cupid providing a sorrowful smoker-lover with a new set of pipes; see Jacob Cats, Silenus Alcibiadis (Middleburg, 1618).

57. See N.D. Shergold, A History of the Spanish Stage (Oxford, 1967), pp. 536–538, 553.

58. See José L. Barrio Garay, introduction to Picasso in Milwaukee, Milwaukee Art Center, October 25, 1970–January 28, 1971.

59. This series of 347 etchings was executed by Picasso in Mougins, March 16 to October 5, 1968, helped by the master printers Piero and Aldo Crommelynck, who in 1963 had brought a hand press from Paris to Mougins. They are fully reproduced in (a) Picasso; 347 Gravures, Leiris (Suite 347); (b) Crommelynck 1970; (c) Bloch, vol IV.

60. La Celestina is the heroine of the play La Tragi-Comedia de Calisto y Melibea by Fernando de Rojas (Burgos, 1499).

61. Otero 1974, p. 170; May 20, 1968.

62. Observation by Cindy Mack, New York University, seminar report, May 12, 1983.

63. Parmelin 1980, p. 82.

64. Schiff 1976, pp. 163–167.

65. A series of 180 drawings by Picasso, done between November 28, 1953, and February 3, 1954, published by Vintage Books, New York, n.d. See Michel Leiris, "Picasso and the Human Comedy;" Louis Aragon, "The Verve of Picasso," both in Schiff 1976, pp. 140–157.

66. Leonardo da Vinci, Treatise on Painting, I (Princeton, 1956), p. 24.

67. Otero 1974, pp. 178, 179. Picasso was complaining that for reasons of censorship, reproductions of these etchings could not be bound with the remaining ones in the Leiris catalog.

68. Alberti 1971, no. 57.

69. Sylvie Béguin and others, Donation Picasso (Paris, 1978), nos. 34 and 35.

70. Alberti 1971, no. 67.

71. Rubin 1972, p. 108 (with colorplate.)

72. See Picasso's Two Dancers, London, summer 1919; repr. ibid.

73. About a parallel between the artistic personalities of Picasso and Joyce see Schiff 1976, pp. 11, 12, 23, 24.

74. See Elaine Maclachlan, Calderón's El Gran Teatro Del Mundo and the Counter-Reformation in Spain (Florence, 1960).

75. See, however, the remarks on Picasso's religiosity in O'Brian 1979, p. 569.

76. Rubin/Esterow 1973, p. 42.

77. Observation by Geelhaar 1981, pp. 48, 50.

78. Daix 1977, p. 398.

79. See Paris 1972/1973, passim.

80. Otero 1974, p. 44.

81. Alberti 1974, p. 15.

82. Alberti 1974, pls. 21, 22, 23, 28.

83. Gallwitz 1971, pls. 40 and 61.

84. See Parmelin 1966 (II), pp. 144, 145.

85. Daix 1977, pp. 399, 400.

# The Plates

**1.**
**Rape of the Sabines.**
*Oil on canvas, January 9, February 7, 1963.*
*Boston, Museum of Fine Arts. Zervos XXIII, 121. Cat. 1.*

**2.**
**Head of a Woman.**
Oil on canvas, January 3, 1963.
Geneva, Galerie Jan Krugier. Zervos XXIII, 112. Cat. 2.

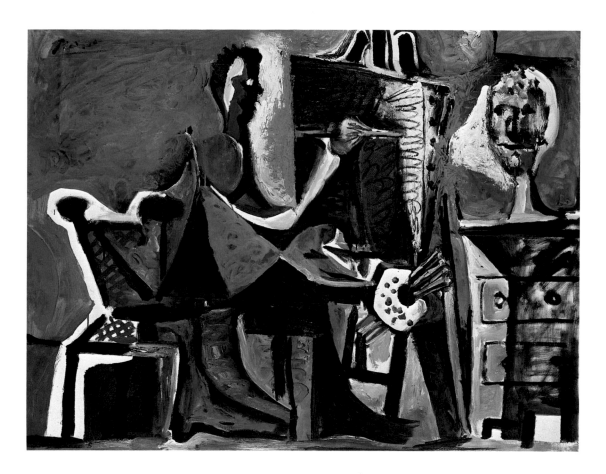

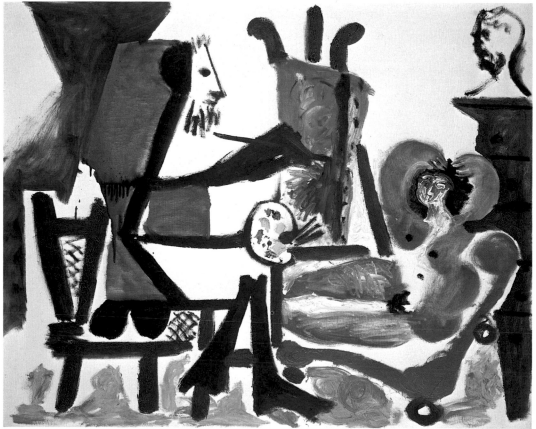

**3.**
**The Artist in the Studio.**
Oil on canvas, February 22 (II), September 17, 1963.  Paris, Galerie Louise Leiris. Zervos XXIII, 153. Cat. 4.

**4.**
**The Artist and His Model.**
Oil on canvas, March 4, 5, 1963.  Geneva, Galerie Jan Krugier. Zervos XXIII, 159. Cat. 5.

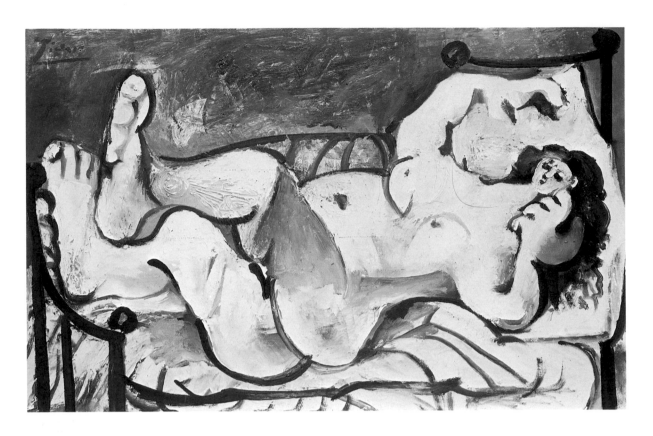

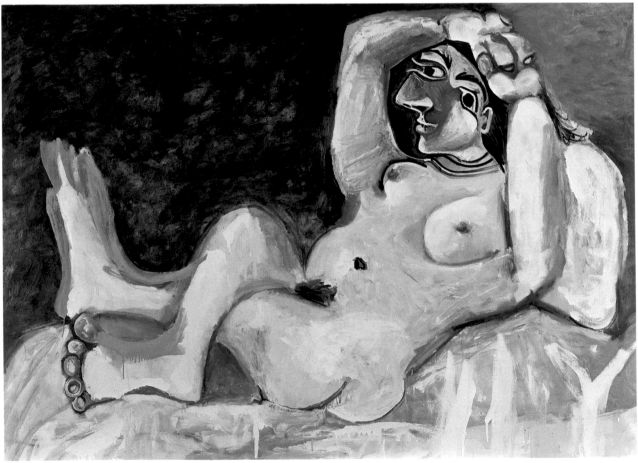

**5.**
**Reclining Nude.**
Oil on canvas, January 9, 18, 1964.   Lucerne, Galerie Rosengart. Zervos XXIV, 25. Cat. 7.

**6.**
**Grand Nude.**
Oil on canvas, February 20–22, March 5, 1964.   Zürich, Kunsthaus. Zervos XXIV, 95. Cat. 9.

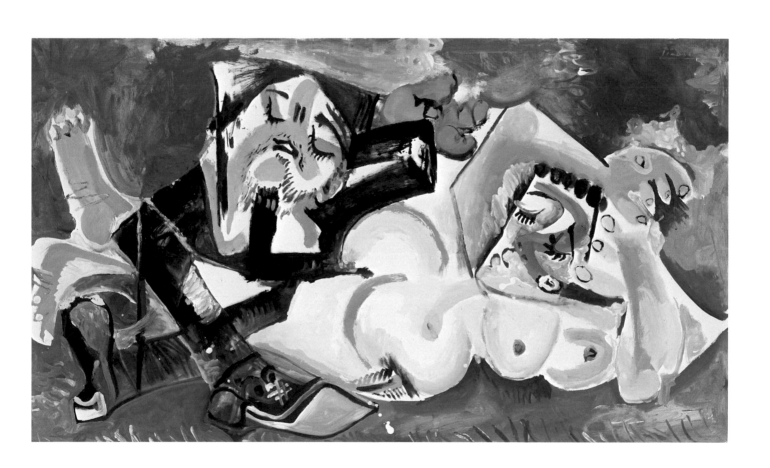

**7.**
**The Sleepers.**
Oil canvas, April 13, 1965.
Paris, Galerie Louise Leiris. Zervos XXV, 106. Cat. 20.

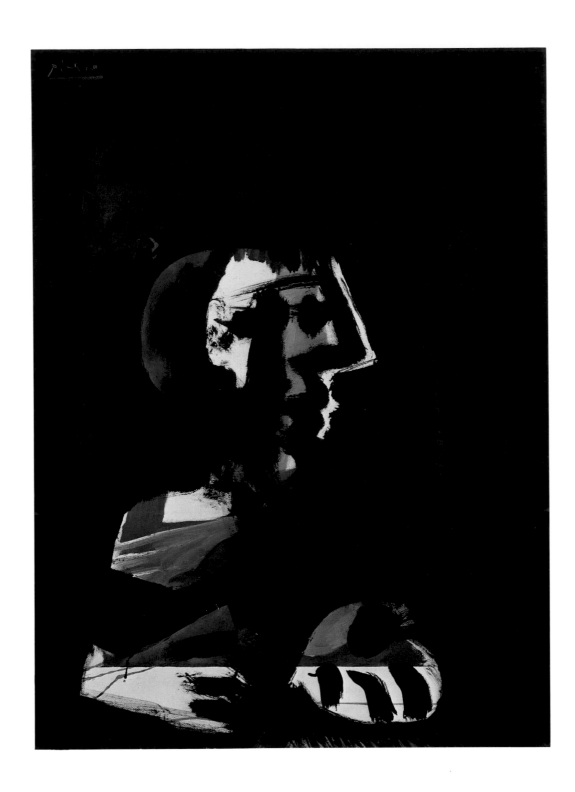

**8.**
**The Artist.**
Gouache and India ink, on a reproduction of a painting of March 30, 1963; October 10, 1964.
Basel, Galerie Beyeler. Zervos XXIV, 215. Cat. 12.

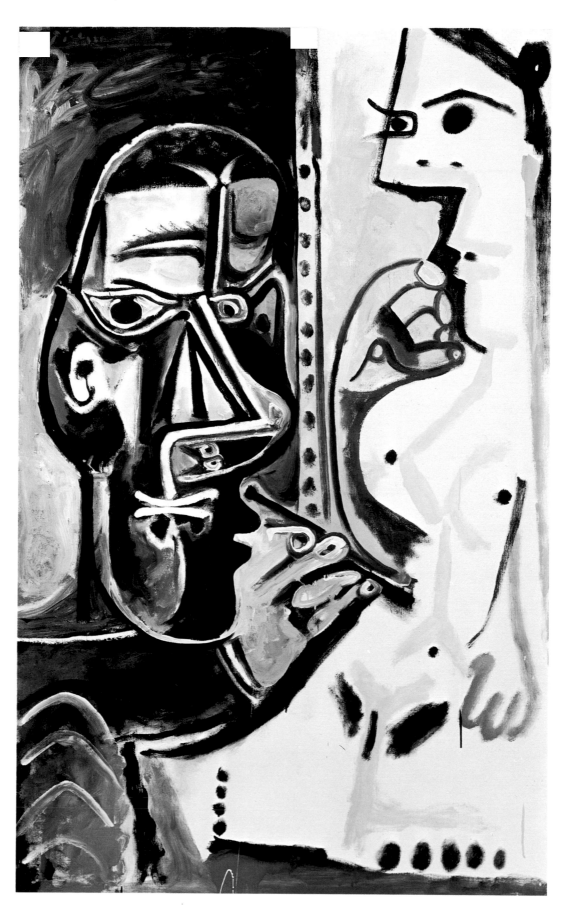

**9.**
**The Artist and His Model.**
Oil on canvas, October 26 (II), November 3, 1964.
Basel, Galerie Beyeler. Zervos XXIV, 246. Cat. 13.

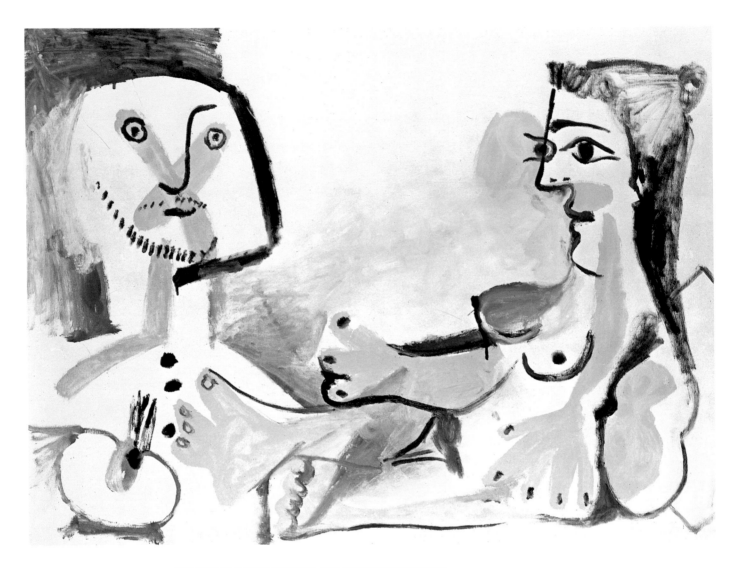

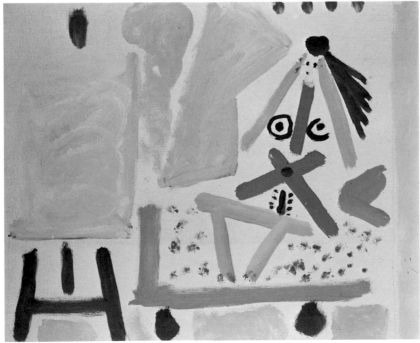

**10.**
**The Artist and His Model.**
Oil on canvas, November 7, 1964 (IV).   Private Collection. Zervos XXIV, 261. Cat. 14.

**11.**
**The Model in the Studio.**
Oil on canvas, March 24, 1965 (II).   Geneva, Galerie Jan Krugier. Zervos XXV, 58. Cat. 18.

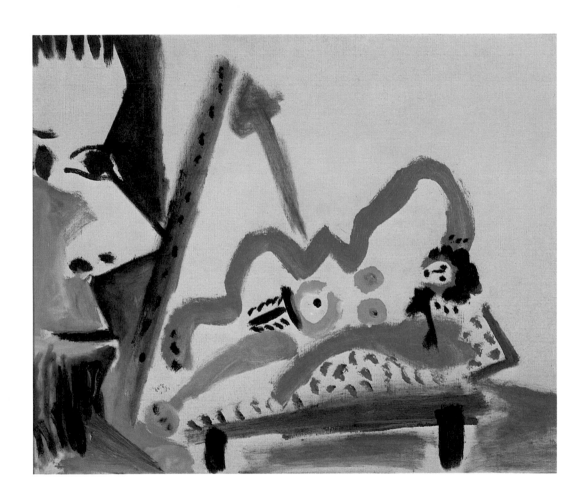

**12.**
**Reclining Nude and Man in Profile.**
Oil on canvas, March 29, 1965 (V).
Private Collection. Zervos XXV, 82, Cat. 19.

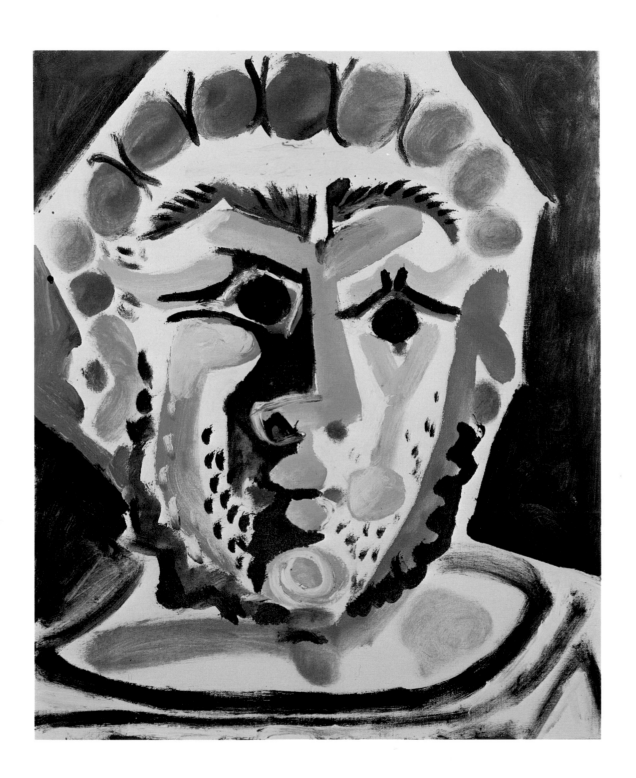

**13.**
**Head of a Man.**
Oil on canvas, June 12, 1965 (II).
Paloma Picasso-Lopez. Zervos XXV, 161. Cat. 22.

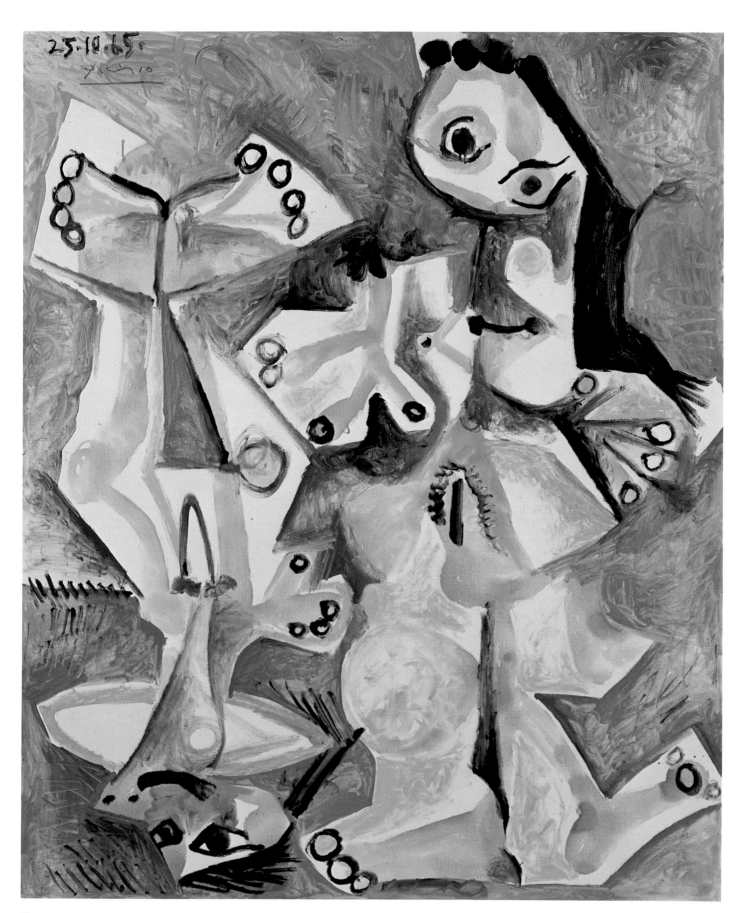

**14.**
**Nude Man and Woman.**
Oil on canvas, October 25, 1965.
Paris, Galerie Louise Leiris. Zervos XXV, 183. Cat. 23.

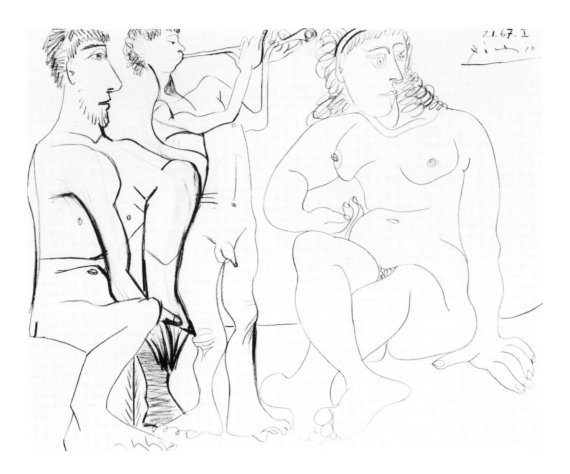

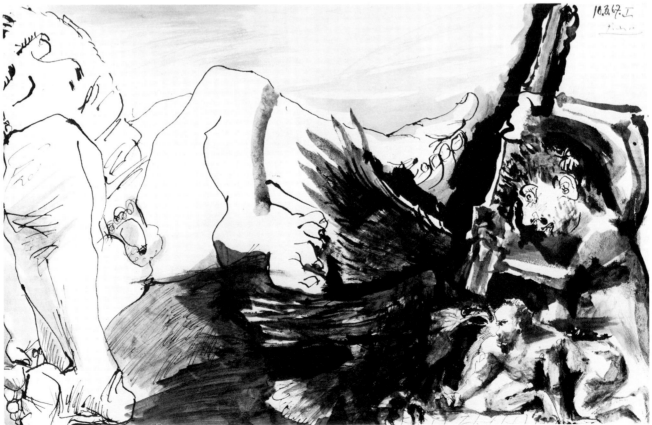

**15.**
**Musician, Man and Woman.**
Brown crayon, January 2, 1967 (I). Tokyo, Fuji Television Gallery Co., Ltd. Zervos XXV, 260. Cat. 26.

**16.**
**Eagle and Figures.**
Ink, March 10, 1967 (I). Basel, Galerie Beyeler. Zervos XXV, 289. Cat. 31.

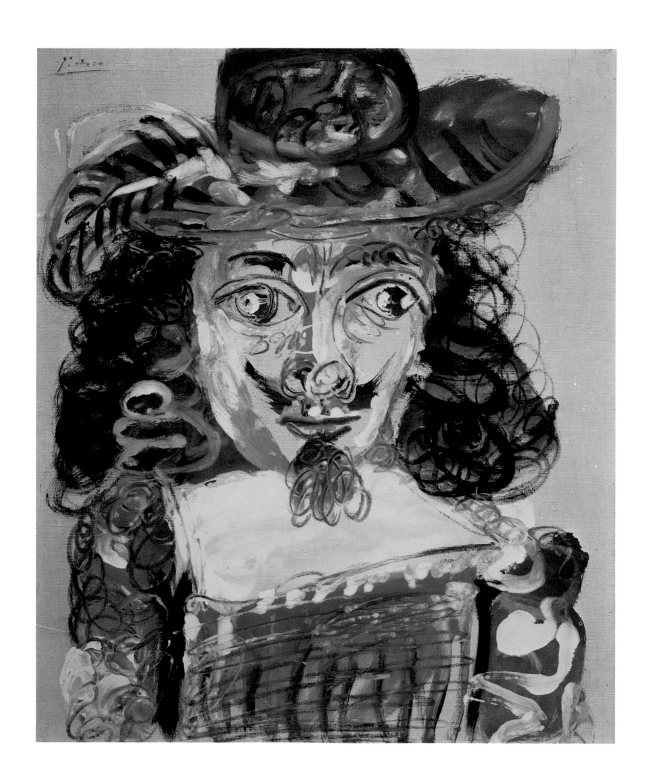

**17.**
**Musketeer, Bust.**
Oil on canvas, May 28, 1967.
New York, courtesy Sindin Galleries. Zervos XXVII, 4. Cat. 33.

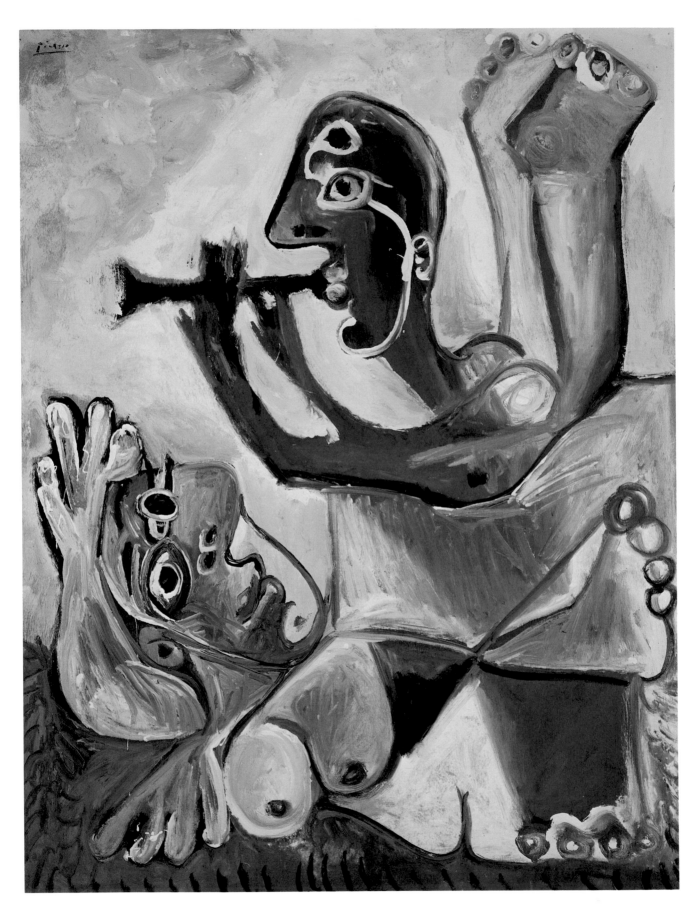

**18.**
**The Aubade.**
Oil on plywood, June 18, 1967.
Lucerne, Galerie Rosengart. Zervos XXVII, 28. Cat. 34.

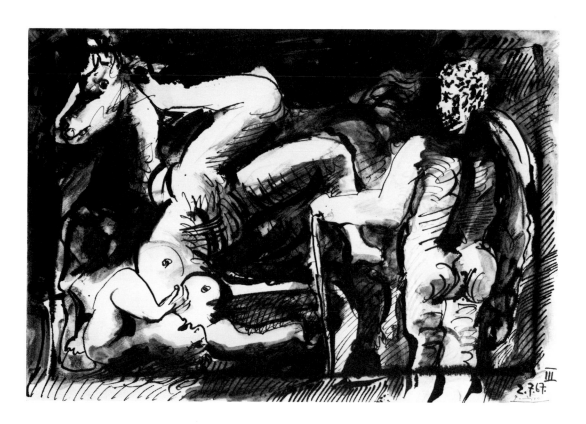

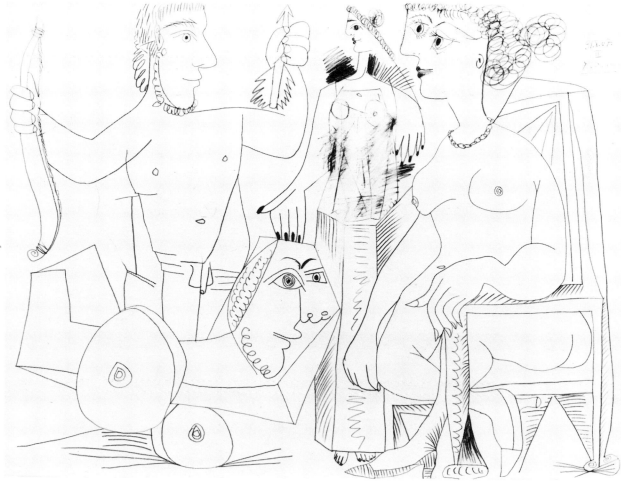

**19.**
**The Fall of the Equestrienne.**
Ink, July 2, 1967 (III).   Lucerne, Galerie Rosengart. Zervos XXVII, 51. Cat. 35.

**20.**
**Return of the Warrior.**
Pencil, August 31 (II), 1967.   Basel, Galerie Beyeler. Zervos XXVII, 111. Cat. 37.

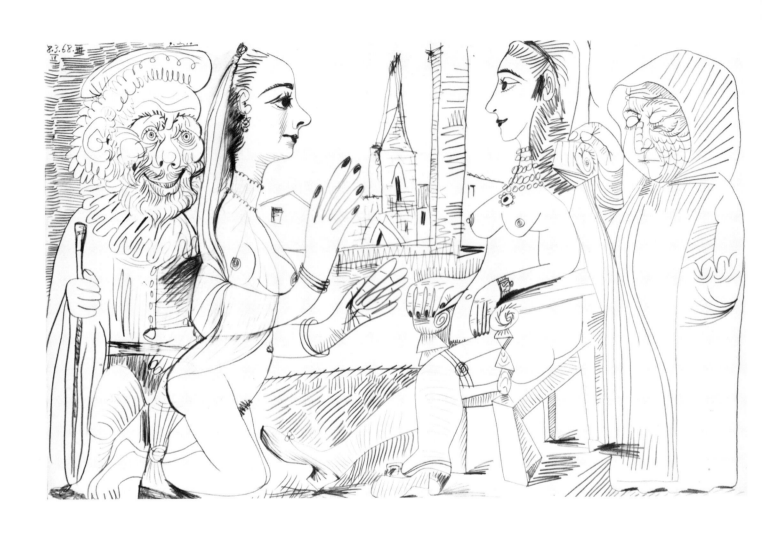

**21.**
**Man and Courtesans (Figures in Front of a Window).**
Pencil, March 8, 1968 (IV).
New York, Collection Daniel Saidenberg. Zervos XXVII, 259. Cat. 42.

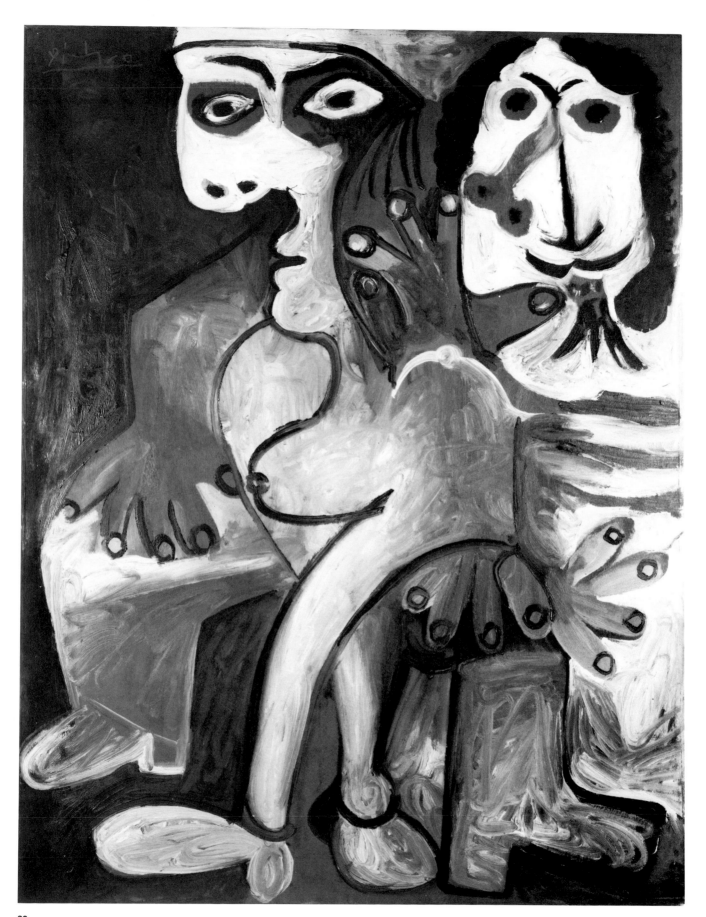

**22.**
**Man and Woman.**
Oil on plywood, September 14 (II), 1968.
Paris, Galerie Louise Leiris. Zervos XXVII, 313. Cat. 45.

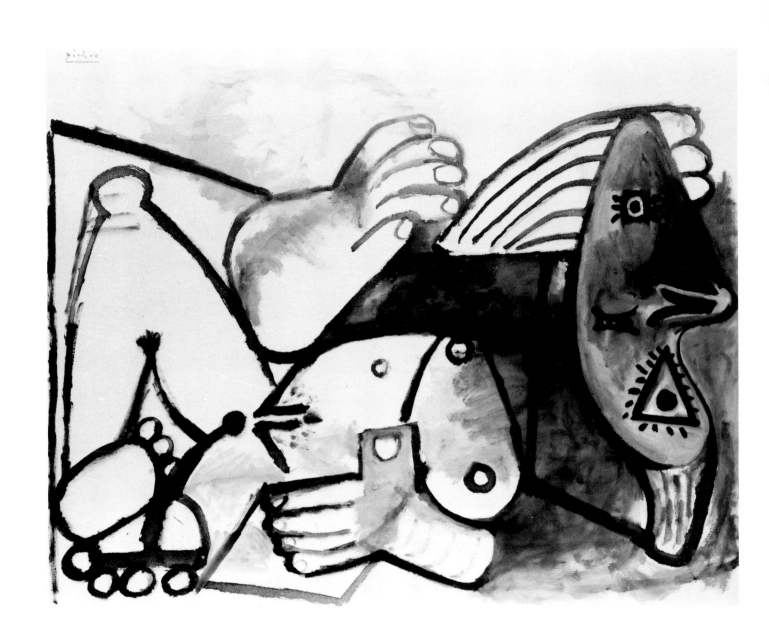

**23.**
**Reclining Nude.**
Oil on canvas, October 10 (I), 1968.
Paris, Galerie Louise Leiris. Zervos XXVII, 337. Cat. 47.

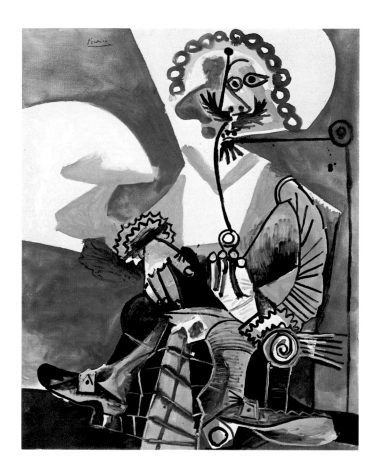

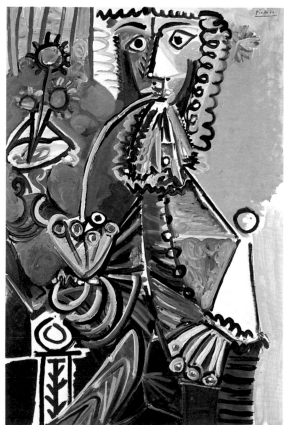

**24.**
**Musketeer with Pipe.**
Oil on canvas, October 16 (I), 1968.   Paris, Galerie Louise Leiris. Zervos XXVII, 340. Cat. 48.

**25.**
**Musketeer with Pipe and Flowers.**
Oil on canvas, November 5, 1968.   Lucerne, Galerie Rosengart. Zervos XXVII, 364. Cat. 49.

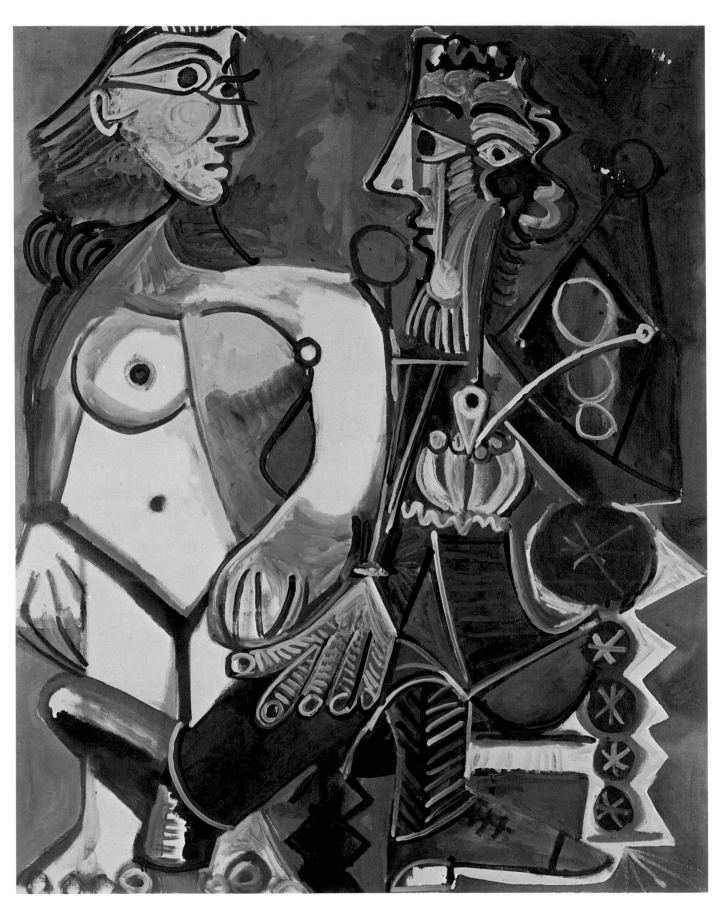

**26.**
**Nude and Smoker.**
Oil on canvas, November 10, 1968.
Lucerne, Galerie Rosengart. Zervos XXVII, 369. Cat. 50.

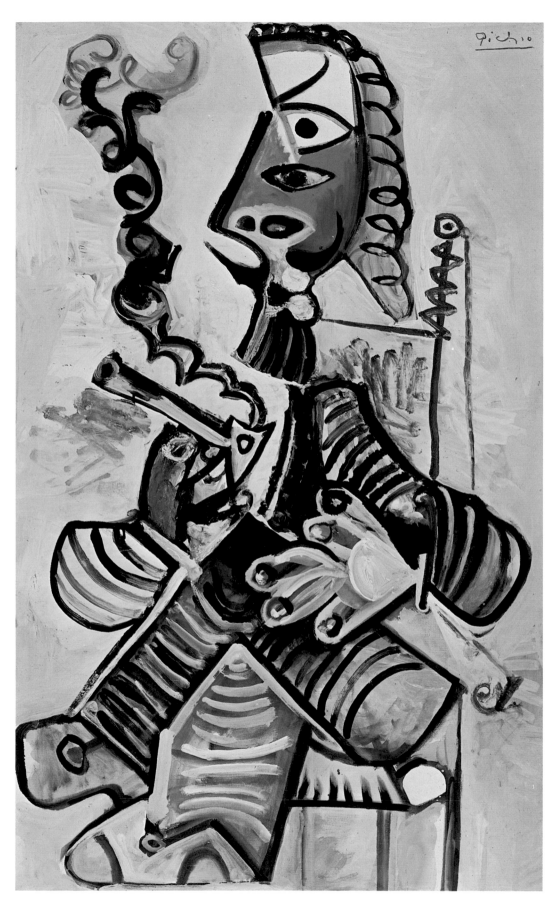

**27.**
**The Smoker.**
Oil on canvas, November 22, 1968.
Lucerne, Galerie Rosengart. Zervos XXVII, 377. Cat. 51.

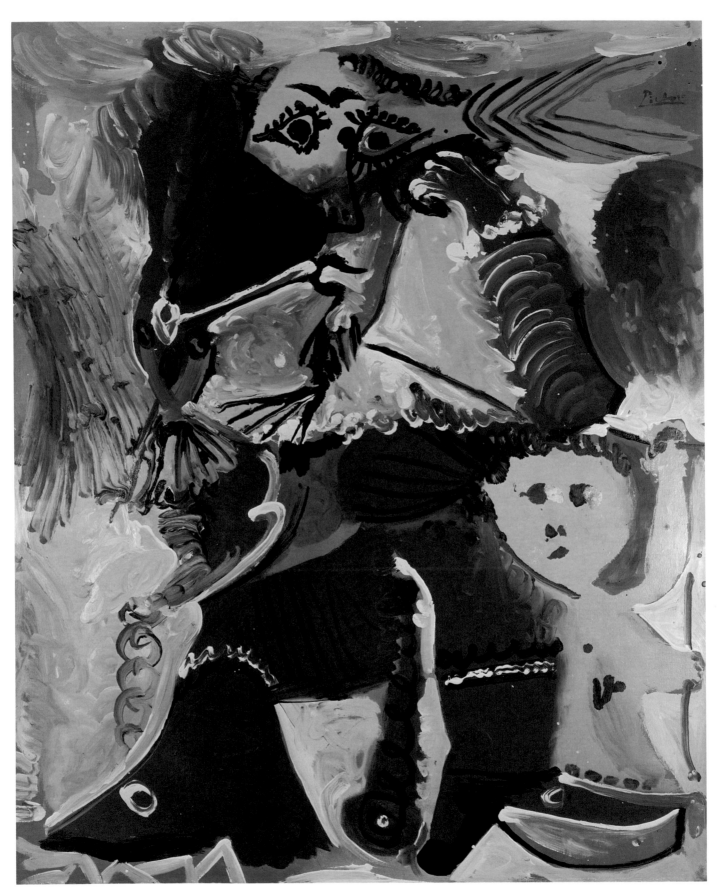

**28.**
**Rembrandt-like Figure and Cupid.**
Oil on canvas, February 19, 1969.
Lucerne, Picasso Collection of the City of Lucerne (Rosengart Donation).
Zervos XXXI, 73. Cat. 55.

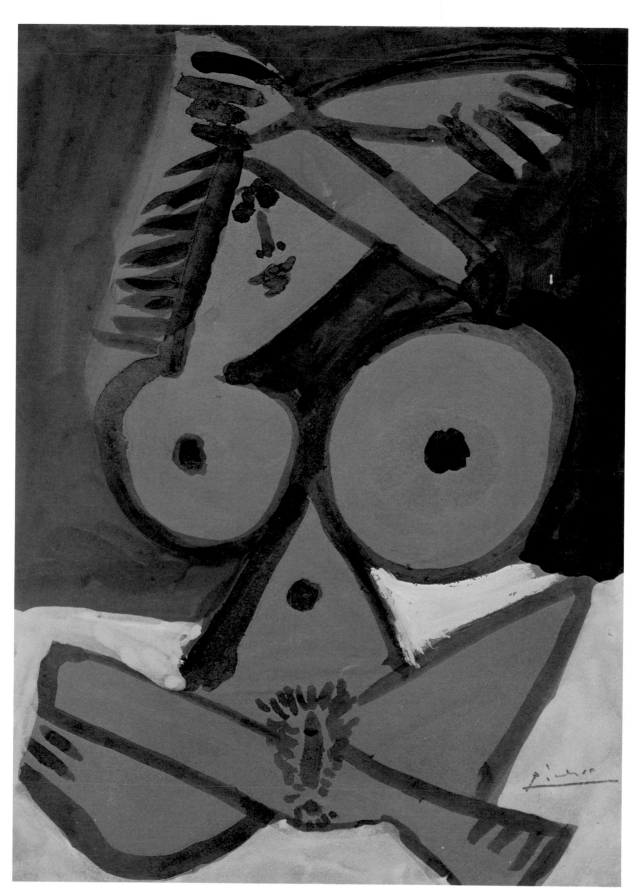

**29.**
**Seated Woman.**
Gouache and ink on carton, April 4, 1972.
Tokyo, Fuji Television Gallery Co., Ltd. Zervos XXXIII, 333. Cat. 106.

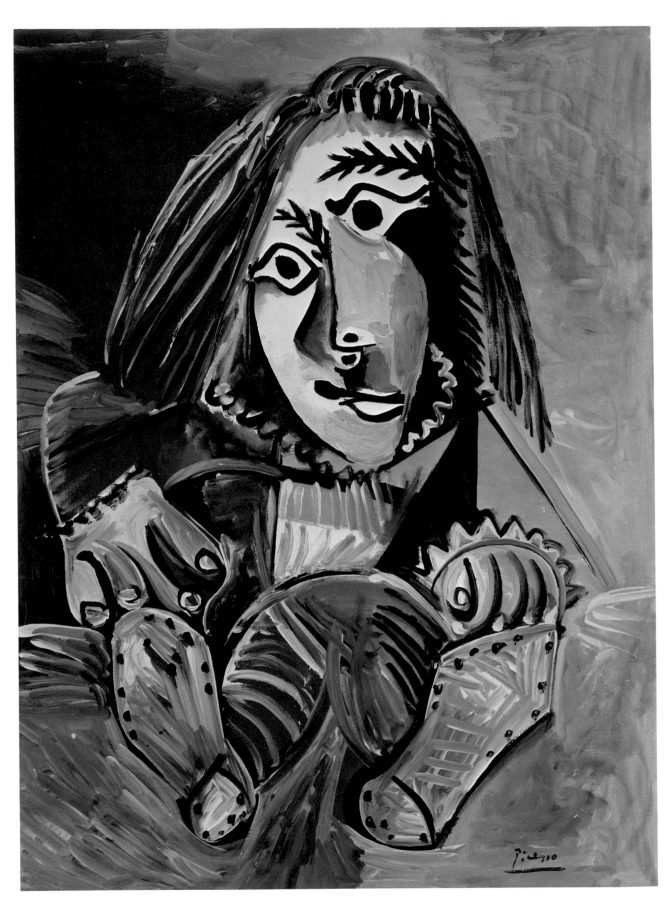

**30.**
**Adolescent.**
Oil on canvas, August 2, 1969.
Paris, Mr. Xavier Vilató. Zervos XXXI, 341. Cat. 59.

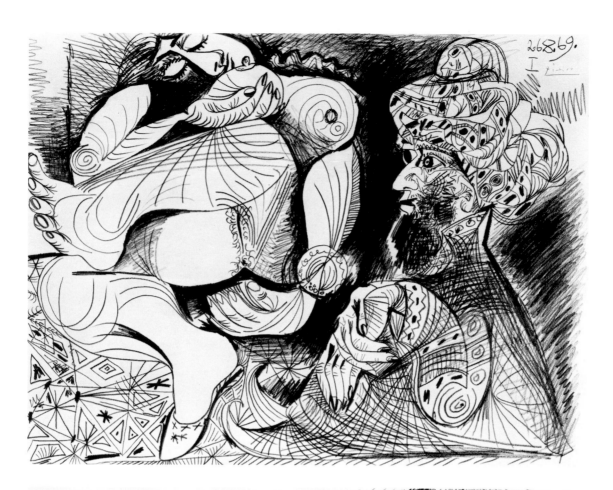

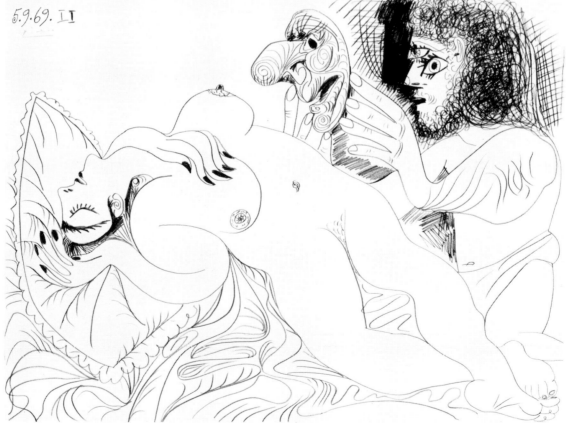

**31.**
**Man Wearing a Turban and Reclining Nude.**
Crayon, August 26, 1969 (I).   Paris, Galerie Louise Leiris. Zervos XXXI, 393. Cat. 61.

**32.**
**Reclining Nude and Man with a Mask.**
Crayon, September 5, 1969 (II).   Basel, Galerie Beyeler. Zervos XXXI, 414. Cat. 62.

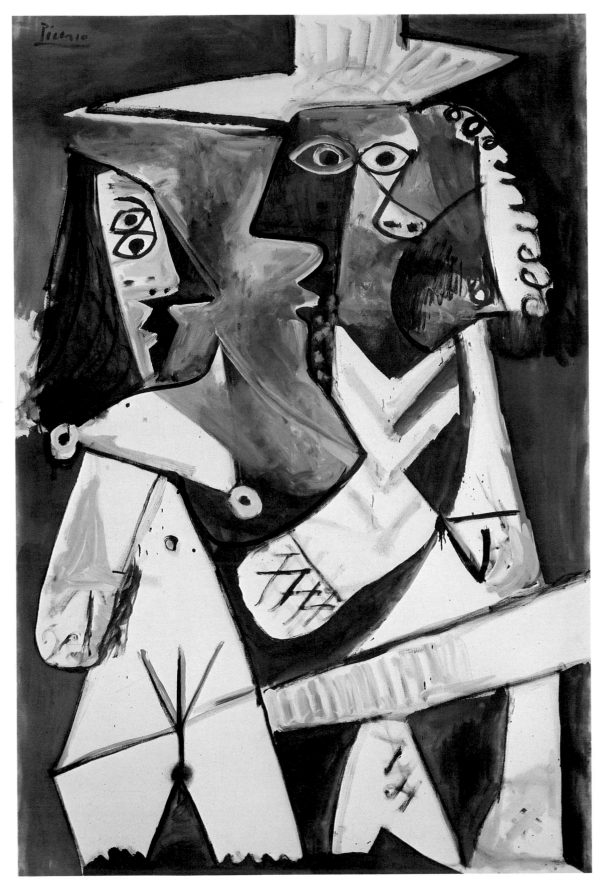

**33.**
**Man and Child.**
Oil on canvas, October 11, 1969.
Paris, Galerie Louise Leiris. Zervos XXXI, 463. Cat. 63.

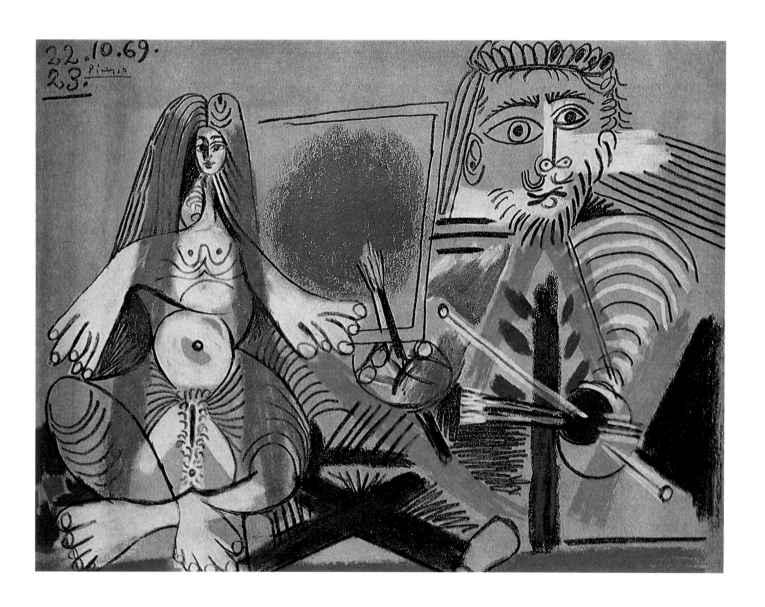

**34.**
**The Artist and His Model** (detail).
Colored crayons on carton, October 22, 23, 1969.
Tokyo, Fuji Television Gallery Co., Ltd. Zervos XXXI, 476. Cat. 64.

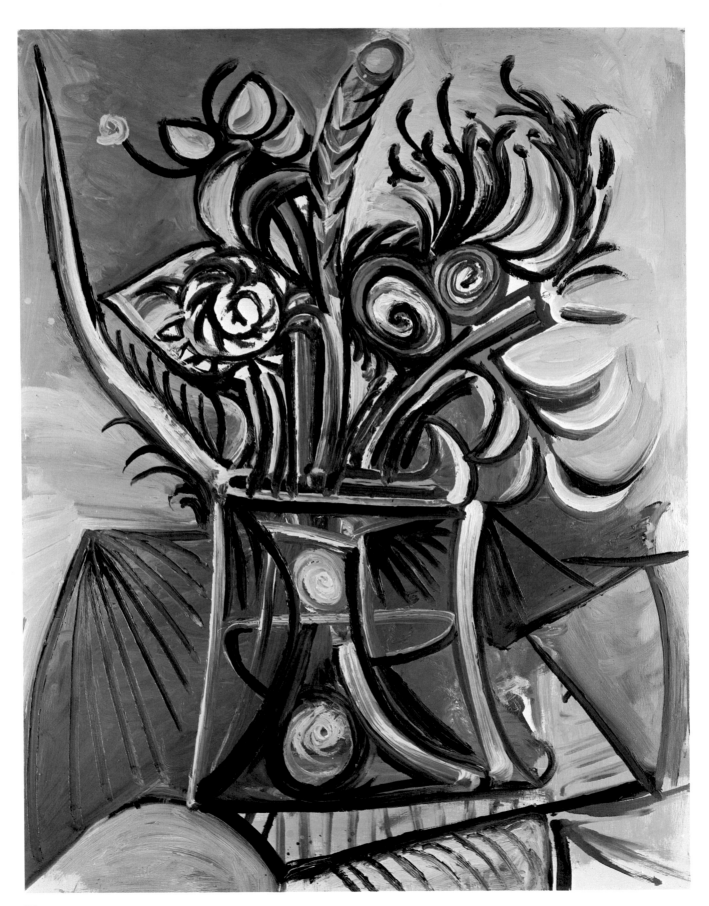

**35.**
**Bouquet.**
Oil on canvas, October 28, 1969.
Basel, Galerie Beyeler. Zervos XXXI, 486. Cat. 66.

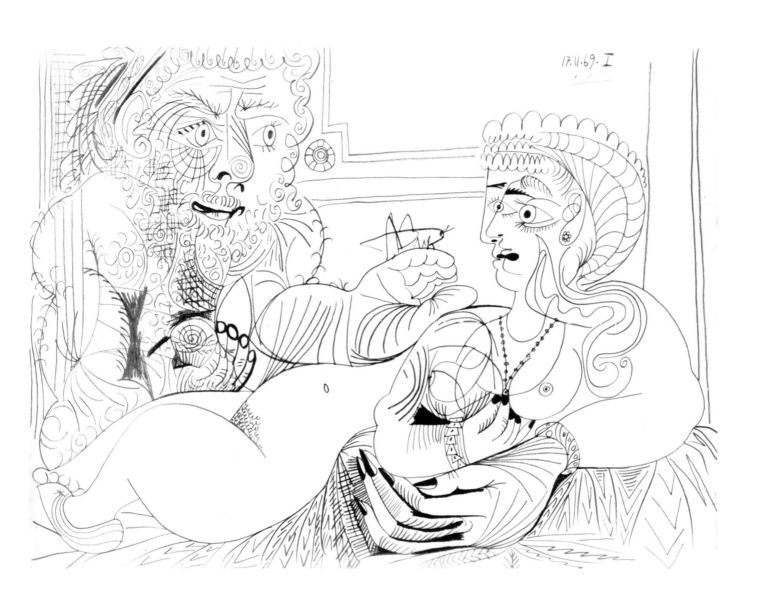

**36.**
**Man and Nude with Grasshopper.**
Crayon, November 17, 1969 (I).
Paris, Galerie Louise Leiris. Zervos XXXI, 502. Cat. 67.

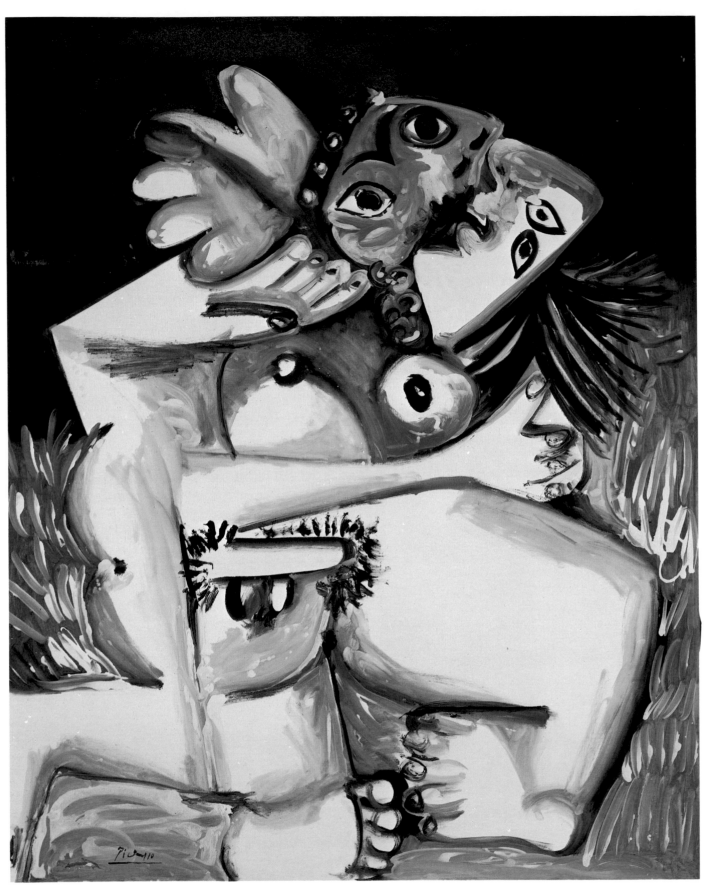

**37.**
**The Embrace.**
Oil on canvas, November 19, 1969 (II).
Paris, Mr. Javier Vilató. Zervos XXXI, 507. Cat. 68.

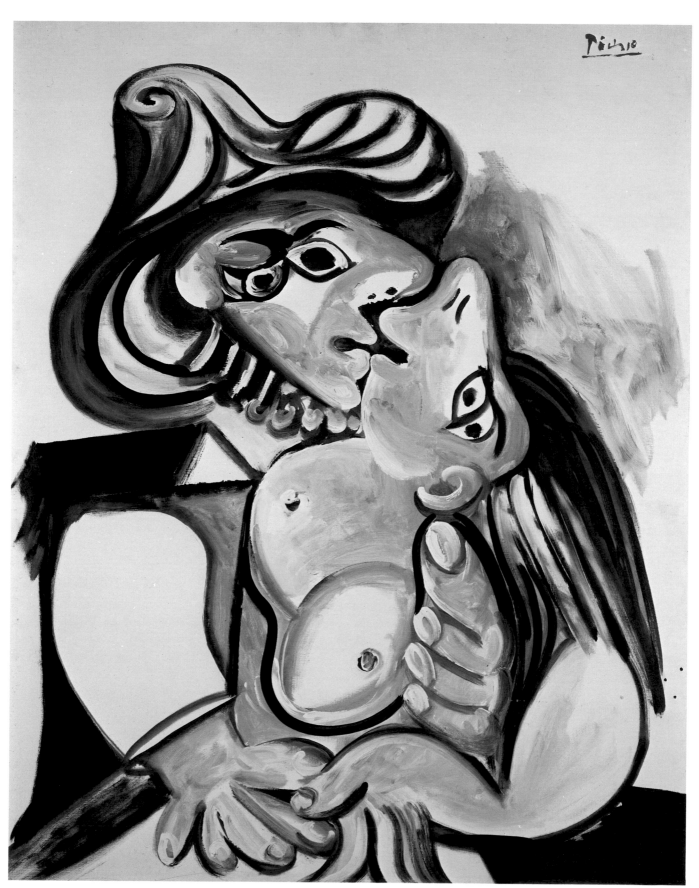

**38.**
**The Kiss.**
Oil on canvas, December 1, 1969 (II).
Basel, Galerie Beyeler. Zervos XXXI, 535. Cat. 69.

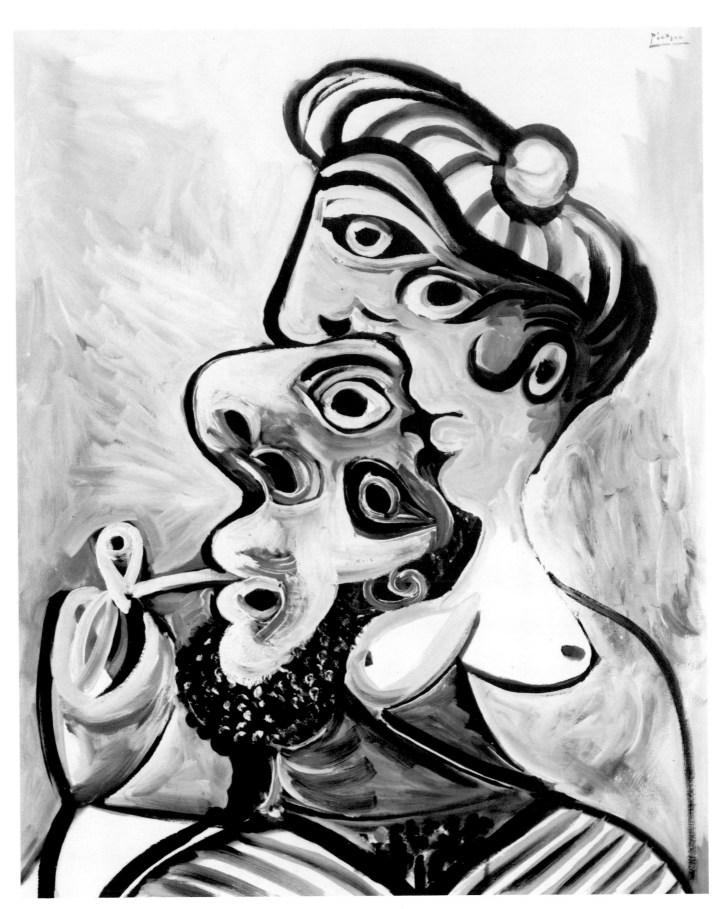

**39.**
**Couple.**
Oil on canvas, December 5, 1969.
Paris, Mr. Javier Vilató. Zervos XXXI, 538. Cat. 70.

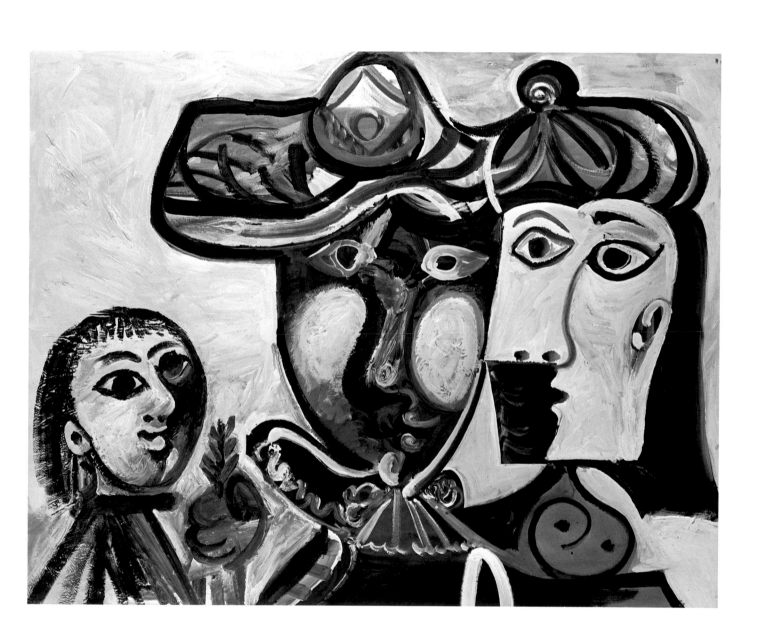

**40.**
**Man, Woman and Child. Busts.**
Oil on canvas, December 26, 1969.
Geneva, Collection Marina Picasso. Zervos XXXI, 563. Cat. 72.

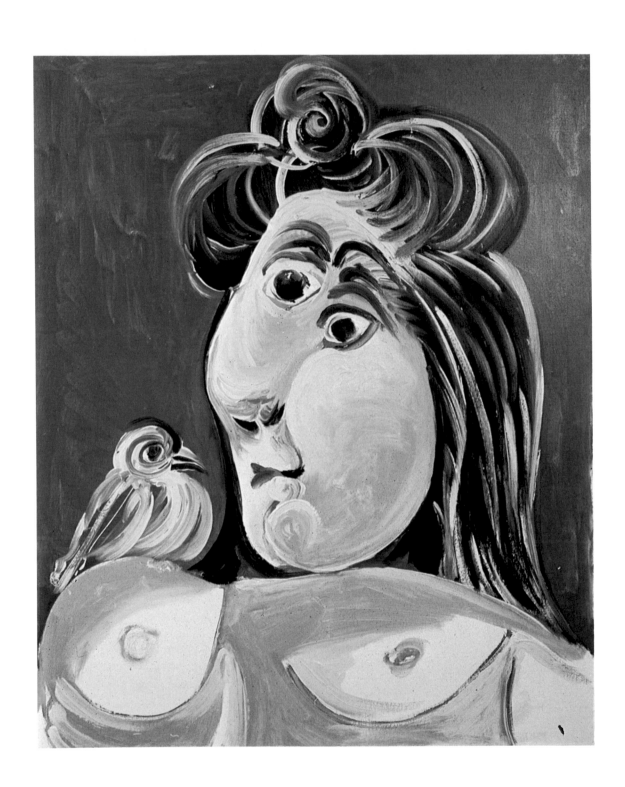

**41.**
**Woman with Bird.**
Oil on canvas, January 14, 1970 (II).
New York, The Pace Gallery. Zervos XXXII, 29. Cat. 75.

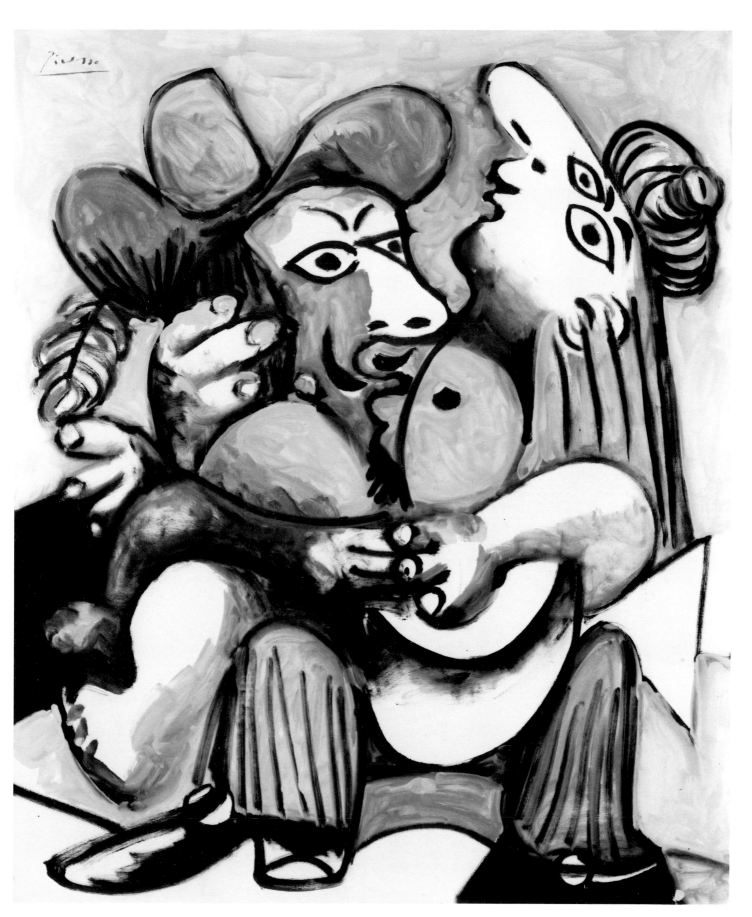

**42.**
**Seated Couple.**
Oil on canvas, January 5, 1970.
Paris, Mr. Javier Vilató. Zervos XXXII, 4. Cat. 73.

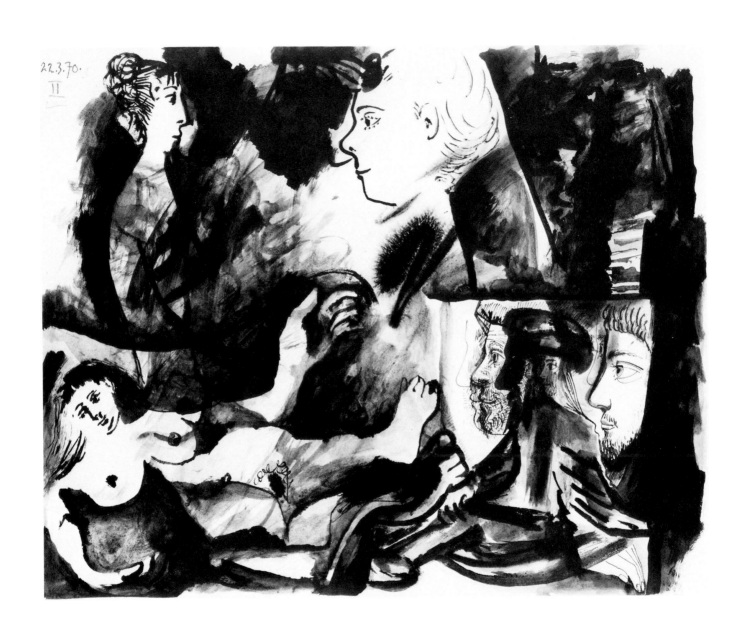

**43.**
**Reclining Nude and Profiles.**
Ink, March 22, 1970 (II).
Tokyo, Fuji Television Gallery Co., Ltd. Zervos XXXII, 50. Cat. 77.

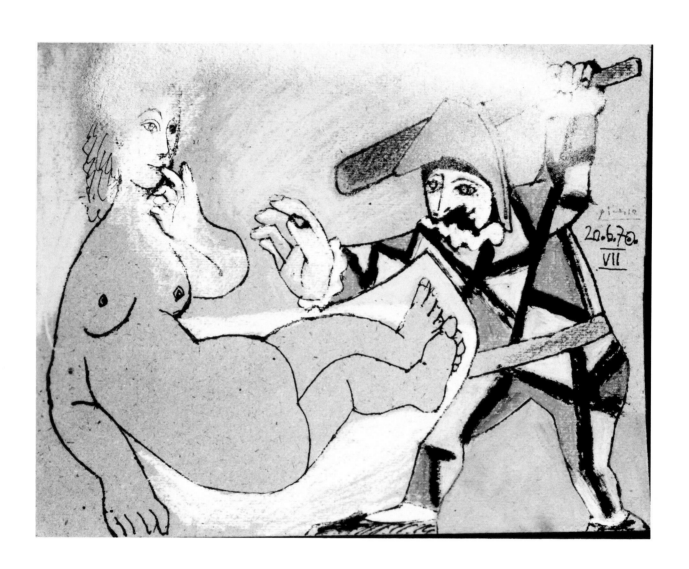

**44.**
**Reclining Nude and Harlequin.**
Ink and colored crayons on board, June 20, 1970 (VII).
Paris, Galerie Louise Leiris. Zervos XXXII, 153. Cat. 80.

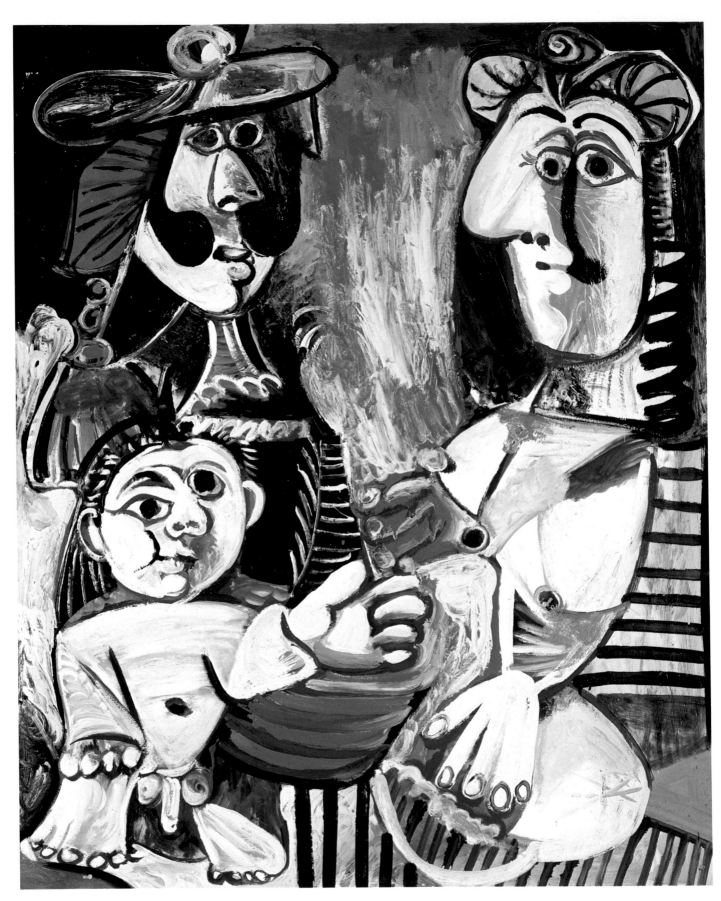

**45.**
**The Family.**
Oil on canvas, September 30, 1970.
Paris, Musée Picasso. Zervos XXXII, 271. Cat. 82.

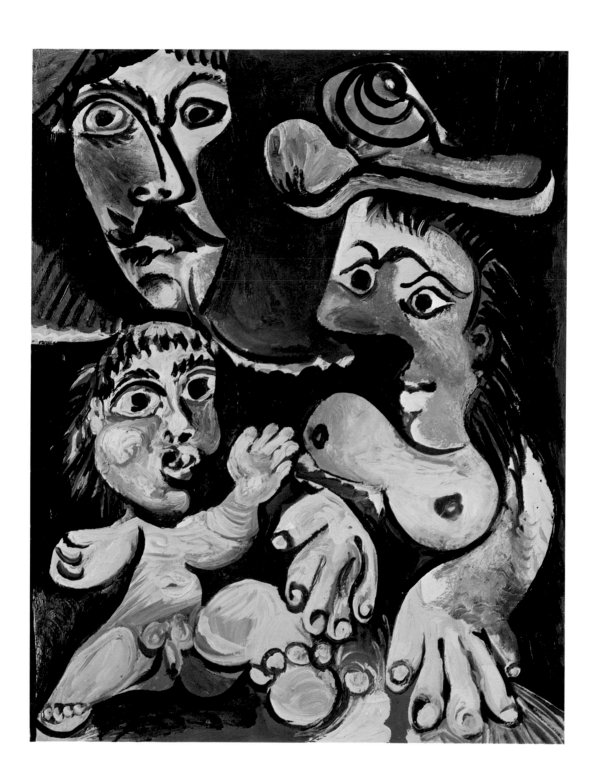

**46.**
**The Family.**
Oil on canvas, September 30, 1970 (II).
Paris, Collection Maya Ruiz Picasso. Zervos XXXII, 272. Cat. 83.

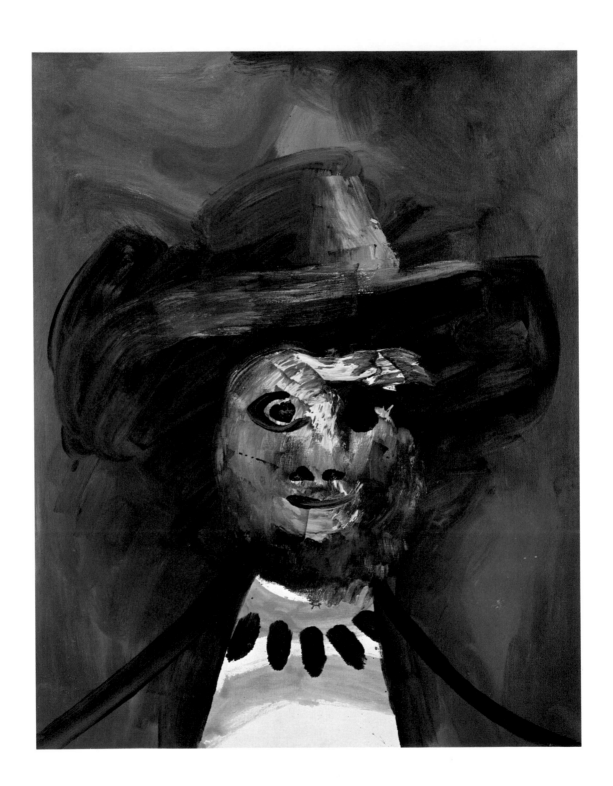

**47.**
**Man with a Big Hat.**
Oil on canvas, November 23, 1970.
Geneva, Collection Marina Picasso. Zervos XXXII, 310. Cat. 84.

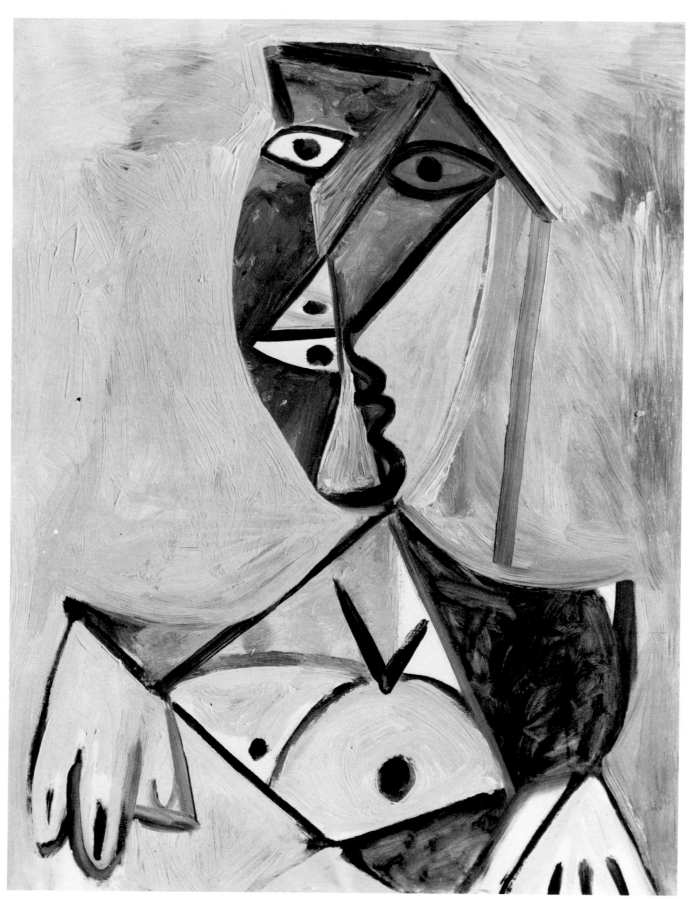

**48.**
**Bust of a Woman.**
Oil on canvas, June 26, 1971.
New York, The Pace Gallery. Zervos XXXIII, 74. Cat. 87.

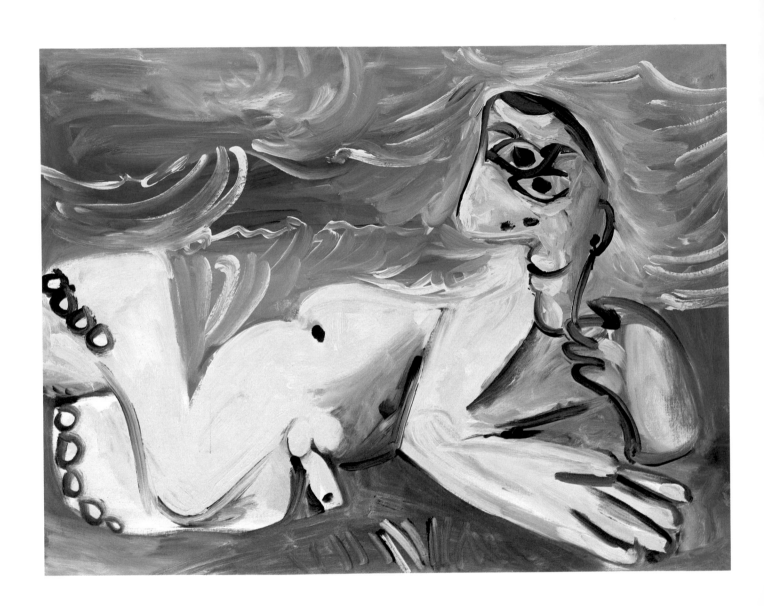

**49.**
**Nude Man Reclining.**
Oil on canvas, July 5, 1971 (II).
Zurich, Thomas Amman Fine Art. Zervos XXXIII, 88. Cat. 89.

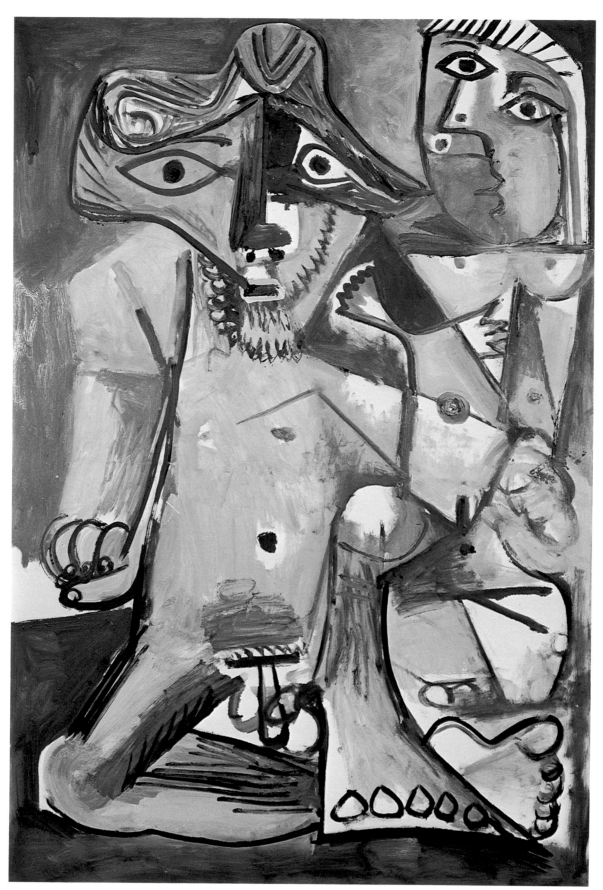

**50.**
**Man and Woman.**
Oil on canvas, August 18, 1971.
From the Collection of Mr. and Mrs. Raymond D. Nasher. Zervos XXXIII, 148. Cat. 93.

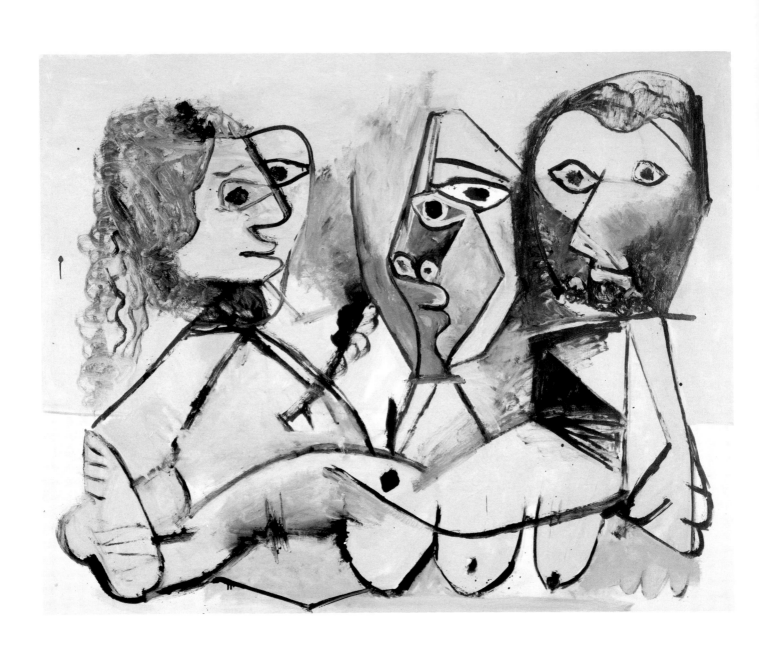

**51.**
**Three Figures.**
Oil on canvas, September 6, 1971.
New York, Acquavella Galleries, Inc. Zervos XXXIII, 169. Cat. 96.

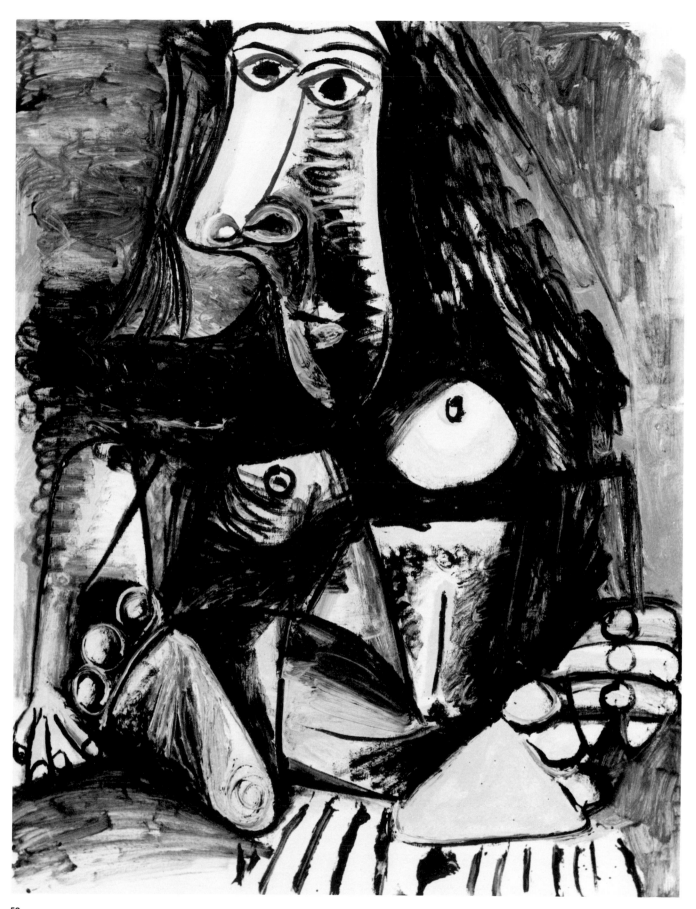

**52.**
**Seated Nude.**
Oil on canvas, September 15, 1971 (II).
New York, Collection Mr. and Mrs. Morton L. Janklow. Zervos XXXIII, 192. Cat. 98.

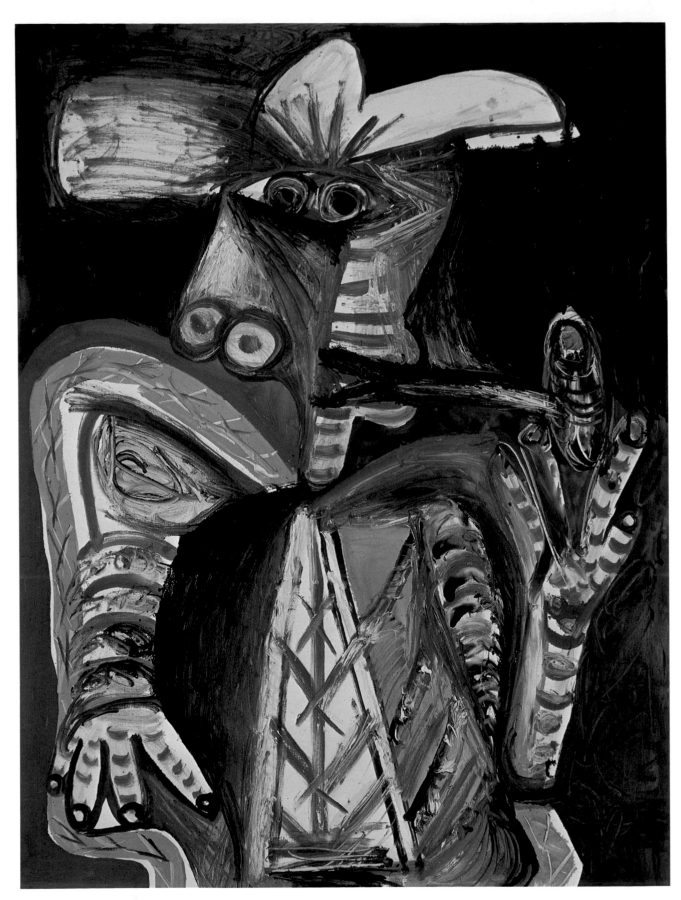

**53.**
**Figure with Pipe.**
Oil on canvas, November 16, 1971.
Geneva, Galerie Jan Krugier. Zervos XXXIII, 230. Cat. 99.

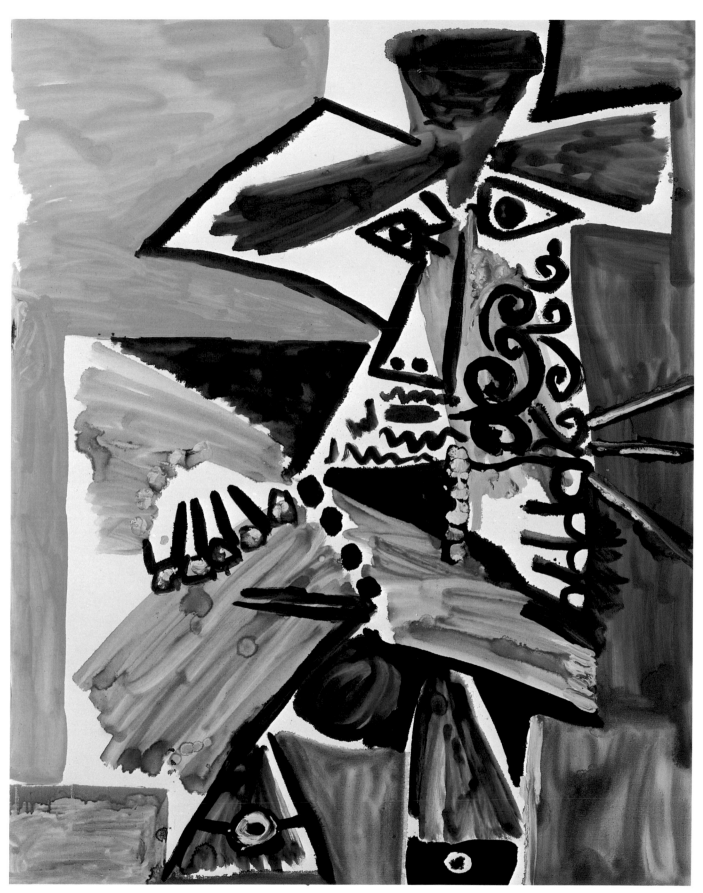

**54.**
**Seated Musketeer.**
Oil on canvas, January 19, 1972.
Paloma Picasso-Lopez. Zervos XXXIII, 278. Cat. 103.

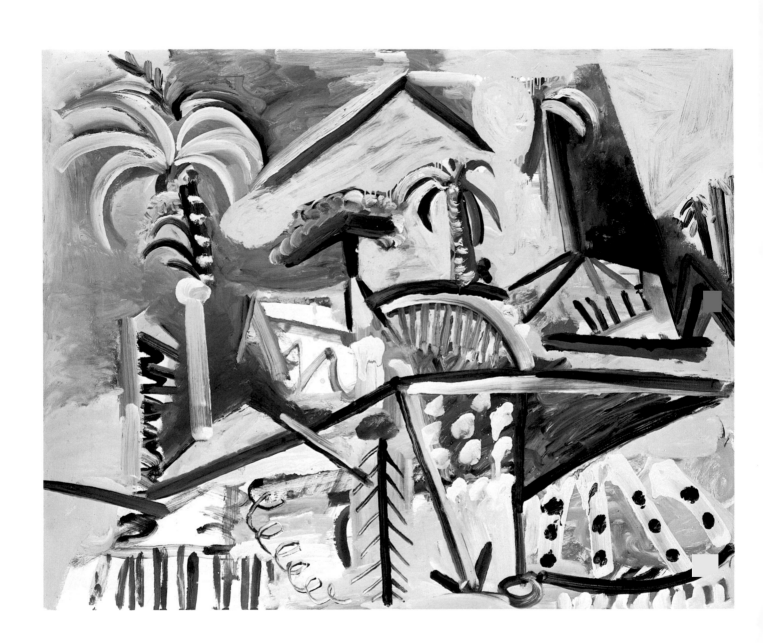

**55.**
**Landscape.**
Oil on canvas, March 31, 1972.
Paris, Musée Picasso, Zervos XXXIII, 331. Cat. 105.

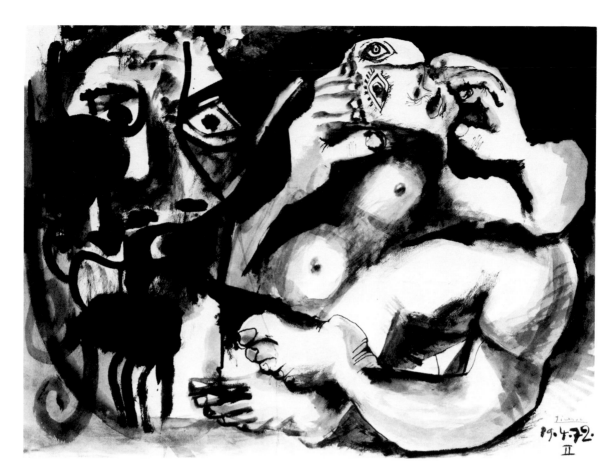

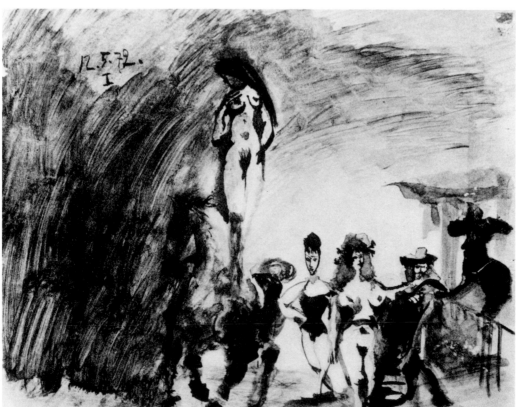

**56.**
**Reclining Nude and Head of a Man.**
Ink, April 19, 1972 (II).    Paris, Galerie Louise Leiris. Zervos XXXIII, 355. Cat. 108.

**57.**
**Equestrienne and Figures.**
Ink, May 12, 1972 (I).    Paris, Collection Maya Ruiz Picasso. Zervos XXXIII, 383. Cat. 111.

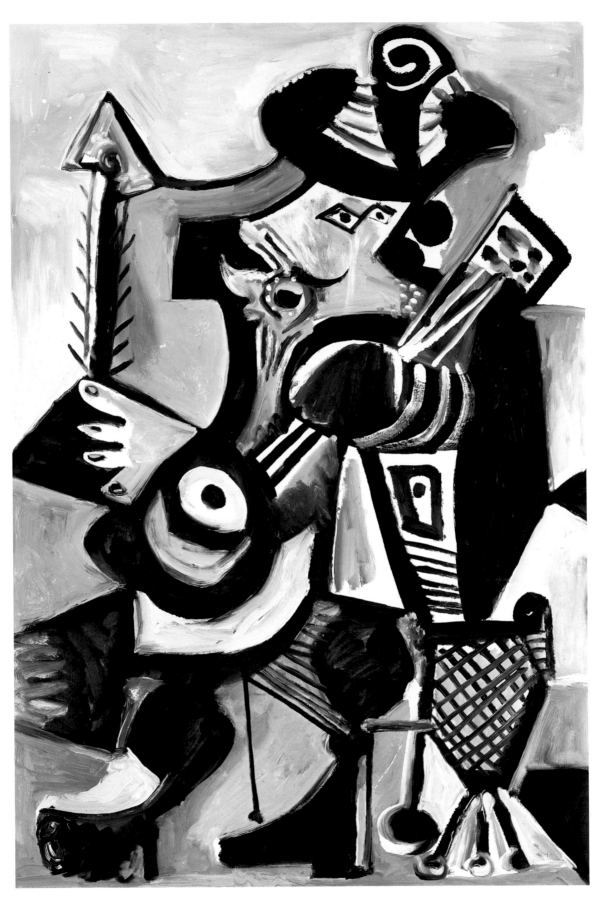

**58.**
**Musician/Musketeer with Guitar.**
Oil on canvas, May 26, 1972.
Paris, Musée Picasso. Zervos XXXIII, 397. Cat. 112.

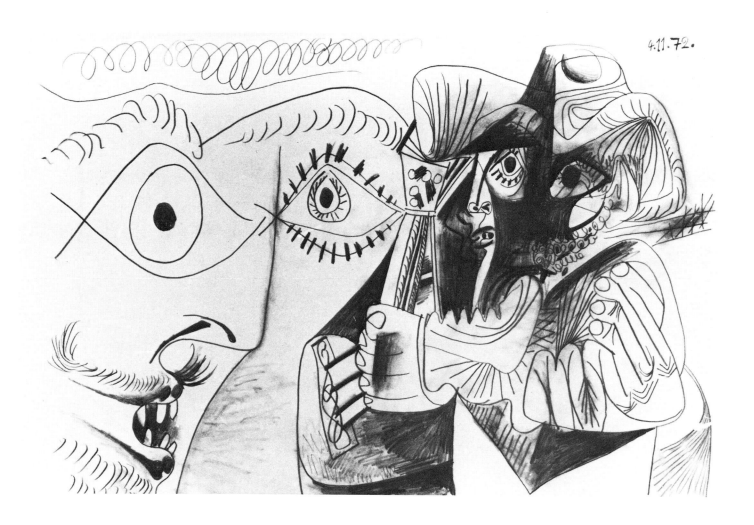

**59.**
**Musketeer with Guitar and Head in Profile.**
Crayon on board, November 4, 1972.
Paris, Musée Picasso. Zervos XXXIII, 529. Cat. 122.

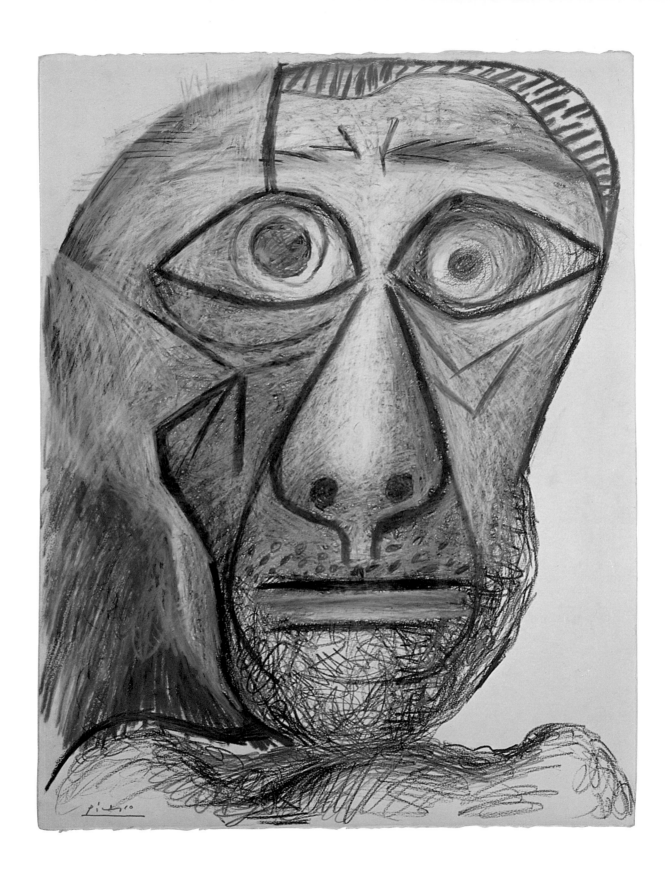

**60.**
**Self-Portrait.**
Crayon and colored crayons, June 30, 1972.
Tokyo, Fuji Television Co. Gallery, Ltd. Zervos XXXIII, 435. Cat. 115.

# Catalog of the Exhibition

**Editor's note:** a Roman numeral appended to a date of a work indicates the chronological placement of the particular work on that particular day. March 20, 1970 (III) means therefore that this work was the third work created by Picasso on March 20, 1970.

In some annotations the title of the work has been added: when no page number or exhibition number could be referred to, or when the title of the work was substantially different from the title used in this exhibition.

Due to the large number of impressions of each graphic work, the graphic works involve such an extensive and complex exhibition history that it is not included in the catalog section (except in the case of general exhibitions which also included paintings and/or drawings). Instead a selected history of graphic exhibitions has been compiled, following the Abbreviated References section.

Measurements in this catalog are given in centimeters and inches, height × width.

# Catalog of the Exhibition

**Paintings and Drawings: 1–123**

**1.**
**L'Enlèvement des Sabines**
**Rape of the Sabines**
(fig. 8 and plate 1)

January 9, February 7, 1963
Oil on canvas, 195 × 130 cm, 76¾ × 51⅛ in;
  signed upper right: "Picasso"
Juliana Cheney Edwards Collection, Fanny P.
  Mason Fund, Robert J. Edwards Fund, Arthur
  Gordon Tompkins Residuary Fund, courtesy
  Museum of Fine Arts, Boston

**Lit:**
Zervos XXIII, 121
Parmelin 1964, p. 36
Parmelin 1965, p. 146, fig. p. 143
Parmelin 1966 (II), p. 71
Dufour 1969, p. 97, fig. p. 96
Gallwitz 1971, p. 150, fig. 248
Leymarie 1971, p. 116, fig. p. 116
Elgar/Maillard 1972, fig. p. 243
Sutherland Boggs 1973, p. 229, fig. 377
Ponge/Descargues 1974, p. 192, fig. p. 192
Baumann 1976, p. 190, fig. 375
Schiff 1976, p. 23; p. 23, note 86 (as pl. 248): in
  Introduction by Gert Schiff, pp. 1–25
Cabanne 1977, pp. 513–514
Daix 1977, p. 385, fig. 147
O'Brian 1979, pp. 573–574

**Exh:**
Paris 1964, No. 17
Paris 1966/67, No. 262
New York 1971, No. 87

**2.**
**Tête de femme**
**Head of a Woman**
(fig. 26 and plate 2)

January 3, 1963
Oil on canvas, 81 × 65 cm, 31¾ × 25⅝ in
Geneva, Galerie Jan Krugier

**Lit:**
Zervos XXIII, 112
Parmelin 1964, p. xvi, fig. 192

**3.**
**Le peintre**
**The Artist**
(fig. 11)

February 22, 1963
Oil on canvas, 97 × 130 cm, 38 × 51⅛ in
Paris, Galerie Louise Leiris

**Lit:**
Zervos XXIII, 151
Parmelin 1965, p. 10, fig. p. 18
Parmelin 1966 (II), p. 102
Gallwitz 1971, p. 164
Ponge/Descargues 1974, p. 272
Daix 1977, p. 386

**Exh:**
Menton 1974, No. 4

**4.**
**Le peintre dans l'atelier**
**The Artist in the Studio**
(fig. 12 and plate 3)

February 22 (II), September 17, 1963
Oil on canvas, 89 × 116 cm, 34½ × 45⅜ in;
  signed upper left: "Picasso"
Paris, Galerie Louise Leiris

**Lit:**
Zervos XXIII, 153
Parmelin 1965, p. 10, fig. p. 19
Parmelin 1966 (II), p. 102
Gallwitz 1971, p. 164
Leymarie 1971, fig. p. 192
Ponge/Descargues 1974, p. 272
Daix 1977, p. 386

**Exh:**
Paris 1964, No. 18
Japan 1977/78, No. 71

**5.**
**Le peintre et son modèle**
**The Artist and His Model**
(fig. 13 and plate 4)

March 4, 5, 1963
Oil on canvas, 81 × 100 cm, 31¾ × 39¼ in
Geneva, Galerie Jan Krugier

**Lit:**
Zervos XXIII, 159
Parmelin 1965, p. 11
Parmelin 1966 (II), p. 102
Gallwitz 1971, p. 164
Ponge/Descargues 1974, p. 272
Daix 1977, p. 386

**6.**
**Portrait de Jacqueline**
**Portrait of Jacqueline**
(fig. 27)

April 22, May 30, 1963
Oil on canvas, 92 × 60 cm, 36¼ × 24 in; signed
  upper left: "Picasso"
Lucerne, Collection Angela Rosengart

**Lit:**
Zervos XXIII, 219
Parmelin 1965, pp. 17–22
Parmelin 1966 (II), pp. 80–81, p. 114
Daix 1977, p. 387

**Exh:**
Lucerne 1966 (Jeune femme)
Lucerne 1971 (Jeune femme)

**7.**
**Nu couché**
**Reclining Nude**
(fig. 23 and plate 5)

January 9, 18, 1964
Oil on canvas, 65 × 100 cm, 25⅝ × 39¼ in;
  signed upper left: "Picasso"
Lucerne, Galerie Rosengart

**Lit:**
Zervos XXIV, 25
Parmelin 1966 (I), fig. p. 81
Gallwitz 1971, p. 155, fig. 255
Geelhaar 1981, p. 28

**Exh:**
Baden-Baden 1968, No. 55
Lucerne 1969 (Nu couché)

Lucerne 1971 (Nu couché)
Basel 1981 (II), No. 1

**8.**
**Nu couché**
**Reclining Nude**
(fig. 22)

January 29, 1964 (I)
Oil on canvas, 89 × 130 cm, 34½ × 51⅛ in
Paloma Picasso-Lopez

**Lit:**
Zervos XXIV, 64
Geelhaar 1981, pp. 27–28, fig. 18

**Exh:**
Paris 1980, No. 41 (Nu couché sur étoffe rose)
Basel 1981 (II), No. 2

**9.**
**Grand nu**
**Grand Nude**
(fig. 24 and plate 6)

February 20–22, March 5, 1964
Oil on canvas, 140 × 195 cm, 55⅛ × 76¾ in;
  signed upper right: "Picasso"
Zürich, Kunsthaus

**Lit:**
Zervos XXIV, 95
Parmelin 1966 (I), fig. p. 91
U.I. (Ursula Isler), "Ein Spätwerk Picassos im
  Kunsthaus Zürich," Neue Zürcher Zeitung, No.
  657, November 4, 1969, p. 33
Gallwitz 1971, p. 152, fig. 254
Elgar/Maillard 1972, p. 160
Glozer 1974, pp. 18, 19, 20
Baumann 1976, pp. 192, 197, fig. 376
Geelhaar 1981, pp. 26–27, 28, 29, fig. 19

**Exh:**
Lucerne 1966 (Grand nu)
Paris 1966/67, No. 267
Amsterdam 1967, No. 126
Baden-Baden 1968, No. 57
Basel 1981 (II), No. 3

**10.**
**Femme assise dans un fauteuil, un chat sur les
  genoux**
**Seated Woman with Cat**
(fig. 28)

February 27 (I), March 22, 1964
Oil on canvas, 146 × 89 cm, 57½ × 34½ in
Paris, Galerie Louise Leiris

**Lit:**
Zervos XXIV, 96
Parmelin 1966 (I), p. 88, fig. p. 94
Daix 1977, p. 388, note 34
Geelhaar 1981, pp. 28–29

**Exh:**
Menton 1974, No. 6
Japan 1977/78, No. 72

**11.**
**Tête d'un barbu**
**Head of a Bearded Man**

June 1, 1964 (II)

Colored crayons, 52.5 × 37.5 cm, 20¾
× 14⅞ in; signed and dated upper right:
"1.6.64.II Picasso"
Tokyo, Fuji Television Gallery Co., Ltd.

**Lit:**
Zervos XXIV, 195
Parmelin 1966 (I), fig. p. 125

**12.**
**Le peintre**
**The Artist**
(fig. 19 and plate 8)

October 10, 1964
Gouache and India ink, on a reproduction
  of a painting of March 30, 1963, (Zervos XXIII,
  198), 98 × 75 cm, 38⅝ × 29½ in; signed
  upper left: "Picasso"
Basel, Galerie Beyeler

**Lit:**
Zervos XXIV, 215
Parmelin 1966 (I), p. 128, fig. p. 133
Parmelin 1966 (II), pp. 118, 119
Cabanne 1977, pp. 525–526
Daix 1977, p. 388, note 33
O'Brian 1979, p. 577
Hohl 1981, p. 19

**Exh:**
Winterthur etc. 1971/72, No. 49
Basel 1981 (I), No. 99
Vienna 1981/82, No. 67

**13.**
**Le peintre et son modèle**
**The Artist and His Model**
(plate 9)

October 26 (II), November 3, 1964
Oil on canvas, 146 × 89 cm, 57½ × 34½ in
Basel, Galerie Beyeler

**Lit:**
Zervos XXIV, 246
Baden-Baden 1968, p. opposite No. 61: in text by
  Klaus Gallwitz
Gallwitz 1971, p. 166, fig. 279
Geelhaar 1981, pp. 18–20, fig. 6
Hohl 1981, p. 18

**Exh:**
Baden-Baden 1968, No. 61
Baden-Baden 1969, No. 148
Minneapolis etc. 1975/76, No. 48
Madrid 1977, No. 29
Barcelona 1977/78, No. 34
Basel 1981 (I), No. 57
Basel 1981 (II), No. 7
Vienna 1981/82, No. 69

**14.**
**Le peintre et son modèle**
**The Artist and His Model**
(fig. 15 and plate 10)

November 7, 1964 (IV)
Oil on canvas, 97 × 130 cm, 38 × 51⅛ in
Private Collection

**Lit:**
Zervos XXIV, 261
Parmelin 1966 (I), fig. p. 146

**Exh:**
Minneapolis etc. 1975/76, No. 50
Basel 1981 (I), No. 58
Basel 1981 (II), No. 8
Vienna 1981/82, No. 70

**15.**
**Le peintre et son modèle**
**The Artist and His Model**
(fig. 16)

November 11, 1964
Oil on canvas, 97 × 130 cm, 38 × 51⅛ in
Buffalo, Albright-Knox Art Gallery, Gift of the
  Seymour H. Knox Foundation, Inc., 1965

**Lit:**
Zervos XXIV, 264
Parmelin 1966 (I), fig. p. 148

**Exh:**
New York 1975 (Artist and His Model)

**16.**
**Tête d'homme**
**Head of a Man**

December 5, 1964 (V)
Oil on canvas, 46 × 38 cm, 18⅛ × 15 in
Geneva, Galerie Jan Krugier

**Lit:**
Zervos XXIV, 303
Parmelin 1966 (I), fig. p. 169

**17.**
**Le peintre au chapeau**
**Artist Wearing a Hat**

March 17, 1965 (III)
Oil on canvas, 73 × 60 cm, 28¾ × 24 in; signed
  lower right: "Picasso"
Switzerland, Private Collection

**Lit:**
Zervos XXV, 44
Gallwitz 1971, fig. 127
Geelhaar 1981, p. 22, fig. 70

**Exh:**
Basel 1981 (II), No. 11

**18.**
**Le modèle dans l'atelier**
**The Model in the Studio**
(fig. 14 and plate 11)

March 24, 1965 (II)
Oil on canvas, 50 × 60 cm, 19⅝ × 24 in
Geneva, Galerie Jan Krugier

**Lit:**
Zervos XXV, 58
Daix 1977, p. 388, note 33; p. 395, note 15

**19.**
**Nu allongé et tête d'homme en profil**
**Reclining Nude and Man in Profile**
(plate 12)

March 29, 1965 (V)
Oil on canvas, 50 × 61 cm, 19⅝ × 24 in
Private Collection

**Lit:**
Zervos XXV, 82

**Exh:**
Paris 1980, No. 43

**20.**
**Les dormeurs**
**The Sleepers**
(fig. 30 and plate 7)

April 13, 1965
Oil on canvas, 114 × 195 cm, 44⅜ × 76¾ in;
  signed upper right: "Picasso"
Paris, Galerie Louise Leiris

**Lit:**
Zervos XXV, 106
Elgar/Maillard 1972, p. 245, fig. p. 246
Ponge/Descargues 1974, fig. p. 168
Cabanne 1977, p. 527
Madrid/Barcelona 1981/82, p. 298

**Exh:**
Paris 1966/67, No. 273
Amsterdam 1967, No. 128
Vienna 1968, No. 67
Baden-Baden 1968, No. 72
Japan 1977/78, No. 74
Basel 1981 (II), No. 14
Madrid/Barcelona 1981/82, No. 133

**21.**
**La pisseuse**
**Woman Making Water**
(fig. 48)

April 16, 1965 (I)
Oil on canvas, 195 × 97 cm, 76¾ × 38 in;
  signed upper right: "Picasso"
Paris, Private Collection

**Lit:**
Zervos XXV, 108
Leiris 1973, p. 256
Cabanne 1977, p. 527 (Woman at the Seashore)

**Exh:**
Paris 1966/67, No. 275 (Femme au bord de
  la mer)

**22.**
**Tête d'homme**
**Head of a Man**
(plate 13)

June 12, 1965 (II)
Oil on canvas, 55 × 46 cm, 21⅝ × 18⅛ in
Paloma Picasso-Lopez

**Lit:**
Zervos XXV, 161

**Exh:**
Basel 1981 (II), No. 17

**23.**
**Homme et femme nus/Deux personnages**
**Nude Man and Woman**
(fig. 34 and plate 14)

October 25, 1965
Oil on canvas, 162 × 130 cm, 63⅜ × 51⅛ in;
  signed and dated upper left: "25.10.65.
  Picasso"
Paris, Galerie Louise Leiris

**Lit:**
Zervos XXV, 183

**Exh:**
Japan 1977/78, No. 73
Basel 1981 (II), No. 18

**24.**
**Homme et musicienne assis**
**Seated Man and Musician**

April 11, 1966 (VII)
India ink and colored crayons, 37 × 54 cm, 14½
  × 21¼ in; signed upper right: "Picasso";
  dated upper left: "11.4.66.VII"
Basel, Galerie Beyeler

**Lit:**
Zervos XXV, 203

**Exh:**
Basel 1981 (I), No. 101

**25.**
**Mousquetaires**
**Musketeers**

December 30, 1966 (III)
Colored crayons, 56 × 46 cm, 22 × 18⅛ in;
signed and dated upper left: "30.12.66.III
Picasso"
Paris, Galerie Louise Leiris

Lit:
Zervos XXV, 266
Feld 1969, fig. 50

**26.**
**Musicien, homme et femme**
**Musician, Man and Woman**
(plate 15)

January 2, 1967 (I)
Brown crayon, 50 × 61 cm, 19⅝ × 24 in; signed
and dated upper right: "2.1.67.I Picasso"
Tokyo, Fuji Television Gallery Co., Ltd.

Lit:
Zervos XXV, 260
Feld 1969, fig. 56

**27.**
**Homme à l'agneau, musicien, coq et enfant**
**à la pastèque**
**Man with Lamb, Musician, Cock and Child**
**with Watermelon**
(fig. 31)

January 20 (I), 1967
Colored crayons, 50 × 65 cm, 19⅝ × 25⅝ in;
signed and dated upper left: "vendredi
20.1.67.I Picasso"
Paris, Galerie Louise Leiris

Lit:
Zervos XXVII, 423
Penrose/Golding 1973, pp. 7–8: in
"Introduction: A Free Man" by Daniel-Henry
Kahnweiler
Sutherland Boggs 1973, p. 232
Alberti 1974, fig. 76

Exh:
Lucerne 1969 (L'Homme à l'agneau)

**28.**
**Homme et femme nue**
**Man and Nude Woman**
(fig. 41)

February 22, 28, March 1, 1967
Oil on canvas, 100 × 81 cm, 39¼ × 31¾ in;
dated upper left: "22.2.67."
Paris, Galerie Louise Leiris

Lit:
Zervos XXV, 292
Basel 1976, p. 172: in text by Franz Meyer
Geelhaar 1981, p. 31, fig. 23
Madrid/Barcelona 1981/82, p. 300

Exh:
New York 1971, No. 99
Menton 1974, No. 8
Japan 1977/78, No. 77
Madrid/Barcelona 1981/82, No. 134

**29.**
**Nu assis et flûtiste**
**Seated Nude and Flute Player**
(fig. 32)

February 26, 27 (I), August 22, 1967
Ink and colored crayon, 46.5 × 63 cm, 18⅜ ×
24¾ in; signed upper left: "Picasso"; dated

upper right: "Domingo 26.2.67.I 27. 22.8.67"
New York, Private Collection

Lit:
Zervos XXVII, 460
Feld 1969, fig. 123
Gallwitz 1971, fig. 285
Elgar/Maillard 1972, p. 169

Exh:
Paris 1968, No. 16

**30.**
**Nu assis et flûtiste**
**Seated Nude and Flute Player**
(fig. 33)

February 26 (VI), 27, 1967
Ink and colored crayons, 65 × 49.5 cm,
25⅝ × 19½ in; signed and dated upper left:
"Dimanche 26.2.67 Picasso 27.VI"
New York, Collection Mr. and Mrs. Daniel
Saidenberg

Lit:
Zervos XXVII, 469
Feld 1969, fig. 128

Exh:
New York 1967/68, No. 20

**31.**
**Aigle et personnages**
**Eagle and Figures**
(plate 16)

March 10, 1967 (I)
Ink, 49.5 × 75.5 cm, 19½ × 29⅝ in; signed and
dated upper right: "10.3.67.I Picasso"
Basel, Galerie Beyeler

Lit:
Zervos XXV, 289
Feld 1969, fig. 151

Exh:
New York 1967/68, No. 27
Winterthur etc. 1971/72, No. 54
Vienna 1981/82, No. 91

**32.**
**Mousquetaire. Tête**
**Musketeer. Head**

April 4, 1967
Oil on canvas, 65 × 54 cm, 25⅝ × 21¼ in
Geneva, Galerie Jan Krugier

Lit:
Zervos XXV, 320

**33.**
**Mousquetaire. Buste**
**Musketeer. Bust**
(plate 17)

May 28, 1967
Oil on canvas, 73 × 60 cm, 28¾ × 24 in
New York, courtesy Sindin Galleries

Lit:
Zervos XXVII, 4

**34.**
**L'Aubade**
**The Aubade**
(fig. 35 and plate 18)

June 18, 1967
Oil on plywood, 162 × 122 cm, 63⅜ × 48 in
Lucerne, Galerie Rosengart

Lit:
Zervos XXVII, 28
Gallwitz 1971, fig. p. 5

Exh:
Lucerne 1971 (L'Aubade)
Marcq-en-Baroeul 1981, No. 17
Basel 1981 (II), No. 26

**35.**
**La chute de la cavalière**
**The Fall of the Equestrienne**
(plate 19)

July 2, 1967 (III)
Ink, 37.5 × 52.5 cm, 14⅞ × 20⅝ in; dated lower
right: "2.7.67.III"
Lucerne, Galerie Rosengart

Lit:
Zervos XXVII, 51
Feld 1969, fig. 202

Exh:
Lucerne 1969 (Chute de la cavalière)
Paris 1968, No. 28

**36.**
**Tête d'homme**
**Head of a Man**

August 3, 1967
Ink and gouache, 75 × 56.5 cm, 29½ × 22¼ in;
signed and dated lower left: "3.8.67. Picasso"
Paris, Galerie Louise Leiris

Lit:
Zervos XXVII, 96
Feld 1969, fig. 247

**37.**
**Retour du guerrier**
**Return of the Warrior**
(plate 20)

August 31 (II), 1967
Pencil, 56.5 × 75 cm, 22¼ × 29½ in; signed
and dated upper right: "31.8.67.II Picasso"
Basel, Galerie Beyeler

Lit:
Zervos XXVII, 111
Feld 1969, fig. 268
Leymarie 1971, fig. p. 163
Karlsruhe/Frankfurt am Main 1974/75, p. 90,
fig. p. 140: in text by Jürgen Thimme
Gallwitz 1981/82, p. 181

Exh:
Paris 1968, No. 67
Winterthur etc. 1971/72, No. 58
Karlsruhe/Frankfurt am Main 1974/75, No. 196
Basel 1981 (I), No. 107
Vienna 1981/82, No. 87

**38.**
**Hommes et femmes nus**
**Nude Men and Women**
(fig. 36)

November 8, 11, 14, December 25, 1967
Ink and gouache, 65 × 58 cm, 25⅝ × 23⅛ in;
signed and dated lower left: "8.11.67. 11.11.67.
14. 25.12.67. Picasso."
New York, Collection Mr. and Mrs. Daniel
Saidenberg

Lit:
Zervos XXVII, 168
Feld 1969, fig. 317

**39.**
**Homme à la pipe et nu couché**
**Man with Pipe and Reclining Nude**

November 16, 1967
Oil on canvas, 146 × 114 cm, 57½ × 44⅜ in;
   dated upper left: "16.11.67."
Zürich, Thomas Amman Fine Art

Lit:
Zervos XXVII, 154

**40.**
**Homme et femme nus**
**Nude Man and Woman**

January 4, 1968 (IV)
Crayon, 48 × 59 cm, 19 × 23½ in; signed upper
   right: "Picasso"; dated lower right:
   "4.1.68.IV"
Basel, Galerie Beyeler

Lit:
Zervos XXVII, 179
Feld 1969, fig. 337

Exh:
Winterthur etc. 1971/72, No. 62
Basel 1981 (I), No. 110
Vienna 1981/82, No. 90

**41.**
**Femme nue à l'oiseau**
**Nude Woman with Bird**
(fig. 45)

Mougins, January 17, 1968
Oil on canvas, 130 × 195 cm, 51⅛ × 76¾ in
Geneva, Collection Marina Picasso

Lit:
Zervos XXVII, 195

Exh:
München etc. 1981/82, No. 271
Tokyo/Kyoto 1983, No. 202

**42.**
**Homme et courtisanes (Personnages devant
   la fenêtre)**
**Man and Courtesans (Figures in Front of
   a Window)**
(plate 21)

March 8, 1968 (IV)
Pencil, 49.2 × 75.5 cm, 19½ × 29⅝ in; signed
   and dated upper left: "8.3.68.IV Picasso"
New York, Collection Daniel Saidenberg

Lit:
Zervos XXVII, 259
Feld 1969, fig. 398

**43.**
**L'Étreinte**
**The Embrace**

September 9, 1968 (I)
Gouache and ink, 11.3 × 15.7 cm, 4½ × 6¼ in;
   signed lower right: "Picasso"; dated upper
   left: "9.9.68.I"
New York, Private Collection

Lit:
Zervos XXVII, 283
Elgar/Maillard 1972, p. 175

**44.**
**L'Étreinte**
**The Embrace**

September 9, 1968 (V)
Pencil, 49.5 × 65 cm, 19½ × 25⅝ in; signed and
   dated lower right: "9.9.68.V Picasso"

Paris, Galerie Louise Leiris

Lit:
Zervos XXVII, 291

**45.**
**Homme et femme**
**Man and Woman**
(plate 22)

September 14 (II), 1968
Oil on plywood, 131 × 98 cm, 51⅝ × 38⅝ in;
   signed upper left: "Picasso"
Paris, Galerie Louise Leiris

Lit:
Zervos XXVII, 313

Exh:
Menton 1974, No. 9

**46.**
**Homme et deux nus**
**Man and Two Nudes**

October 2 (II), 1968
Ink, 50.5 × 65 cm, 19⅞ × 25⅝ in; signed and
   dated upper right: "2.10.68.II Picasso"
Paris, Galerie Louise Leiris

Lit:
Zervos XXVII, 316

**47.**
**Nu couché**
**Reclining Nude**
(plate 23)

October 10 (I), 1968
Oil on canvas, 130 × 162 cm, 51⅛ × 63⅜ in;
   signed upper left: "Picasso"
Paris, Galerie Louise Leiris

Lit:
Zervos XXVII, 337

Exh:
Basel 1981 (II), No. 29

**48.**
**Mousquetaire à la pipe**
**Musketeer with Pipe**
(plate 24)

October 16 (I), 1968
Oil on canvas, 162 × 130 cm, 63⅜ × 51⅛ in;
   signed upper left: "Picasso"
Paris, Galerie Louise Leiris

Lit:
Zervos XXVII, 340

Exh:
Japan 1977/78, No. 79
Basel 1981 (II), No. 31

**49.**
**Le gentilhomme à la pipe**
**Musketeer with Pipe and Flowers**
(fig. 59 and plate 25)

November 5, 1968
Oil on canvas, 145.5 × 97 cm, 57¼ × 38 in;
   signed upper right: "Picasso"
Lucerne, Galerie Rosengart

Lit:
Zervos XXVII, 364
Glozer 1974, pp. 20–21
Basel 1976, p. 174: in text by Franz Meyer
Geelhaar 1981, p. 40; p. 40, note 102; fig. 77

Exh:
Lucerne 1969 (Le gentilhomme à la pipe)

Marcq-en-Baroeul 1981, No. 23
Basel 1981 (II), No. 32 (Mousquetaire à la pipe
   et fleurs/Musketier mit Pfeife und Blumen)

**50.**
**Nu et fumeur**
**Nude and Smoker**
(fig. 42 and plate 26)

November 10, 1968
Oil on canvas, 162 × 130 cm, 63⅜ × 51⅛ in;
   signed upper right: "Picasso"
Lucerne, Galerie Rosengart

Lit:
Zervos XXVII, 369
Gallwitz 1971, fig. 261
Elgar/Maillard 1972, fig. p. 247
Glozer 1974, pp. 20–21
Basel 1976, pp. 158 (as No. 88), 174, 176: in text
   by Franz Meyer
Geelhaar 1981, pp. 40, 43; p. 43, note 103;
   fig. 78

Exh:
Lucerne 1969 (Nu et fumeur)
Basel 1976, No. 88
Basel 1981 (II), No. 33

**51.**
**Le fumeur**
**The Smoker**
(fig. 38 and plate 27)

November 22, 1968
Oil on canvas, 146 × 89 cm, 57½ × 34½ in;
   signed upper right: "Picasso"
Lucerne, Galerie Rosengart

Lit:
Zervos XXVII, 377
Elgar/Maillard 1972, fig. p. 247
Glozer 1974, pp. 20–21
Geelhaar 1981, p. 43; p. 43, note 104; fig. 32

Exh:
Lucerne 1969 (Le fumeur)
Lucerne 1971 (Le fumeur)
Basel 1981 (II), No. 35

**52.**
**Nu debout et mousquetaire assis**
**Standing Nude with Seated Musketeer**

November 30, 1968
Oil on canvas, 162 × 129.5 cm, 63⅜ × 51⅛ in;
   signed upper right: "Picasso"
New York, jointly owned by The Metropolitan
   Museum of Art and A. L. and Blanche Levine,
   1981

Lit:
Zervos XXVII, 384

**53.**
**Nu assis et amour**
**Seated Nude and Cupid**

December 16 (VI), 1968
India ink, 44 × 31.5 cm, 17¼ × 12⅜ in; signed
   and dated upper left: "16.12.68.VI Picasso"
Paris, Galerie Louise Leiris

Lit:
Zervos XXVII, 399

**54.**
**Deux hommes et nu debout**
**Two Men and Standing Nude**

January 23, 1969

Paris, Galerie Louise Leiris
Crayon, 31.5 × 44 cm, 12⅜ × 17¼ in; signed
    and dated upper right: "23.1.69. Picasso"

**Lit:**
Zervos XXXI, 26

**55.**
**Personnage rembranesque et amour**
**Rembrandt-like Figure and Cupid**
(fig. 62 and plate 28)

February 19, 1969
Oil on canvas, 162 × 130 cm, 63⅜ × 51⅛ in;
    signed upper right: "Picasso"
Lucerne, Picasso Collection of the City of
    Lucerne (Rosengart Donation)

**Lit:**
Zervos XXXI, 73
Alberti 1971, p. 95, fig. 83
Gallwitz 1971, fig. 4
Barr-Sharrar 1972, p. 527, note 44 (as no. 7)
Glozer 1974, pp. 20, 21
Basel 1976, p. 178: in text by Franz Meyer

**Exh:**
Lucerne 1969 (*Personnage rembranesque et
    amour*)
Avignon 1970, No. 7
Lucerne 1978 (*Rembrandtesque Figure and
    Cupid*)
Basel 1981 (II), No. 37

**56.**
**Tête d'homme**
**Head of a Man**
(fig. 58)

March 27, 1969 (III)
Oil on canvas, 81 × 65 cm, 31¾ × 25⅝ in
The Collection of Owen Morrissey

**Lit:**
Zervos XXXI, 125
Alberti 1971, fig. 7

**Exh:**
Avignon 1970, No. 15
New York 1981, p. 40

**57.**
**Homme et femme nus**
**Nude Man and Woman**

April 30, 1969 (VI)
Ink, 22 × 31 cm, 8⅝ × 12⅛ in; signed and
    dated upper right: "30.4.69.VI Picasso"
Basel, Galerie Beyeler
(Verso: *Tête d'homme*, Z. XXXI, 174)

**Lit:**
Zervos XXXI, 173

**Exh:**
London 1970, No. 35

**57a.**
**Tête d'homme**
**Head of a Man**
(verso of 57)

April 30 (VI), May 1 (VII), 1969
Ink, 22 × 31 cm, 8⅝ × 12⅛ in; dated left half of
    the drawing: "30.4.69.VI Picasso"
Basel, Galerie Beyeler
(Recto: *Homme et femme nus*, Z. XXXI, 173)

**Lit:**
Zervos XXXI, 174

**Exh:**
London 1970, No. 35ª

**58.**
**Homme à l'épée dans un fauteuil**
**Man with Sword**
(figs. 37 and 61)

July 19, 1969
Oil on canvas, 195 × 130 cm, 76¾ × 51⅛ in
Paris, Collection Maya Ruiz Picasso

**Lit:**
Zervos XXXI, 328
Alberti 1971, p. 196, fig. 199

**Exh:**
Avignon 1970, No. 62

**59.**
**Adolescent**
**Adolescent**
(fig. 55 and plate 30)

August 2, 1969
Oil on canvas, 130 × 97 cm, 51⅛ × 38 in
Paris, Mr. Xavier Vilató

**Lit:**
Zervos XXXI, 341
Alberti 1971, fig. 55
Gallwitz 1971, fig. 314

**Exh:**
Avignon 1970, colorplate (*Adolescent*)
Basel 1981 (II), No. 39

**60.**
**Femme couchée**
**Reclining Nude**

August 10, 1969 (II)
Crayon, 50.5 × 65.5 cm, 19⅞ × 25¾ in; signed
    and dated upper left: "Dimanche 10.8.69.II
    Picasso"
New York, Saidenberg Gallery

**Lit:**
Zervos XXXI, 357
Alberti 1971, fig. 122

**Exh:**
Avignon 1970, Dessin No. 15
New York 1971, No. 106

**61.**
**Homme au turban et nu couché**
**Man Wearing a Turban and Reclining Nude**
(plate 31)

August 26, 1969 (I)
Crayon, 50.5 × 65.5 cm, 19⅞ × 25¾ in; signed
    and dated upper right: "26.8.69.I Picasso"
Paris, Galerie Louise Leiris

**Lit:**
Zervos XXXI, 393

**62.**
**Nu couché et homme au masque**
**Reclining Nude and Man with a Mask**
(plate 32)

September 5, 1969 (II)
Crayon, 50.5 × 65 cm, 19⅞ × 25⅝ in; signed
    and dated upper left:" 5.9.69.II Picasso"
Basel, Galerie Beyeler

**Lit:**
Zervos XXXI, 414

**Exh:**
Winterthur etc. 1971/72, No. 72
Basel 1981 (I), No. 115
Vienna 1981/82, No. 93

**63.**
**Homme et enfant**
**Man and Child**
(plate 33)

October 11, 1969
Oil on canvas, 195 × 130 cm, 76¾ × 51⅛ in
Paris, Galerie Louise Leiris

**Lit:**
Zervos XXXI, 463
Alberti 1971, fig. 23 (*Homme et femme*)

**Exh:**
Avignon 1970, No. 90 (*Homme et femme*)
Japan 1977/78, No. 82 (*Homme et femme*)
Basel 1981 (II), No. 41

**64.**
**Peintre et modèle**
**The Artist and His Model**
(plate 34 )

October 22, 23, 1969
Colored crayons on carton, 25.4 × 32.5 cm, 11⅛
    × 12¾ in; signed and dated upper left:
    "22.10.69. 23. Picasso"
Tokyo, Fuji Television Gallery Co., Ltd.

**Lit:**
Zervos XXXI, 476

**Exh:**
Tokyo/Osaka 1971, No. 29

**65.**
**Vase de fleurs sur une table**
**Bouquet**

October 27, 1969
Oil on canvas, 116 × 89 cm, 45⅜ × 34½ in
Private Collection

**Lit:**
Zervos XXXI, 485
Alberti 1971, fig. 27
Gallwitz 1971, fig. 39
Malraux 1976, fig. 28

**Exh:**
Avignon 1970, No. 106
New York 1981, p. 28
Basel 1981 (II), No. 43

**66.**
**Vase de fleurs sur une table**
**Bouquet**
(plate 35)

October 28, 1969
Oil on canvas, 116 × 89 cm, 45⅜ × 34½ in
Basel, Galerie Beyeler

**Lit:**
Zervos XXXI, 486
Alberti 1971, fig. 28
Gallwitz 1971, fig. 38
Hohl 1981, p. 19

**Exh:**
Avignon 1970, No. 107
Basel 1981 (I), No. 62 (and frontispiece)
Basel 1981 (II), No. 44
Vienna 1981/82, No. 75

**67.**
**Homme et nu à la sauterelle**
**Man and Nude with Grasshopper**
(plate 36)

November 17, 1969 (I)

Crayon, 49.5 × 65.5 cm, 19½ × 25¾ in; signed and dated upper right: "17.11.69.I Picasso"
Paris, Galerie Louise Leiris

Lit:
Zervos XXXI, 502

Exh:
New York 1980, No. 43: in "Listing of Additional Works"

## 68.
**L'Étreinte**
**The Embrace**
(fig. 95 and plate 37)

November 19, 1969 (II)
Oil on canvas, 162 × 130 cm, 63⅜ × 51⅛ in
Paris, Mr. Javier Vilató

Lit:
Zervos XXXI, 507
Alberti 1971, p. 114, fig. 97 (Couple)
Gallwitz 1971, fig. 310 (Couple. Paar)

Exh:
Avignon 1970, No. 116 (Couple)
Basel 1981 (II), No. 46

## 69.
**Le baiser**
**The Kiss**
(fig. 93 and plate 38)

December 1, 1969 (II)
Oil on canvas, 146 × 114 cm, 57½ × 44⅜ in
Basel, Galerie Beyeler

Lit:
Zervos XXXI, 535
Alberti 1971, pp. 70–71, fig. 67
Cabanne 1977, p. 551
Daix 1977, fig. 157

Exh:
Avignon 1970, No. 124
Basel 1981 (II), No. 47
Vienna 1981/82, No. 76

## 70.
**Homme et femme. Bustes.**
**Couple**
(plate 39)

December 5, 1969
Oil on canvas, 146 × 114 cm, 57½ × 44⅜ in
Paris, Mr. Javier Vilató

Lit:
Zervos XXXI, 538
Alberti 1971, fig. 87 (Femme et fumeur)

Exh:
Avignon 1970, No. 128

## 71.
**Nu assis et trois personnages**
**Seated Nude and Three Figures**
(fig. 101)

December 18, 1969 (I)
Crayon, 43.5 × 54 cm, 17⅛ × 21¼ in; signed and dated upper left: "18.12.69.I Picasso"
Paris, Galerie Louise Leiris

Lit:
Zervos XXXI, 554
Alberti 1971, fig. 146

Exh:
Avignon 1970, Dessin No. 39
Menton 1974, No. 11

## 72.
**Homme, femme et enfant. Bustes.**
**Man, Woman and Child. Busts.**
(plate 40)

December 26, 1969
Oil on canvas, 130 × 162 cm, 51⅛ × 63⅜ in
Geneva, Collection Marina Picasso

Lit:
Zervos XXXI, 563
Alberti 1971, fig. 38

Exh:
Avignon 1970, No. 139
München etc. 1981/82, No. 272
Tokyo/Kyoto 1983, No. 203

## 73.
**Couple assis**
**Seated Couple**
(plate 42)

January 5, 1970
Oil on canvas, 162 × 130 cm, 63⅜ × 51⅛ in
Paris, Mr. Javier Vilató

Lit:
Zervos XXXII, 4
Alberti 1971, p. 115, fig. 99
Gallwitz 1971, fig. 317

Exh:
Avignon 1970, No. 142

## 74.
**Couple au miroir**
**Couple in Front of a Mirror**

January 12, 1970
Crayon on board, 35.5 × 50.5 cm, 14 × 19⅞ in; signed and dated upper right: "12.1.70. Picasso"
Private Collection

Lit:
Zervos XXXII, 18
Sutherland Boggs 1973, p. 271, note 156 (as no. 10)

Exh:
Paris 1971, No. 10

## 75.
**Femme à l'oiseau**
**Woman with Bird**
(fig. 96 and plate 41)

January 14, 1970 (II)
Oil on canvas, 100 × 81 cm, 39¼ × 31¾ in
New York, The Pace Gallery

Lit:
Zervos XXXII, 29
Alberti 1971, fig. 105

Exh:
Avignon 1970, No. 159
New York 1981, p. 25

## 76.
**L'Étreinte**
**The Embrace**

March 20, 1970 (III)
Ink, 52.4 × 65.5 cm, 20⅝ × 25¾ in; signed and dated upper right: "20.3.70.III Picasso"
Paris, Galerie Louise Leiris
(Verso: L'Étreinte, Z. XXXII, 47)

Lit:
Zervos XXXII, 46

Exh:
Paris 1971, No. 17

## 76a.
**L'Étreinte**
**The Embrace**
(verso of 76)

March 20, 1970 (IV)
Ink, 52.4 × 65.5 cm, 20⅝ × 25¾ in; signed and dated upper right: "20.3.70.IV Picasso"
Paris, Galerie Louise Leiris
(Recto: L'Étreinte, Z. XXXII, 46)

Lit:
Zervos XXXII, 47

Exh:
Paris 1971, No. 17 bis

## 77.
**Nu couché et têtes de profil**
**Reclining Nude and Profiles**
(plate 43)

March 22, 1970 (II)
Ink, 52.4 × 65.6 cm, 20⅝ × 25¾ in; signed and dated upper left: "22.3.70.II Picasso"
Tokyo, Fuji Television Gallery Co., Ltd.

Lit:
Zervos XXXII, 50

Exh:
Paris 1971, No. 19

## 78.
**Deux nus debout et homme assis**
**Two Standing Nudes and Seated Man**

May 22, 1970
Ink on carton, 39.7 × 50.4 cm, 15⅝ × 19¾ in; signed and dated upper right: "22.5.70. Picasso"
Tokyo, Fuji Television Gallery Co., Ltd.

Lit:
Zervos XXXII, 81

Exh:
Paris 1971, No. 25

## 79.
**Cinq nus**
**Five Nudes**

May 30, 1970 (I)
Ink, 30.8 × 22.8 cm, 12⅛ × 9 in; signed and dated upper left: "Picasso 30.5.70.I"
Lucerne, Galerie Rosengart

Lit:
Zervos XXXII, 89

## 80.
**Nu couché et Arlequin**
**Reclining Nude and Harlequin**
(plate 44)

June 20, 1970 (VII)
Ink and colored crayons on board, 23.5 × 29.4 cm, 9¼ × 11⅝ in; signed and dated right center: "Picasso 20.6.70.VII"
Paris, Galerie Louise Leiris

Lit:
Zervos XXXII, 153
Sutherland Boggs 1973, p. 271, note 143 (as no. 70)

Exh:
Paris 1971, No. 70

**81.**
**Nu aux oiseaux**
**Nude with Birds**

August 2, 1970
Crayon, 33 × 50 cm, 13 × 19⅝ in; signed and
    dated upper right: "Domingo 2.8.70. Picasso"
Lucerne, Galerie Rosengart

**Lit:**
Zervos XXXII, 245

**Exh:**
Paris 1971, No. 144

**82.**
**La famille**
**The Family**
(fig. 120 and plate 45)

September 30, 1970
Oil on canvas, 162 × 130 cm, 63⅜ × 51⅛ in
Paris, Musée Picasso

**Lit:**
Zervos XXXII, 271
Alberti 1974, fig. 18
Geelhaar 1981, p. 62, fig. 62
Madrid/Barcelona 1981/82, p. 308

**Exh:**
Avignon 1973, No. 8
Paris 1979/80, No. 370
Basel 1981 (II), No. 49
Madrid/Barcelona 1981/82, No. 138

**83.**
**La famille**
**The Family**
(fig. 121 and plate 46)

September 30, 1970 (II), Mougins
Oil on canvas, 116 × 89 cm, 45⅜ × 34½ in
Paris, Collection Maya Ruiz Picasso

**Lit:**
Zervos XXXII, 272
Alberti 1974, fig. 16

**Exh:**
Avignon 1973, No. 9
London 1981, No. 126

**84.**
**Buste d'homme au chapeau**
**Man with a Big Hat**
(fig. 124 and plate 47)

November 23, 1970
Oil on canvas, 81 × 65 cm, 31¾ × 25⅝ in
Geneva, Collection Marina Picasso

**Lit:**
Zervos XXXII, 310
Char 1973, last page; reprinted in Schiff 1976,
    see p. 171, incl. note 1
Alberti 1974, fig. 186
Duncan 1975, p. 283, fig. p. 283
Daix 1977, p. 401, note 19

**Exh:**
Avignon 1973, No. 38
München etc. 1981/82, No. 277
Tokyo/Kyoto 1983, No. 204

**85.**
**Arlequin dans un fauteuil**
**Harlequin in an Armchair**

December 20, 1970 (V)
Crayon, 65 × 50 cm, 25⅝ × 19⅝ in; signed and
    dated upper left: "20.12.70.V Picasso"
Paris, Galerie Louise Leiris

**Lit:**
Zervos XXXII, 332

**Exh:**
Paris 1971, No. 165
Menton 1974, No. 14
New York 1980, No. 44
Cambridge, Mass. etc. 1981, No. 99

**86.**
**Peintre et modèle**
**Artist and Model**
(fig. 20)

January 25, 1971
Ink and chalk on green paper, 51.2 × 65 cm,
    20⅛ × 25⅝ in; signed lower right: "Picasso";
    dated upper right: "lundi 25.1.71."
Paris, Galerie Louise Leiris

**Lit:**
Zervos XXXIII, 32

**87.**
**Buste de femme**
**Bust of a Woman**
(plate 48)

June 26, 1971
Oil on canvas, 116 × 89 cm, 45⅜ × 34½ in
New York, The Pace Gallery

**Lit:**
Zervos XXXIII, 74
Alberti 1974, fig. 124

**Exh:**
Avignon 1973, No. 60
New York 1981, p. 42 No. 106

**88.**
**Buste d'homme écrivant**
**Bust of a Man Writing**
(fig. 50)

June 28, 1971 (II)
Oil on canvas, 116 × 89 cm, 45⅜ × 34½ in
Geneva, Galerie Jan Krugier

**Lit:**
Zervos XXXIII, 78
Alberti 1974, fig. 88
München etc. 1981/82, p. 412: in text by August
    Kaiser

**Exh:**
Avignon 1973, No. 78 (*Personnage au livre*)
München etc. 1981/82, No. 275 (*Sinnender mann
    mit Schreibheft. Personnage*)
Tokyo/Kyoto 1983, No. 205 (*Man in Thoughtful
    Mood at Desk*)

**89.**
**Homme nu couché**
**Nude Man Reclining**
(plate 49)

July 5, 1971 (II)
Oil on canvas, 89 × 116 cm, 34½ × 45⅜ in
Zürich, Thomas Amman Fine Art

**Lit:**
Zervos XXXIII, 88
Alberti 1974, fig. 104

**Exh:**
Avignon 1973, No. 76

**90.**
**Tête d'homme au béret**
**Head of a Man with Cap**

July 9, 1971
Oil on canvas, 81 × 65 cm, 31¾ × 25⅝ in
Paris, Collection Maya Ruiz Picasso

**Lit:**
Zervos XXXIII, 94
Alberti 1974, fig. 189
Palau i Fabre 1981, fig. 148

**Exh:**
Avignon 1973, No. 82
Basel 1981 (II), No. 56

**91.**
**Nu accroupi**
**Crouching Nude**
(fig. 118)

July 26, 1971 (II)
Oil on canvas, 116 × 89 cm, 45⅜ × 34½ in
Paloma Picasso-Lopez

**Lit:**
Zervos XXXIII, 118
Daix 1973, p. 13 (*Femme couchée*); fig. p. 15
Alberti 1974, fig. 161
Ponge/Descargues 1974, fig. p. 261 (*Femme
    couchée*)
Basel 1976, p. 158: in text by Franz Meyer
Daix 1977, p. 399; p. 401, note 13; fig. 160
    (*Femme couchée de dos*)

**Exh:**
Avignon 1973, No. 99 (*Femme couchée*)
New York 1981, p. 23 (*Femme couchée*)
Basel 1981 (II), No. 60

**92.**
**Tête d'homme**
**Head of a Man**
(fig. 60)

July 31, 1971 (II)
Oil on canvas, 73 × 60 cm, 28¾ × 24 in
Paris, Collection Maya Ruiz Picasso

**Lit:**
Zervos XXXIII, 129
Daix 1973, fig. p. 12
Alberti 1974, fig. 25
Daix 1977, p. 401, note 15 (as no. 107)

**Exh:**
Avignon 1973, No. 107

**93.**
**Homme et femme nus**
**Man and Woman**
(fig. 119 and plate 50)

August 18, 1971
Oil on canvas, 195 × 130 cm, 76¾ × 51⅛ in
From the Collection of Mr. and Mrs. Raymond
    D. Nasher

**Lit:**
Zervos XXXIII, 148
Alberti 1974, fig. 136

**Exh:**
Avignon 1973, No. 119
New York 1981, p. 11
Basel 1981 (II), No. 67

**94.**
**La cycliste**
**The Bicyclist**

August 25, 1971
Crayon and colored ink on carton, 31 × 22 cm,
    12⅛ × 8⅝ in; signed and dated: "25.8.71.
    Picasso"
Tokyo, Fuji Television Gallery Co., Ltd.

Lit:
Zervos XXXIII, 154

**95.**
**Homme à la flûte et enfant**
**Flute Player and Child**

September 1, 1971 (I)
Crayon on carton, 27.8 × 21.2 cm, 10⅞ × 8⅛
in; signed and dated upper left: "Picasso
1.9.71.I"
Tokyo, Fuji Television Gallery Co., Ltd.

Lit:
Zervos XXXIII, 162

**96.**
**Trois personnages**
**Three Figures**
(plate 51)

September 6, 1971
Oil on canvas, 130 × 162 cm, 51⅛ × 63⅜ in
New York, Acquavella Galleries, Inc.

Lit:
Zervos XXXIII, 169

Exh:
Avignon 1973, No. 126
New York 1981, p. 26

**97.**
**Nu allongé**
**Reclining Nude**

September 7, 1971
Oil on canvas, 130 × 195 cm, 51⅛ × 76¾ in
Switzerland, Mrs. Gilbert de Botton

Lit:
Zervos XXXIII, 170

Exh:
Avignon 1973, No. 127

**98.**
**Nu assis**
**Seated Nude**
(plate 52)

September 15, 1971 (II)
Oil on canvas, 116 × 89 cm, 45⅜ × 34½ in
New York, Collection Mr. and Mrs. Morton L.
  Janklow

Lit:
Zervos XXXIII, 192
Alberti 1974, fig. 109

Exh:
Avignon 1973, No. 133
New York 1981, p. 46
Basel 1981 (II), No. 69

**99.**
**Personnage à la pipe**
**Figure with Pipe**
(plate 53)

November 16, 1971
Oil on canvas, 130 × 97 cm, 51⅛ × 38 in
Geneva, Galerie Jan Krugier

Lit:
Zervos XXXIII, 230

**100.**
**Nu et homme assis**
**Nude and Seated Man**
(fig. 21)

December 1–6, 1971
India ink, crayon, and chalk, 50 × 66.2 cm, 19⅝
  × 26 in; dated right center: "Picasso 1.12.71.
  6.12.71."
Paris, Galerie Louise Leiris

Lit:
Zervos XXXIII, 252

Exh:
Paris 1972/73, No. 17

**101.**
**Femme nue et personnage assis**
**Nude Woman and Seated Man**

December 2, 1971
Ink, 43 × 54 cm, 17 × 21¼ in; signed and dated
  upper right: "2.12.71. Picasso"
Tokyo, Fuji Television Gallery Co., Ltd.

Lit:
Zervos XXXIII, 254

Exh:
Paris 1972/73, No. 19

**102.**
**Deux nus et trois hommes debout**
**Two Nudes and Three Men**

December 31, 1971
Ink, 50.5 × 66.5 cm, 19⅞ × 26⅛ in; signed and
  dated upper center: "Picasso 31.12.71."
New York, Saidenberg Gallery

Lit:
Zervos XXXIII, 259

Exh:
Paris 1972/73, No. 24

**103.**
**Mousquetaire assis**
**Seated Musketeer**
(plate 54)

January 19, 1972
Oil on canvas, 146 × 114 cm, 57½ × 44⅜ in
Paloma Picasso-Lopez

Lit:
Zervos XXXIII, 278
Alberti 1974, fig. 48

Exh:
Avignon 1973, No. 155
New York 1981, p. 35

**104.**
**Deux femmes**
**Two Women**

February 26, 27, 1972
Ink and gouache, 55.5 × 74.8 cm, 21¾ × 29⅜
  in; signed and dated lower right: "26.2.72. 27.
  Picasso"
Paris, Galerie Louise Leiris

Lit:
Zervos XXXIII, 327

**105.**
**Paysage**
**Landscape**
(plate 55)

Wednesday March 31, 1972
Oil on canvas, 130 × 162 cm, 51⅛ × 63⅜ in
Paris, Musée Picasso

Lit:
Zervos XXXIII, 331

Daix 1973, p. 13
Alberti 1974, fig. 63
Geelhaar 1981, p. 24, fig. 17

Exh:
Avignon 1973, No. 179
Paris 1979/80, No. 375
Minneapolis 1980, No. 160
London 1981, No. 129

**106.**
**Femme assise**
**Seated Woman**
(plate 29)

April 4, 1972
Gouache and ink on carton, 30.8 × 22 cm, 12⅛
  × 8⅝ in; signed lower right: "Picasso"
Tokyo, Fuji Television Gallery Co., Ltd.

Lit:
Zervos XXXIII, 333

Exh:
Paris 1972/73, No. 32

**107.**
**Le jeune peintre**
**The Young Painter**
(fig. 125 and frontispiece)

Friday April 14, 1972 (III)
Oil on canvas, 92 × 73 cm, 36¼ × 28¾ in
Paris, Musée Picasso

Lit:
Zervos XXXIII, 350
Char 1973; reprinted in Schiff 1976, see p. 169
Daix 1973, p. 13
Alberti 1974, fig. 166
Glozer 1974, pp. 195–196
Ponge/Descargues 1974, fig. p. 257
Duncan 1975, p. 284
Schiff 1976, p. 6, incl. note 10: in Introduction by
  Gert Schiff, pp. 1–25, fig. 40
Cabanne 1977, pp. 567–569
Daix 1977, p. 399; p. 401, note 18; fig. 162
Geelhaar 1981, p. 22, fig. 14

Exh:
Avignon 1973, No. 192
Paris 1979/80, No. 376

**108.**
**Nu couché et tête d'homme**
**Reclining Nude and Head of a Man**
(plate 56)

April 19, 1972 (II)
Ink, 49.3 × 64.5 cm, 19½ × 25⅜ in; signed and
  dated lower right: "Picasso 19.4.72.II"
Paris, Galerie Louise Leiris

Lit:
Zervos XXXIII, 355

Exh:
Paris 1972/73, No. 40
Menton 1974, No. 19

**109.**
**Portrait Mousquetaire**
**Portrait of a Musketeer**

April 27, 1972 (VI)
Ink, gouache, and colored crayons on carton, 27
  × 21.5 cm, 10⅝ × 8¼ in; signed upper right:
  "Picasso"; dated lower left: "27.4.72.VI"
Tokyo, Fuji Television Gallery Co., Ltd.

**Lit:**
Zervos XXXIII, 370

**Exh:**
Paris 1972/73, No. 53

**110.**
**Deux mousquetaires devant un verre**
**Two Musketeers with a Glass**

April 28, 1972
Ink and colored crayons on carton, 28.2 × 21.7
    cm, 11 × 8½ in; signed and dated lower left:
    "Picasso 28.4.72."
New York, Saidenberg Gallery

**Lit:**
Zervos XXXIII, 361

**Exh:**
Paris 1972/73, No. 54

**111.**
**Ecuyère et personnages**
**Equestrienne and Figures**
(plate 57)

May 12, 1972 (I)
Ink, 40 × 50 cm, 15¾ × 19⅝ in; dated upper
    left: "12.5.72.I"
Paris, Collection Maya Ruiz Picasso

**Lit:**
Zervos XXXIII, 383
München etc. 1981/82, p. 413

**112.**
**Musicien/Mousquetaire à la guitare**
**Musician/Musketeer with Guitar**
(plate 58)

May 26, 1972
Oil on canvas, 195 × 130 cm, 76¾ × 51⅛ in
Paris, Musée Picasso

**Lit:**
Zervos XXXIII, 397
Alberti 1974, pp. 35–36, fig. 190

**Exh:**
Avignon 1973, No. 200
Paris 1979/80, No. 377
London 1981, No. 130

**113.**
**Femme nue et mousquetaire**
**Nude Woman and Musketeer**

June 5, 1972 (I)
Crayon and ink, 29 × 22 cm, 11½ × 8⅝ in;
    signed and dated upper right: "5.6.72.I
    Picasso"
Tokyo, Fuji Television Gallery Co., Ltd.

**Lit:**
Zervos XXXIII, 407

**Exh:**
Paris 1972/73, No. 77

**114.**
**Nu debout et homme assis**
**Standing Nude and Seated Man**

June 19, 22, 1972
Ink and colored crayons, 30 × 22.8 cm, 11⅞ × 9
    in; signed and dated upper right: "Picasso
    lundi 19.6.72. 22."
Paris, Galerie Louise Leiris

**Lit:**
Zervos XXXIII, 428

**115.**
**Autoportrait**
**Self-Portrait**
(fig. 126, plate 60 and cover)

June 30, 1972
Crayon and colored crayons, 65.7 × 50.5 cm,
    25⅞ × 19⅞ in; signed lower left: "Picasso"
Tokyo, Fuji Television Gallery Co., Ltd.

**Lit:**
Zervos XXXIII, 435
Ponge/Descargues 1974, p. 253, fig. p. 254
Porzio/Valsecchi 1974, fig. p. 85
Cabanne 1977, p. 562
Daix 1977, pp. 396, 399, 400; note 20; fig. 163
Cambridge, Mass. etc. 1981, p. 234: In text by
    Gary Tinterow

**Exh:**
Paris 1972/73, No. 102

**116.**
**Tête d'homme**
**Head of a Man**

July 9, 1972
Crayon, 65.7 × 50.5 cm, 25⅞ × 19⅞ in; signed
    and dated upper left: "Dimanche 9.7.72.
    Picasso"
Tokyo, Fuji Television Gallery Co., Ltd.

**Lit:**
Zervos XXXIII, 450

**Exh:**
Paris 1972/73, No. 115

**117.**
**Buste de femme et quatre têtes d'hommes**
**Bust of a Woman and Four Male Heads**
(fig. 122)

July 23, 1972
Ink and gouache, 29.5 × 44 cm, 11⅝ × 17¼ in;
    signed and dated upper right: "23.7.72.
    Picasso"
Tokyo, Fuji Television Gallery Co., Ltd.

**Lit:**
Zervos XXXIII, 475

**Exh:**
Paris 1972/73, No. 140

**118.**
**Trois personnages et chien**
**Three Figures and Dog**
(fig. 123)

July 24, 1972
Ink and gouache, 29.8 × 44.2 cm, 11¾ × 17⅜
    in; signed and dated lower left: "24.7.72.
    Picasso"
Tokyo, Fuji Television Gallery Co., Ltd.

**Lit:**
Zervos XXXIII, 476

**Exh:**
Paris 1972/73, No. 141

**119.**
**Couple**
**Couple**

August 6, 1972 (III)
Ink, 47.7 × 69.5 cm, 18⅝ × 27⅜ in; signed and
    dated upper left: "Dimanche 6 Aout 1972. III
    Picasso"
Basel, Galerie Beyeler

**Lit:**
Zervos XXXIII, 494

**Exh:**
Paris 1972/73, No. 157
Basel 1981 (I), No. 120

**120.**
**Nu au verre et têtes**
**Nude with Glass and Heads**

August 18, 1972
Ink, 59 × 75.7 cm, 23½ × 29¾ in; signed and
    dated upper right: "Picasso. 18.8.72"
Tokyo, Fuji Television Gallery Co., Ltd.

**Lit:**
Zervos XXXIII, 507

**Exh:**
Paris 1972/73, No. 171

**121.**
**Mousquetaire à l'épée**
**Musketeer with Sword**

October 8, 1972
Ink and watercolor, 23.5 × 18 cm, 9¼ × 7⅞ in
Paris, Collection Maya Ruiz Picasso
(Verso: *Tête de mort*, Z. XXXIII, 517)

**Lit:**
Zervos XXXIII, 515

**121a.**
**Tête**
**Head**
(verso of 121)

October 8, 1972
India ink and watercolor, 23.5 × 18 cm, 9¼ ×
    7⅞ in; dated upper half: "8 octobre 1972."
Paris, Collection Maya Ruiz Picasso
(Recto: *Mousquetaire à l'épée*, Z. XXXIII, 515)

**Lit:**
Zervos XXXIII, 517

**122.**
**Mousquetaire à la guitare et tête de profil**
**Musketeer with Guitar and Head in Profile**
(plate 59)

November 4, 1972
Crayon on board, 32.5 × 50 cm, 12¾ × 19⅝ in;
    dated: "4.11.72."
Paris, Musée Picasso

**Lit:**
Zervos XXXIII, 529

**123.**
**Profil aux mains jointes, tête et colombe**
**Profile with Folded Hands, Head and Pigeon**

November 12, 1972
India ink on board, 32.5 × 50 cm, 12¾ × 19⅝
    in; dated upper left: "12.11.72."
Paris, Collection Maya Ruiz Picasso

**Lit:**
Zervos XXXIII, 532

## Early Graphics, 1963–1967: 124–137

**124.**
**L'Étreinte**
**The Embrace**

October 23, 1963 (I)
Aquatint, 32 × 42 cm, 12⅝ × 16½ in
Paris, Galerie Louise Leiris

**Lit:**
Bloch No. 1115
Rodriguez-Aguilera 1975, p. 228, fig. 557
Cabanne 1977, p. 517
Daix 1977, p. 392

**Exh:**
Barcelona 1968, No. 24
Hannover 1973, No. 235
Barcelona 1979, No. 31

**125.**
**Dans l'atelier**
**In the Studio**

November 8, 1963
Aquatint and etching, 32 × 42 cm, 12⅝ × 16½ in
Paris, Galerie Louise Leiris

**Lit:**
Bloch No. 1123
Rodriguez-Aguilera 1975, p. 229, fig. 576
Daix 1977, p. 392; p. 394, note 11

**Exh:**
Barcelona 1968, No. 30
Baden-Baden 1969, No. 209
Paris 1982, No. 166

**126.**
**Étreinte**
**Embrace**

November 23, 1963 (II)
Aquatint, etching, and drypoint, 32 × 42 cm, 12⅝ × 16½ in
Paris, Galerie Louise Leiris

**Lit:**
Bloch No. 1135
Daix 1977, p. 392; p. 394, note 8

**Exh:**
Barcelona 1968, No. 38
Barcelona 1979, No. 32

**127.**
**Dans l'atelier**
**In the Studio**

November 27, 1963
Burin and aquatint, 23.5 × 33.5 cm, 9¼ × 13¼ in
Paris, Galerie Louise Leiris

**Lit:**
Bloch No. 1138
Museo Picasso 1971, p. 132
Rodriguez-Aguilera 1975, p. 229, fig. 586
Green 1981, pp. 16, 40 (as No. 72)

**Exh:**
Barcelona 1968, No. 40
Vienna 1968, No. 241
Baden-Baden 1969, No. 219
Paris 1982, No. 172

**128.**
**Le peintre et son modèle**
**The Artist and His Model**

December 5, 1963
Aquatint, drypoint, and burin, 38 × 50 cm, 15 × 19⅝ in
Paris, Galerie Louise Leiris

**Lit:**
Bloch No. 1141
Museo Picasso 1971, p. 132

Rodriguez-Aguilera 1975, p. 229, fig. 589
Daix 1977, p. 392; p. 394, note 9

**Exh:**
Baden-Baden 1969, No. 221
Stuttgart 1981, No. 329
Paris 1982, No. 171

**129.**
**Peintre au travail**
**Artist at Work**
(fig. 17)

February 3, 1964 (III)
Aquatint, etching and drypoint, 32.5 × 47.5 cm, 12¾ × 18⅝ in
Paris, Galerie Louise Leiris

**Lit:**
Bloch No. 1157
Museo Picasso 1971, p. 134
Rodriguez-Aguilera 1975, p. 229, fig. 595
Baumann 1976, p. 192, fig. 383

**Exh:**
Baden-Baden 1969, No. 227

**130.**
**Fumeur**
**Smoker**

September 7, 1964 (III)
Aquatint and etching, 42 × 32 cm, 16½ × 12⅝ in
Paris, Galerie Louise Leiris

**Lit:**
Bloch No. 1175
Bolliger 1967, p. 68
Museo Picasso 1971, p. 136
Rodriguez-Aguilera 1975, p. 226, fig. 414
Cabanne 1977, p. 523
Daix 1977, p. 392; p. 394, note 13
Green 1981, pp. 6, 16, 23

**Exh:**
Vienna 1968, No. 248

**131.**
**Le sculpteur**
**The sculptor**

February 26–27, 1965 (II)
Aquatint and burin, 39 × 28 cm, 15⅜ × 11 in
Paris, Galerie Louise Leiris

**Lit:**
Bloch No. 1196
Bolliger 1967, p. 58
Fermigier 1969, fig. 250
Museo Picasso 1971, p. 136
Rodriguez-Aguilera 1975, p. 229, fig. 603
Baumann 1976, p. 192, fig. 386
Daix 1977, p. 392; p. 395, note 14

**Exh:**
Baden-Baden 1969, No. 235
Hannover 1973, No. 246a
Paris 1982, No. 176
Mexico 1982/83, No. 171

**132.**
**Dans l'atelier**
**In the Studio**
(fig. 18)

March 14, 1965 (II)
Aquatint and drypoint, 25 × 38.5 cm, 9⅞ × 15⅛ in
Paris, Galerie Louise Leiris

**Lit:**
Bloch No. 1223
Museo Picasso 1971, p. 139
Rodriguez-Aguilera 1975, p. 229, fig. 618
Daix 1977, p. 392; p. 395, note 15

**Exh:**
Vienna 1968, No. 255
Baden-Baden 1969, No. 251
Hannover 1973, No. 250

**133.**
**Modèle au fume-cigarette**
**Model with Cigarette-holder**

October 22, 1966 (II)
Etching and aquatint, 27.5 × 38 cm, 10¾ × 15 in
Paris, Galerie Louise Leiris

**Lit:**
Bloch No. 1382
Museo Picasso 1971, p. 141
Rodriguez-Aguilera 1975, p. 230, fig. 634

**134.**
**Trois personnages**
**Three Figures**

October 22, 1966 (III)
Etching and aquatint, 28 × 39 cm, 11 × 15⅜ in
Paris, Galerie Louise Leiris

**Lit:**
Bloch No. 1384
Museo Picasso 1971, p. 142
Rodriguez-Aguilera 1975, p. 228, fig. 547

**135.**
**Susanne et les vieillards**
**Susanna and the Elders**

October 25, 1966 (IV)
Etching and aquatint, 27.5 × 38 cm, 10¾ × 15 in
Paris, Galerie Louise Leiris

**Lit:**
Bloch No. 1390
Museo Picasso 1971, p. 142
Elgar/Maillard 1972, p. 162
Rodriguez-Aguilera 1975, p. 228, fig. 549

**136.**
**Femme assise dans un fauteuil**
**Seated Woman**
(fig. 29)

October 26, 27, 1966 (IV)
Etching, drypoint, and aquatint, 47.5 × 32.5 cm, 18⅝ × 12¾ in
Paris, Galerie Louise Leiris

**Lit:**
Bloch No. 1394
Museo Picasso 1971, p. 143
Rodriguez-Aguilera 1975, p. 228, fig. 534

**137.**
**Vénus foraine**
**Fairground Venus**

December 5, 1966 (III)
Etching and drypoint, 32 × 42 cm, 12⅝ × 16½ in
Paris, Galerie Louise Leiris

**Lit:**
Bloch No. 1232
Karlsruhe/Frankfurt am Main 1974/75, p. 89
Rodriguez-Aguilera 1975, p. 228, fig. 535
Green 1981, p. 53

**Exh:**
Barcelona 1968, No. 60
Hannover 1973, No. 253
Karlsruhe/Frankfurt am Main 1974/75, No. 183

## Suite 347: 138–170

**138.**
(fig. 70)

March 16–22, 1968 (I)
Etching, 39.5 × 56.5 cm, 15½ × 22¼ in
New York, Reiss-Cohen, Inc.

**Lit:**
Leiris No. 1
Bloch No. 1481; Vol. IV, p. 20, in: Introduction by
    Felix Andreas Baumann
Dufour 1969, p. 118, fig. p. 118
Crommelynck 1970, p. 20, fig. 1
Leymarie 1971, fig. p. 151
Museo Picasso 1971, p. 146
Sutherland Boggs 1973, p. 233, fig. 381
Glozer 1974, p. 183
Baumann 1976, p. 201, fig. 393
Schiff 1976, fig. 2
New York 1980: in "Prints and Illustrated Books"
    by Alexandra Schwartz, incl. fig.
Häsli 1981, pp. 72–76, fig. 63
Green 1981, pp. 16, 54 (as No. 109)
Skedsmo 1981
Washington 1981/82, p. 20: in Introduction by
    E. A. Carmean, Jr.
Perucchi 1981, p. 125, note 4

**Exh:**
Hannover 1973, No. 256
New York 1980, Nos. 141–144 (Prints and
    Illustrated Books)
London 1981, No. 439
Basel 1981 (II), No. G 11
Washington 1981/82, No. 97
Mexico 1982/83, No. 172

**139.**

March 24, 1968 (II)
Etching, 42.5 × 34.5 cm, 16¾ × 13½ in
New York, Courtesy Pace Master Prints

**Lit:**
Leiris No. 6
Bloch No. 1486
Crommelynck 1970, fig. 6
Museo Picasso 1971, p. 146
Green 1981, p. 6 (as No. 74)
Skedsmo 1981

**Exh:**
Hannover 1973, No. 258

**140.**

April 8, 1968
Aquatint, 32 × 47 cm, 12⅝ × 18½ in
New York, Reiss-Cohen, Inc.

**Lit:**
Leiris No. 20
Bloch No. 1500
Crommelynck 1970, fig. 20
Museo Picasso 1971, p. 148

**141.**

April 8, 1968 (II)
Etching, 31.5 × 41.5 cm, 12⅜ × 16⅜ in
New York, Reiss-Cohen, Inc.

**Lit:**
Leiris No. 21
Bloch No. 1501
Crommelynck 1970, fig. 21
Museo Picasso 1971, p. 148

**142.**
(fig. 73)

April 11, 1968 (II)
Etching, 31.5 × 41.5 cm, 12⅜ × 16⅜ in
New York, Reiss-Cohen, Inc.

**Lit:**
Leiris No. 25
Bloch No. 1505
Crommelynck 1970, fig. 25
Museo Picasso 1971, p. 148

**Exh:**
Hannover 1973, No. 265

**143.**

April 27 (I), 28, 1968
Etching, 28 × 39 cm, 11 × 15⅜ in
New York, Reiss-Cohen, Inc.

**Lit:**
Leiris No. 55
Bloch No. 1535
Crommelynck 1970, fig. 55
Museo Picasso 1971, p. 151

**Exh:**
Basel 1981 (II), No. G 20

**144.**

April 28, 1968 (II)
Etching, 28 × 39 cm, 11 × 15⅜ in
New York, Courtesy Pace Master Prints

**Lit:**
Leiris No. 56
Bloch No. 1536
Crommelynck 1970, fig. 56
Museo Picasso 1971, p. 151
Green 1981, pp. 16, 54

**Exh:**
Hannover 1973, No. 269
Stuttgart 1981, No. 362

**145.**

April 29, 1968 (I)
Aquatint, etching, 28 × 39 cm, 11 × 15⅜ in
New York, Reiss-Cohen, Inc.

**Lit:**
Leiris No. 57
Bloch No. 1537
Crommelynck 1970, fig. 57
Museo Picasso 1971, p. 152

**146.**
(fig. 79)

May 5, 1968 (II)
Etching, 32.5 × 40 cm, 12¾ × 15¾ in
New York, Reiss-Cohen, Inc.

**Lit:**
Leiris No. 65
Bloch No. 1545
Crommelynck 1970, fig. 65
Museo Picasso 1971, p. 152
Geelhaar 1981, p. 32, note 77; fig. 25

**Exh:**
Basel 1981 (II), No. G 21

**147.**
(fig. 71)

May 13, 1968
Etching, 41.5 × 49.5 cm, 16⅜ × 19½ in
New York, Reiss-Cohen, Inc.

**Lit:**
Leiris No. 81
Bloch No. 1561
Crommelynck 1970, fig. 81
Museo Picasso 1971, p. 154

**Exh:**
Hannover 1973, No. 271
New York 1980, p. 458
Basel 1981 (II), No. G 25

**148.**
(fig. 66)

May 14, 1968 (III)
Etching, 29.5 × 34.5 cm, 11⅝ × 13½ in
New York, Reiss-Cohen, Inc.

**Lit:**
Leiris No. 85
Bloch No. 1565
Crommelynck 1970, fig. 85
Museo Picasso 1971, p. 154

**149.**
(fig. 67)

May 15, 1968 (II)
Aquatint, 29.5 × 34.5 cm, 11⅝ × 13½ in
New York, Reiss-Cohen, Inc.

**Lit:**
Leiris No. 87
Bloch No. 1567
Crommelynck 1970, fig. 87
Museo Picasso 1971, p. 155

**Exh:**
Hannover 1973, No. 272
Basel 1981 (II), No. G 27

**150.**

May 25, 1968 (I)
Aquatint, 30 × 34.5 cm, 11¾ × 13½ in
New York, Reiss-Cohen, Inc.

**Lit:**
Leiris No. 109
Bloch No. 1589
Crommelynck 1970, fig. 109
Museo Picasso 1971, p. 157

**Exh:**
Hannover 1973, No. 275
Basel 1981 (II), No. G 31

**151.**

May 25, 1968 (II)
Aquatint, drypoint, 23.5 × 33 cm, 9½ × 13 in
New York, Reiss-Cohen, Inc.

**Lit:**
Leiris No. 110
Bloch No. 1590
Crommelynck 1970, fig. 110
Museo Picasso 1971, p. 157
Barr-Sharrar 1972, pp. 518, 528 (incl. note 48);
    fig. 12
Geelhaar 1981, p. 35; p. 35, note 84; p. 44,
    note 111

**152.**
(fig. 76)

May 28, 1968
Aquatint, 49.5 × 33.5 cm, 19½ × 13¼ in
New York, Reiss-Cohen, Inc.

**Lit:**
Leiris No. 123
Bloch No. 1604
Crommelynck 1970, fig. 123
Museo Picasso 1971, p. 158
Schiff 1976, p. 164
Washington 1981/82, p. 20: in Introduction by
    E. A. Carmean, Jr.

**Exh:**
Basel 1981 (II), No. G 35
Washington 1981/82, No. 98

**153.**

June 1, 1968 (I)
Aquatint, 33.5 × 49.5 cm, 13¼ × 19½ in
New York, Reiss-Cohen, Inc.

**Lit:**
Leiris No. 134
Bloch No. 1614
Crommelynck 1970, fig. 134
Museo Picasso 1971, p. 159

**154.**
(fig. 78)

June 1, 1968 (II)
Etching, 41.5 × 49 cm, 16¼ × 19¼ in
New York, Reiss-Cohen, Inc.

**Lit:**
Leiris No. 135
Bloch No. 1615
Crommelynck 1970, fig. 135
Leymarie 1971, fig. p. 166
Museo Picasso 1971, p. 159
Washington 1981/82, p. 20: in Introduction by
    E. A. Carmean, Jr.

**Exh:**
Basel 1981 (II), No. G 37
Washington 1981/82, No. 99

**155.**

June 3, 1968 (I)
Etching, aquatint, 22 × 29 cm, 8⅝ × 11½ in
New York, Reiss-Cohen, Inc.

**Lit:**
Leiris No. 139
Bloch No. 1619
Crommelynck 1970, fig. 139
Museo Picasso 1971, p. 160

**156.**

June 22, 1968 (II)
Aquatint, 20.5 × 15 cm, 8 × 6 in
New York, Reiss-Cohen, Inc.

**Lit:**
Leiris No. 179
Bloch No. 1659
Crommelynck 1970, fig. 179
Museo Picasso 1971, p. 164

**157.**
(fig. 81)

June 26, 1968 (I)
Aquatint, 9 × 12.5 cm, 3½ × 5 in
New York, Reiss-Cohen, Inc.

**Lit:**
Leiris No. 188
Bloch No. 1668
Crommelynck 1970, fig. 188
Museo Picasso 1971, p. 165
De Rojas 1971, fig. p. 179
Schiff 1976, pp. 166–167, fig. 34
Geelhaar 1981, p. 20 (incl. note 36)
Skedsmo 1981

**158.**
(fig. 99)

June 26, 1968 (VI)
Aquatint, drypoint, 15 × 20.5 cm, 6 × 8 cm
New York, Reiss-Cohen, Inc.

**Lit:**
Leiris No. 193
Bloch No. 1673
Crommelynck 1970, fig. 193
Museo Picasso 1971, p. 165

**159.**
(fig. 68)

July 27, 1968 (III)
Etching, 31.5 × 31.5 cm, 12⅜ × 12⅜ in
New York, Reiss-Cohen, Inc.

**Lit:**
Leiris No. 221
Bloch No. 1701
Crommelynck 1970, fig. 221
Museo Picasso 1971, p. 168
Green 1981, pp. 6, 54

**160.**
(fig. 69)

July 28, 1968 (I)
Aquatint, 32 × 31.5 cm, 12⅝ × 12⅝ in
New York, Reiss-Cohen, Inc.

**Lit:**
Leiris No. 223
Bloch No. 1703
Crommelynck 1970, fig. 223
Museo Picasso 1971, p. 168

**161.**

August 5, 1968 (VI)
Etching, 31.5 × 31.5 cm, 12⅜ × 12⅜ in
New York, Reiss-Cohen, Inc.

**Lit:**
Leiris No. 251
Bloch No. 1731
Crommelynck 1970, fig. 251
Museo Picasso 1971, p. 171

**162.**

August 9, 1968 (III)
Etching, 26.5 × 21 cm, 10⅜ × 8¼ in
New York, Courtesy Pace Master Prints

**Lit:**
Leiris No. 262
Bloch No. 1742
Crommelynck 1970, fig. 262
Museo Picasso 1971, p. 172

**163.**
(fig. 100)

August 18, 1968 (III)
Etching, 15.5 × 20.5 cm, 6⅛ × 8 in
New York, Reiss-Cohen, Inc.

**Lit:**
Leiris No. 284
Bloch No. 1764
Crommelynck 1970, fig. 284
Museo Picasso 1971, p. 174

**164.**

August 20, 1968 (I)
Etching, 28 × 39 cm, 11 × 15¾ in
New York, Reiss-Cohen, Inc.

**Lit:**
Leiris No. 289
Bloch No. 1769
Crommelynck 1970, fig. 289
Leymarie 1971, fig. p. 282
Museo Picasso 1971, p. 175
Schiff 1976, p. 18, note 68: in Introduction by
    Gert Schiff, pp. 1–25
Geelhaar 1981, p. 52, fig. 54

**Exh:**
Hannover 1973, No. 280
Basel 1981 (II), No. G 42

**165.**
(fig. 83)

August 29, 1968 (I)
Etching, 28 × 39 cm, 11 × 15⅜ in
New York, Reiss-Cohen, Inc.

**Lit:**
Leiris No. 296
Bloch No. 1776
Crommelynck 1970, fig. 296
Museo Picasso 1971, p. 176
Otero 1974, p. 178
Schiff 1976, p. 18, note 68: in Introduction by
    Gert Schiff, pp. 1–25
Geelhaar 1981, p. 20, note 41

**Exh:**
Barcelona 1979, No. 34

**166.**
(fig. 84)

September 1, 1968 (III)
Etching, 15 × 20.5 cm, 6 × 8 in
New York, Reiss-Cohen, Inc.

**Lit:**
Leiris No. 303
Bloch No. 1783
Crommelynck 1970, fig. 303
Museo Picasso 1971, p. 176
Otero 1974, p. 178
Schiff 1976, p. 18, note 68: in Introduction by
    Gert Schiff, pp. 1–25
Cabanne 1977, p. 543
Geelhaar 1981, p. 20, fig. 10

**Exh:**
Barcelona 1979, No. 41
Basel 1981 (II), No. G 46

**167.**
(fig. 85)

September 4, 1968 (I)
Etching, 15 × 20.5 cm, 6 × 8 in
New York, Reiss-Cohen, Inc.

**Lit:**
Leiris No. 310
Bloch No. 1790
Crommelynck 1970, fig. 310
Museo Picasso 1971, p. 177
Otero 1974, p. 178

Schiff 1976, p. 18, note 68: in Introduction by
   Gert Schiff, pp. 1–25
Geelhaar 1981, pp. 20, 46; p. 46, note 121

**Exh:**
Barcelona 1979, No. 48

**168.**
(fig. 86)

September 4, 1968 (III)
Etching, 15 × 20.5 cm, 6 × 8 in
New York, Reiss-Cohen, Inc.

**Lit:**
Leiris No. 312
Bloch No. 1792
Crommelynck 1970, fig. 312
Museo Picasso 1971, p. 177
Otero 1974, p. 178
Schiff 1976, p. 18, note 68: in Introduction by
   Gert Schiff, pp. 1–25
Geelhaar 1981, pp. 20, 46, 48, 50; p. 46, note
   121; p. 50, note 132

**Exh:**
Barcelona 1979, No. 50

**169.**

September 26, 1968 (IV)
Etching, 21 × 26.5 cm, 8¼ × 10½ in
New York, Reiss-Cohen, Inc.

**Lit:**
Leiris No. 339
Bloch No. 1819
Crommelynck 1970, fig. 339
Museo Picasso 1971, p. 180
Sutherland Boggs 1973, p. 234, fig. 379

**170.**

September 28, 1968 (I)
Etching, 21 × 26.5 cm, 8¼ × 10½ in
New York, Reiss-Cohen, Inc.

**Lit:**
Leiris No. 342
Bloch No. 1822
Crommelynck 1970, fig. 342
Museo Picasso 1971, p. 180
Barr-Sharrar 1972, p. 528, fig. 24
Steinberg 1972, p. 105, note 12
Schiff 1976, p. 167: in "Picasso's *Suite 347*, or
   Painting as an Act of Love" by Gert Schiff, pp.
   163–167. (Slightly revised from "Woman as
   Sex Object,": *Art News Annual 1972*, edited
   by Thomas B. Hess and Linda Nochlin)
Skedsmo 1981

## *156 Last Etchings:* 171–191

**171.**
(fig. 108)

February 3 (II) and March 5, 6, 1970
Etching, aquatint, scraper, 50 × 42 cm, 19⅝ ×
   16½ in
Courtesy Liza & Mike Moses

**Lit:**
Leiris No. 10
Bloch No. 1865
Geelhaar 1978, p. 289 (as No. 10)
Geelhaar 1981, fig. 1

**Exh:**
New York 1980, p. 458
Basel 1981 (II), No. G 51

**172.**

February 19, 1970
Etching, 51 × 64 cm, 20⅛ × 25⅛ in
Paris, Galerie Louise Leiris

**Lit:**
Leiris No. 16
Bloch No. 1871

**Exh:**
Basel 1981 (II), No. G 53

**173.**

March 11, 1970
Etching, 32 × 42 cm, 12⅝ × 16½ in
New York, Courtesy Pace Master Prints

**Lit:**
Leiris No. 19
Bloch No. 1874
Geelhaar 1978, p. 289 (as No. 19)

**Exh:**
Basel 1981 (II), No. G 54

**174.**
(fig. 106)

April 14, 1970
Etching, 51 × 54 cm, 20⅛ × 21¼ in
New York, Aldis Browne Fine Arts

**Lit:**
Leiris No. 35
Bloch No. 1890

**Exh:**
Basel 1981 (II), No. G 56

**175.**
(fig. 107)

April 19, 20, 1970
Etching, 37 × 49.5 cm, 14½ × 19½ in
New York, Aldis Browne Fine Arts

**Lit:**
Leiris No. 36
Bloch No. 1891
Perucchi 1978

**Exh:**
Basel 1981 (II), No. G 57

**176.**
(fig. 97)

May 11, 1970 (II)
Etching, 27.5 × 35 cm, 10¾ × 13¾ in
New York, Courtesy Pace Master Prints

**Lit:**
Leiris No. 44
Bloch No. 1899

**177.**

May 13, 1970
Etching, 27.5 × 35 cm, 10¾ × 13¾ in
New York, Courtesy Pace Master Prints

**Lit:**
Leiris No. 48
Bloch No. 1903

**178.**

May 23, 1970
Etching, 27.5 × 35 cm, 10¾ × 13¾ in
New York, Courtesy Sindin Galleries

**Lit:**
Leiris No. 54
Bloch No. 1909

**179.**

February 25, 1971
Etching, 21 × 15 cm, 8⅛ × 6 in
Paris, Galerie Louise Leiris

**Lit:**
Leiris No. 58
Bloch No. 1913
Gedo 1980, fig. p. 257
Geelhaar 1981, p. 20 (incl. note 35)

**180.**

March 3, 1971 (IV)
Etching, 15 × 21 cm, 6 × 8⅛ in
New York, Courtesy Pace Master Prints

**Lit:**
Leiris No. 63
Bloch No. 1918
Daix 1977, p. 401, note 11
Geelhaar 1981, p. 50; p. 50, note 134; fig. 56

**Exh:**
Basel 1981 (II) No. G 60

**181.**

March 19 (II), 20–22, 1971
Etching, 37 × 49.5 cm, 14½ × 19½ in
New York, Aldis Browne Fine Arts

**Lit:**
Leiris No. 91
Bloch No. 1946
Cabanne 1973, pp. 149–150
Rubin/Esterow 1973, p. 42
Cabanne 1977, pp. 555–556
Daix 1977, p. 398
Perucchi 1981, pp. 127, 129; fig. 495

**Exh:**
Basel 1981 (II), No. G 68

**182.**
(fig. 111)

April 1, 1971 (II)
Etching, 23 × 31 cm, 9 × 12⅛ in
New York, Aldis Browne Fine Arts

**Lit:**
Leiris No. 105
Bloch No. 1960
Cabanne 1973, pp. 149–150
Rubin/Esterow 1973, p. 42
Cabanne 1977, pp. 555–556
Daix 1977, p. 398

**183.**
(fig. 112)

April 4, 1971
Etching, 37 × 50 cm, 14½ × 19⅝ in
New York, Courtesy Sindin Galleries

**Lit:**
Leiris No. 109
Bloch No. 1964
Cabanne 1973, pp. 149–150, fig. 149
Rubin/Esterow 1973, p. 42
Cabanne 1977, pp. 555–556
Daix 1977, p. 398
Perucchi 1978, incl. fig.
Geelhaar 1981, p. 46, fig. 44
Perucchi 1981, p. 127

**Exh:**
Basel 1981 (II), No. G 70

**184.**
April 9, 1971
Etching, 37 × 50 cm, 14½ × 19⅝ in
New York, Aldis Browne Fine Arts

**Lit:**
Leiris No. 111
Bloch No. 1966
Cabanne 1973, pp. 149–150
Rubin/Esterow 1973, p. 42
Cabanne 1977, pp. 555–556
Daix 1977, p. 398

**185.**
(fig. 114)
April 11, 1971
Etching, 37 × 50 cm, 14½ × 19⅝ in
New York, Aldis Browne Fine Arts

**Lit:**
Leiris No. 113
Bloch No. 1968
Cabanne 1973, pp. 149–150
Rubin/Esterow 1973, p. 42
Cabanne 1977, pp. 555–556
Daix 1977, p. 398

**Exh:**
Basel 1981 (II), No. G 72

**186.**
(fig. 110)
May 1–4, 1971
Drypoint, scraper, 37 × 50 cm, 14½ × 19⅝ in
Paris, Galerie Louise Leiris

**Lit:**
Leiris No. 117
Bloch No. 1972
Cabanne 1973, pp. 149–150

Rubin/Esterow 1973, p. 42
Cabanne 1977, p. 555–556
Daix 1977, p. 398
Geelhaar 1981, p. 46, fig. 47

**Exh:**
Basel 1981 (II), No. G 75

**187.**
May 5 (II), 6, 1971
Etching, 37 × 50 cm, 14½ × 19⅝ in
New York, Courtesy Pace Master Prints

**Lit:**
Leiris No. 120
Bloch No. 1975
Cabanne 1973, pp. 149–150
Rubin/Esterow 1973, p. 42
Cabanne 1977, pp. 555–556
Daix 1977, p. 398
Geelhaar 1981, p. 50; p. 50, note 133

**188.**
May 14, 1971
Etching, 37 × 50 cm, 14½ × 19⅝ in
Paris, Galerie Louise Leiris

**Lit:**
Leiris No. 126
Bloch No. 1981
Cabanne 1973, pp. 149–150
Rubin/Esterow 1973, p. 42
Cabanne 1977, pp. 555–556
Daix 1977, p. 398

**189.**
May 17, 18, 1971
Etching, 37 × 50 cm, 14½ × 19⅝ in
New York, Courtesy Pace Master Prints

**Lit:**
Leiris No. 129
Bloch No. 1984

Cabanne 1973, pp. 149–150
Rubin/Esterow 1973, p. 42
Cabanne 1977, pp. 555–556
Daix 1977, p. 398
Geelhaar 1981, pp. 46, 48, 50; p. 50, note 132;
fig. 50

**Exh:**
Basel 1981 (II), No. G 78

**190.**
May 19, 21, 23, 24, 26, 30, 31, June 2, 1971
Aquatint, drypoint, and scraper, 37 × 50 cm,
14½ × 19⅝ in
Paris, Galerie Louise Leiris

**Lit:**
Leiris No. 130
Bloch No. 1985
Cabanne 1973, pp. 150–151, fig. p. 150–151
Rubin/Esterow 1973, p. 42
Cabanne 1977, pp. 555–556
Daix 1977, p. 398
Geelhaar 1981, pp. 48, 50; p. 50, note 132

**191.**
May 20, 1971
Etching, 37 × 50 cm, 14½ × 19⅝ in
New York, Courtesy Pace Master Prints

**Lit:**
Leiris No. 131
Bloch No. 1986
Cabanne 1973, pp. 149–150
Rubin/Esterow 1973, p. 42
Cabanne 1977, pp. 555–556
Daix 1977, p. 398
Geelhaar 1981, pp. 46, 48, 50; p. 50, note 132;
fig. 51

**Exh:**
Basel 1981 (II), No. G 79

# Abbreviated References

## Selected Bibliography

**Alberti 1971**
Alberti, Rafael. *Picasso en Avignon. Commentaires à une peinture en mouvement.* Paris: Éditions Cercle d'Art, 1971.

**Alberti 1974**
———. *Picasso, le rayon ininterrompu.* Paris: Éditions Cercle d'Art, 1974.

**Ashton 1972**
Ashton, Dore. *Picasso on Art: A Selection of Views.* New York: Viking Press, 1972.

**Barr-Sharrar 1972**
Barr-Sharrar, Beryl. "Some Aspects of Early Autobiographical Imagery in Picasso's 'Suite 347'." *The Art Bulletin,* vol. LIV, no. 4 (December 1972), pp. 516–539.

**Baumann 1976**
Baumann, Felix Andreas. *Pablo Picasso: Leben und Werk.* Stuttgart: Verlag Gerd Hatje, 1976.

**Bloch**
Bloch, Georges. *Pablo Picasso. Catalogue of the Printed Graphic Work 1904–1967.* Vol. I. Établi à l'occasion de l'Exposition au Musée des Beaux-Arts de Zürich, Juin–Août 1968. Bern: Éditions Kornfeld et Klipstein, 1968.

———. *Pablo Picasso, Catalogue of the Printed Graphic Work 1966–1969.* Vol. II. Bern: Éditions Kornfeld et Klipstein, 1971.

———. *Pablo Picasso. Catalogue of the Printed Graphic Work 1970–1972.* Vol. IV. Bern: Éditions Kornfeld et Klipstein, 1979.

**Bolliger 1967**
Bolliger, Hans. *Picasso. Graphic Works 1955–1965.* Introduction by Kurt Leonhard. London: Thames and Hudson, 1967.

**Cabanne 1973**
Cabanne, Pierre. "Degas chez Picasso." *Connaissance des Arts,* No. 262 (December 1973), pp. 146–151.

**Cabanne 1977**
———. *Pablo Picasso. His Life and Times.* New York: William Morrow and Company, 1977.

**Char 1973**
Char, René. *Picasso under the Etesian Winds.* Preface to the exhibition catalog *Picasso 1970–1972, 201 peintures, du 23 mai au 23 septembre 1973;* Palais des Papes, Avignon. In

*Picasso in Perspective*, edited by Gert Schiff, pp. 168–171. Englewood Cliffs, N.J.: Prentice-Hall, 1976.

**Crommelynck 1970**
Crommelynck, Piero, and Aldo. *Picasso 347.* Vols. I, II. New York: Random House/Maecenas Press, 1970.

**Daix 1973**
Daix, Pierre. "L'arrière-saison de Picasso ou l'art de rester à l'avant-garde." In *XXe siècle*, No. 41 (December 1973), pp. 10–16. Partly reprinted in *A Picasso Anthology: Documents, Criticism, Reminiscences*, edited by Marilyn McCully, pp. 274–277. Princeton, N.J.: Princeton University Press, 1982.

**Daix 1977**
———. *La vie de peintre de Pablo Picasso.* Paris: Éditions du Seuil, 1977.

**Dufour 1969**
Dufour, Pierre. *Picasso 1950–1968. Étude biographique et critique.* Geneva: Éditions d'art Albert Skira, 1969.

**Duncan 1975**
Duncan, David Douglas. *Goodbye Picasso.* New York: Grosset & Dunlap, 1975.

**Elgar/Maillard 1972**
Elgar, Frank, and Maillard, Robert. *Picasso. Study of His Work; Biographical Study.* rev. ed. New York: Tudor Publishing Company, 1972.

**Feld 1969**
Feld, Charles. *Picasso. Dessins 27.3.66–15.3.68.* Preface by René Char. Paris: Éditions Cercle d'Art, 1969.

**Fermigier 1969**
Fermigier, André. *Picasso.* Paris: Livre de Poche, 1969.

**Gallwitz 1971**
Gallwitz, Klaus. *Picasso Laureatus. Sein malerisches Werk seit 1945.* Essay by José Bergamín. Lucerne and Frankfurt am Main: Verlag C. J. Bucher, 1971.

**Gallwitz 1981/82**
———. "Zum Spätwerk Picassos." In *Pablo Picasso. Eine Ausstellung zum hundertsten Geburtstag. Werke aus der Sammlung Marina Picasso.* Haus der Kunst, München; Köln; Frankfurt am Main; Zürich, February 14, 1981–March 28, 1982.

**Gedo 1980**
Gedo, Mary Mathews. *Picasso: Art as Autobiography.* Chicago and London: University of Chicago Press, 1980.

**Geelhaar 1978**
Geelhaar, Christian. "Pablo Picasso, 156 graphische Blätter 1970–1972." *Pantheon*, vol. 36, no. 3 (July/August/September 1978), pp. 288–289.

**Geelhaar 1981**
———. "Themen 1964–1972." In *Pablo Picasso: Das Spätwerk—Themen 1964–1972.* Kunstmuseum, Basel, September 6–November 8, 1981.

**Glozer 1974**
Glozer, Laszlo. *Kunstkritiken.* Frankfurt am Main: Suhrkamp Verlag, 1974.

**Green 1981**
Green, Christopher. *Picasso Graphics.* Arts Council of Great Britain, French Institute, London; Jarrow; Milton Keynes; Rochdale; Wolverhampton; Bristol; Reading; February 17–December 19, 1981.

**Greenberg 1966**
Greenberg, Clement. "Picasso Since 1945." *Artforum*, vol. 5 (October 1966), pp. 28–31.

**Häsli 1981**
Häsli, Richard. "Zu zwei Altersradierungen von Picasso." In *Pablo Picasso. Das Spätwerk—Themen 1964–72.* Kunstmuseum, Basel, September 6–November 8, 1981.

**Hoffman 1979**
Hoffmann, Werner. *Gegenstimmen, Aufsätze zur Kunst des 20. Jahrhunderts.* Frankfurt am Main: 1979.

**Hohl 1981**
Hohl, Reinhold. "Pablo Picasso: Portrait of the Artist as a Man of Intelligence." In *Picasso 1881–1981.* Galerie Beyeler, Basel, April–July 1981.

**Leiris (Suite 347)**
Leiris, Louise, Galerie. *Picasso. 347 gravures. 13/3/68–5/10/68.* Galerie Louise Leiris, Paris; The Art Institute of Chicago, Chicago; December 18, 1968–February 1, 1969.

**Leiris (156 Last Etchings)**
———. *Picasso. 156 gravures récentes.* Galerie Louise Leiris, Paris, January 24–February 24, 1973.

**Leiris 1973**
Leiris, Michel. "The Artist and His Model." In *Picasso in Retrospect*, edited by Roland Penrose and John Golding, pp. 243–262. New York: Praeger, 1973.

**Leymarie 1971**
Leymarie, Jean, *Picasso. Métamorphoses et unité.* Geneva: Éditions d'Art Albert Skira, 1971.

**Malraux 1976**
Malraux, André. *Picasso's Mask.* New York: Holt, Rinehart and Winston, 1976.

**Museo Picasso 1971**
Museo Picasso. *Catálogo 1.* Ayuntamiento de Barcelona. Barcelona: I. G. Seix y Barral Hnos, 1971.

**O'Brian 1979**
O'Brian, Patrick. *Pablo Ruiz Picasso.* Paris: Éditions Gallimard, 1979.

**Otero 1974**
Otero, Roberto. *Forever Picasso.* New York: Harry N. Abrams, 1974.

**Palau i Fabre 1981**
Palau i Fabre, Josep. *Picasso.* Barcelona: Edicions Polígrafa, 1981.

**Parmelin 1964**
Parmelin, Hélène. *Picasso: Women, Cannes and Mougins, 1954–1963.* (*Secrets d'alcôve d'un atelier*, Vol. I). Preface by Douglas Cooper. Paris: Éditions Cercle d'Art, 1964. Amsterdam: Harry N. Abrams, 1964.

**Parmelin 1965**
———. *Picasso: The Artist and His Model and Other Recent Works.* (*Secrets d'alcôve d'un atelier*, Vol. 2). New York: Harry N. Abrams, 1965.

**Parmelin 1966 (I)**
———. *Picasso. Notre Dame de Vie.* (*Secrets d'alcôve d'un atelier*, Vol. 3). Paris: Éditions Cercle d'Art, 1966.

**Parmelin 1966 (II)**
———. *Picasso dit.* Paris: Gonthier, 1966.

**Parmelin 1980**
———. *Voyage en Picasso.* Paris: Éditions Robert Laffont, 1980.

**Penrose 1959**
Penrose, Roland. *Picasso: His Life and Work.* New York: Harper & Brothers, 1959.

**Penrose/Golding 1973**
———, and Golding, John, eds. *Picasso in Retrospect.* New York: Praeger, 1973.

**Perucchi 1978**
Perucchi-Petri, Ursula. *Pablo Picasso, 156 graphicsche Blätter 1970–1972.* Graphisches Kabinett, Kunsthaus Zürich, March 31–May 16, 1978.

**Perucchi 1981**
———, "Pablo Picasso. 27 graphische Werke." In *Bericht der Gottfried Keller-Stiftung 1977–1980.* Bern: 1981, pp. 121–157.

**Ponge/Descargues 1974**
Ponge, Francis, and Descargues, Pierre. *Picasso de Draeger.* With Edward Quinn. Paris: Draeger, 1974.

**Porzio/Valsecchi 1974**
Porzio, Domenico, and Valsecchi, Marco. *Understanding Picasso.* With an introduction by Thomas M. Messer. New York: Newsweek Books, 1974.

**Rodríguez-Aguilera 1975**
Rodríguez-Aguilera, Cesáreo. *Picassos in Barcelona.* New York: Rizzoli International Publications, 1975.

**De Rojas 1971**
De Rojas, Fernando. *La Célestine.* Paris: Éditions de l'Atelier Crommelynck, 1971.

**Rubin 1972**
Rubin, William. *Picasso in the Collection of the Museum of Modern Art.* New York: The Museum of Modern Art, 1972.

**Rubin/Esterow 1973**
———, and Esterow, Milton. "Visits with Picasso at Mougins." *Art News*, vol. 72, no. 6 (Summer 1973), pp. 42–46.

**Schiff 1972**
Schiff, Gert. "Picasso's *Suite 347*, or Painting as an Act of Love." In *Woman as Sex Object, Art News Annual 1972*, edited by Thomas B. Hess and Linda Nochlin, New York: 1972, pp. 239–253. Reprinted, slightly revised, in *Picasso in Perspective*, edited by Gert Schiff, pp. 163–167. Englewood Cliffs, N.J.: Prentice-Hall, 1976.

**Schiff 1976**
———, ed. *Picasso in Perspective.* Englewood Cliffs, N.J.: Prentice-Hall, 1976.

**Schmidt 1981**
Schmidt, Werner. "Vom Inhalt der letzten graphischen Folge Picassos." In *Pablo Picasso, Die letzten graphischen Blätter, Aus der Sammlung Ludwig, Aachen.* Ausstellungskatalog Kupferstichkabinett der Staatlichen Kunstsammlung Dresden, May 8–July 15, 1981, pp. 8–16.

**Skedsmo 1981**
Skedsmo, Tone. "Suite 347." In *Picasso/347.* Henie–Onstad Kunstsenter, Høvikodden, June 23–August 23, 1981.

**Steinberg 1972**
Steinberg, Leo. "A Working Equation or—Picasso in the Homestretch." *The Print Collec-

tor's Newsletter, vol. III, no. 5 (November/December 1972), pp. 102–105.

**Sutherland Boggs 1973**
Sutherland Boggs, Jean. "The Last Thirty Years." In Picasso in Retrospect, edited by Roland Penrose and John Golding, pp. 197–241. New York: Praeger, 1973.

**Zervos**
Zervos, Christian. Pablo Picasso. Catalogue des peintures et dessins. 33 vols. Paris: Cahiers d'Art, 1932–1978.

# Exhibitions

**Paris 1964**
*Picasso. Peintures 1962–1963.* Galerie Louise Leiris, Paris, January 15–February 15, 1964.

**Lucerne 1966**
*Picasso. Deux époques. Paintings 1960–65 and of 1934, 1937, 1944.* Galerie Rosengart, Lucerne, Summer 1966.

**Washington 1966**
*Picasso Since 1945.* Washington Gallery of Modern Art, Washington, D.C., June 30–September 4, 1966.

**Paris 1966/67**
*Hommage à Pablo Picasso. Peintures: Grand Palais. Dessins, Sculptures, Céramiques: Petit Palais,* Paris, November 1966–February 1967.

**Amsterdam 1967**
*Picasso.* Stedelijk Museum, Amsterdam, March 4–April 30, 1967.

**New York 1967/68**
*Picasso 1966–1967.* Saidenberg Gallery, New York, December 11, 1967–January 31, 1968.

**Paris 1968**
*Picasso. Dessins 1966–1967.* Galerie Louise Leiris, Paris, February 28–March 23, 1968.

**Barcelona 1968**
*Picasso. Pinturas. Dibujos. Grabados.* Sala Gaspar, Barcelona, March 1968.

**Vienna 1968**
*Pablo Picasso.* Österreichisches Museum für angewandte Kunst, Vienna, April 24–June 30, 1968.

**Baden-Baden 1968**
*Pablo Picasso. Das Spätwerk. Malerei und Zeichnung seit 1944.* Staatliche Kunsthalle, Baden-Baden, July 15–October 6, 1968.

**Basel 1969**
*Spanish Artists. Gris, Picasso, Miró, Chillida, Tapiès.* Galerie Beyeler, Basel, May–July 1969.

**Lucerne 1969**
*Picasso Today. Recent Works.* Galerie Rosengart, Lucerne, Summer 1969.

**Baden-Baden 1969**
*Maler und Modell.* Staatliche Kunsthalle, Baden-Baden, July 28–October 19, 1969.

**London 1970**
*Picasso Drawings.* The Waddington Galleries I, London, February 10–March 7, 1970.

**Avignon 1970**
*Pablo Picasso 1969–1970.* Palais des Papes, Avignon, May 1–September 30, 1970.

**Tokyo/Osaka 1971**
*Picasso at 90.* The Sankei Shimbun, Fuji Television Gallery, Tokyo, March 30–April 4, 1971; Osaka, April 6–April 11, 1971.

**Paris 1971**
*Picasso. Dessins en noir et en couleurs: December 15, 1969–January 12, 1971,* Galerie Louise Leiris, Paris, April 23–June 5, 1971.

**Lucerne 1971**
*Picasso, 25 Werke, 25 Jahre 1947–1971.* Galerie Rosengart, Lucerne, 1971.

**New York 1971**
*Homage to Picasso for His 90th Birthday. Exhibition for the Benefit of the American Cancer Society.* Saidenberg Gallery, Inc. (Years: 1901–1924), and Marlborough Gallery, Inc. (Years: 1924–1971), New York, October 1971.

**Winterthur etc. 1971/72**
*Picasso. 90 Drawings and Works in Colour.* Kunstmuseum, Winterthur, October 9–November 15, 1971. Galerie Beyeler, Basel, November 20, 1971–January 15, 1972. Wallraf-Richartz-Museum, Köln, January 25–February 28, 1972.

**Paris 1972/73**
*Picasso. 172 dessins en noir et en couleurs.* Galerie Louise Leiris, Paris, December 1, 1972–January 13, 1973.

**Avignon 1973**
*Picasso 1970–1972. 201 peintures.* Palais des Papes, Avignon, May 23–September 23, 1973.

**Hannover 1973**
*Picasso in Hannover.* Kunstverein Hannover, Hannover, October 23–November 25, 1973.

**Menton 1974**
*Dixième Biennale Internationale d'Art de Menton.* Palais de l'Europe, Menton, July–September 1974.

**Tokyo 1974**
*Pablo Picasso.* Fuji Television Gallery, Tokyo, 1974.

**Karlsruhe/Frankfurt am Main 1974/75**
*Picasso und die Antike.* Badisches Landesmuseum, Karlsruhe, September 6–November 17, 1974. Städtische Galerie, Frankfurt am Main, December 4, 1974–February 2, 1975.

**New York 1975**
*Picasso. A Loan Exhibition for the Benefit of Cancer Care, Inc., The National Cancer Foundation.* Acquavella Galleries, Inc., New York, April 15–May 17, 1975.

**Minneapolis etc. 1975/76**
*Picasso, Braque, Leger. Masterpieces from Swiss Collections.* The Minneapolis Institute of Arts, Minneapolis, October 30, 1975–January 4, 1976; The Sarah Campbell Blaffer Gallery, Houston, January 17–March 7, 1976; The San Francisco Museum of Modern Art, San Francisco, March 19–May 4, 1976.

**Basel 1976**
*Picasso aus dem Museum of Modern Art New York und Schweizer Sammlungen.* Kunstmuseum, Basel, June 15–September 12, 1976.

**Madrid 1977**
*Picasso.* Fundación Juan March, Madrid, September–November 1977.

**Japan 1977/78**
*Exposition Picasso. Japon 1977/78.* Musée de la Ville de Tokyo, Tokyo; Musée Préfectoral d'Aichi, Nagoya; Centre Culturel, Fukuoka; Musée National d'Art Moderne, Kyoto. October 15, 1977–March 5, 1978.

**Barcelona 1977/78**
*Exposición Picasso.* Fundación Juan March. Museo Picasso, Barcelona. December 5, 1977–January 10, 1978.

**Lucerne 1978**
*Picasso—Eight Works from the Last Twenty Years of His Life.* Am Rhyn-Haus, Lucerne, 1978.

**Barcelona 1979**
*Picasso eròtic/Picasso erótico.* Museo Picasso, Barcelona, February 27–March 3, 1979.

**Paris 1979/80**
*Picasso. Oeuvres reçues en paiement des droits de succession.* Grand Palais, Paris, October 12, 1979–January 7, 1980.

**Minneapolis 1980**
*Picasso from the Musée Picasso, Paris.* Walker Art Center, Minneapolis, February 10–March 30, 1980.

**New York 1980**
*Pablo Picasso. A Retrospective.* The Museum of Modern Art, New York, May 22–September 16, 1980.

**Paris 1980**
*Picasso. Peintures. 1901–1971.* Galerie Claude Bernard, Paris, June 1980.

**New York 1981**
*Picasso. The Avignon Paintings.* The Pace Gallery, New York, January 30–March 14, 1981.

**Marcq-en-Baroeul 1981**
*Picasso 1953–1973.* Septentrion, Fondation Anne et Albert Prouvost, Marcq-en-Baroeul, February 14–May 17, 1981.

**München etc. 1981/82**
*Pablo Picasso. Eine Ausstellung zum hundertsten Geburtstag. Werke aus der Sammlung Marina Picasso.* Haus der Kunst, München; Köln; Frankfurt am Main; Zürich, February 14, 1981–March 28, 1982.

**Cambridge, Mass. etc. 1981**
*Master Drawings by Picasso.* Fogg Art Museum, Cambridge, Massachusetts, February 20–April 5, 1981; The Art Institute of Chicago, Chicago, April 29–June 14, 1981; Philadelphia Museum of Art, Philadelphia, July 11–August 23, 1981.

**Stuttgart 1981**
*Pablo Picasso in der Staatsgalerie Stuttgart. Ausstellung zum 100.en Geburtstag des Künstlers mit Leihgaben aus Sammlungen in Baden-Württemberg.* Staatsgalerie Stuttgart, Stuttgart, March 1–May 17, 1981.

**Basel 1981 (I)**
*Picasso 1881–1981.* Galerie Beyeler, Basel, April–July, 1981.

**London 1981**
*Picasso's Picassos. An Exhibition From the Musée Picasso, Paris.* Arts Council of Great Britain, Hayward Gallery, London, July 17–October 11, 1981.

**Basel 1981 (II)**
*Pablo Picasso—Das Spätwerk—Themen 1964–1972.* Kunstmuseum, Basel, September 6–November 8, 1981.

**Washington 1981/82**
*The Morton G. Neumann Family Collection. Volume III. Picasso Prints and Drawings.* Na-

tional Gallery of Art, Washington, D.C. October 25, 1981–January 24, 1982.

**Vienna 1981/82**
*Picasso in Wien. Pablo Picasso (1881–1973). Bilder. Zeichnungen. Plastiken.* Kulturamt der Stadt Wien, Rathaus Wien, Vienna, November 1981–January 1982.

**Madrid/Barcelona 1981/82**
*Picasso 1881–1973. Exposició Antològica.* Museo Español de Arte Contemporáneo, Madrid, November–December 1981; Museo Picasso, Barcelona, January–February 1982.

**Paris 1982**
*Picasso. La pièce à musique de Mougins.* Centre Culturel du Marais, Paris, 1982.

**Mexico 1982/83**
*Los Picassos de Picasso en México–Una Exposición Retrospectiva.* Museo Rufino Tamayo, Mexico, November 1982–January 1983.

**Tokyo/Kyoto 1983**
*Picasso. Masterpieces from Marina Picasso Collection and from Museums in U.S.A. and U.S.S.R.* Tokyo, April 2–May 29, 1983; Kyoto, June 10–July 24, 1983.

# Selected Graphic Exhibitions

### General Graphic Exhibitions

*Picasso. 85 gravures. Présentées à l'occasion de son 85e anniversaire le 25 octobre 1966.* Berggruen, Paris, 1966.

*Picasso. Sixty Years of Graphic Works.* Los Angeles County Museum of Art, Los Angeles, October 25–December 24, 1966.

*Pablo Picasso. Gravures.* Bibliothèque Nationale, Paris, November 1966–February 1967.

*Picasso. Gravures.* Galerie Beyeler, Basel, November–March 1967.

*Pablo Picasso. Le peintre et son modèle. 44 gravures originales. 1963–1965.* Galerie Gérald Cramer, Genève, November 24, 1966–January 21, 1967

*Pablo Picasso. Druckgraphik. Aus dem Besitz der Kunsthalle Bremen.* Kunsthalle Bremen, Bremen, December 11, 1966–January 22, 1967.

*Picasso. Exposition de gravures de Pablo Picasso à Belgrade.* Belgrade, June 10–August 1, 1967.

*Picasso. Gravures.* Cabinet des Estampes, Musée d'Art et d'Histoire, Genève, June 24–September 10, 1967.

*Pablo Picasso.* Galerija Suvremene Umjetnosti, November 17–December 31, 1967.

*Pablo Picasso. Das graphische Werk. Eine Wegleitung zur Ausstellung im Kunsthaus Zürich.* Kunsthaus, Zürich, May 25–July 28, 1968.

*Graphik von Pablo Picasso. Sammlung GLB.* Auction 133 at Kornfeld and Klipstein, Bern, June 13, 1969.

*Picasso. One Hundred Graphics.* Auction at Parke-Bernet Galleries, New York, December 11, 1969.

*Graphik von Pablo Picasso. Sammlung J. C. D. und V. B.* Auction 139 at Kornfeld and Klipstein, Bern, June 20, 1970.

*Picasso. Graphik von 1904 bis 1968.* Haus der Kunst, München, June 20–September 27, 1970.

*Picasso Grafik. Aus dem Besitz der Bremer Kunsthalle.* Kunsthalle, Bielefeld, 1970.

*Stiftung Daniel-Henry Kahnweiler. 20 graphische Werke Picassos.* Kunsthalle, Mannheim, December 12, 1970–January 17, 1971.

*Hommage à Picasso. 90 gravures présentées à l'occasion de ses 90 ans le 25 octobre 1971.* Berggruen, Paris, 1971.

*Picasso. 200 gravures.* Le Musée de Tel-Aviv, Tel-Aviv, April–June 1972.

*Pablo Picasso. Druckgraphik. Schenkung Georges Bloch.* Gottfried Keller-Stiftung, Bern, 1972.

*Picasso. His Graphic Work in the Israel Museum Collection.* Spertus Hall, The Israel Museum, Jerusalem, January–March 1973.

*Picasso. Druckgraphik, Gedächtnisausstellung. Eine Auswahl aus dem Besitz der Kunsthalle Bremen.* Kunsthalle Bremen, Bremen, May 20–July 8, 1973.

*Graphik von Pablo Picasso. Aus Sammlung GB.* Auction 148 at Kornfeld and Klipstein, Bern, June 21, 1973.

*Pablo Picasso.* Museo del Grabada Latinoamericano, San Juan, Puerto Rico, November 9–November 24, 1973.

*Pablo Picasso: das graphische Werk.* Hamburg; Frankfurt; Stuttgart; October 19, 1974–March 30, 1975.

*Pablo Picasso. Estampes originales, livres illustrés. 1905–1972.* Galerie Patrick Cramer, Genève, November 24–January 14, 1977.

*Picasso Graphik. Aus dem Besitz des Dresdner Kupferstich-Kabinettes im Museum der bildenden Künste Leipzig.* Museum der bildenden Künste, Leipzig, April 28–June 25, 1978.

*Pablo Picasso. Ausgewählte Graphik. Kunstmuseum Hannover mit Sammlung Sprengel.* Kunstmuseum Hannover, Hannover, December 14, 1980–February 1, 1981.

*Picasso Graphics.* Arts Council of Great Britain, French Institute, London; Jarrow; Milton Keynes; Rochdale; Wolverhampton; Bristol; Reading; February 17–December 19, 1981.

*Picasso. Obra Gráfica original. 1904–1971.* Ministeria de Cultura, Collection Museo Español de Arte Contemporáneo, Madrid, May–July 1981.

*Picasso.* Waddington Graphics, London. July 14–August 29, 1981.

*Picasso and Printmaking.* Grunwald Center for the Graphic Arts, University of California, Los Angeles, 1981.

*Pablo Picasso. Graphische Werke 1904–1972.* Galerie Kornfeld, Bern, October 25–December 22, 1982.

### Suite 347

*Picasso. 347 gravures. 13/3/68–5/10/68.* Galerie Louise Leiris, Paris; The Art Institute of Chicago, Chicago; December 18, 1968–February 1, 1969.

*Picasso. 347 graphische Blätter vom 16.3.1968 bis 5.10.1968.* Kunsthaus, Zürich, April 12–May 20, 1969.

*Pablo Picasso. 347 graphische Blätter aus dem Jahre 1968.* Akademie der Künste, Berlin, June 1–June 29, 1969; Hamburger Kunsthalle, Hamburg, July 11–August 10, 1969; Kölnischer Kunstverein, Köln, September 7–October 12, 1969.

*Pablo Picasso.* Musée National d'Art Moderne, Tokyo, 1970.

*347 x Picasso. Graphische Blätter aus dem Jahre 1968.* Württembergischer Kunstverein, Stuttgart, October 8–November 22, 1970.

*Picasso, 347 Engravings, 16/3/68–5/10/68.* Institute of Contemporary Arts, London, 1970.

*Picasso. 150 Grabados.* Museo de Bellas Artes, Caracas, March 1971.

*Pablo Picasso; 347 Radierungen des Sommers 1968.* Stuck-Villa, München, April–June, 1971.

*Picasso. 347 Engravings.* The Waddington Galleries II, London, September 13–October 17, 1972.

*Picasso/347.* Henie-Onstad Kunstsenter, Høvikodden. June 23–August 23, 1981.

### 156 Last Etchings

*Picasso. 156 gravures récentes.* Galerie Louise Leiris, Paris, January 24–February 24, 1973.

*Pablo Picasso, 156 graphische Blätter 1970–1972.* Kunsthaus, Zürich, March 31–May 16, 1978.

*Pablo Picasso. Letzte graphische Blätter. 1970–1972.* Kestner-Gesellschaft, Hannover, May 4–May 27, 1979.

*Pablo Picasso, Die letzten graphischen Blätter, Aus der Sammlung Ludwig, Aachen.* Kupferstichkabinett der Staatlichen Kunstsammlung Dresden, May 8–July 15, 1981.

## Lending Institutions

Acquavella Galleries, Inc., New York
Albright-Knox Art Gallery, Buffalo, New York
Thomas Amman Fine Arts, Zürich
Galerie Beyeler, Basel
Aldis Browne Fine Arts, Ltd., New York
Fuji Television Gallery Co., Ltd., Tokyo
Galerie Jan Krugier, Geneva
Kunsthaus Zürich, Zürich
Galerie Louise Leiris, Paris
The Metropolitan Museum of Art, New York
Musée Picasso, Paris
Museum of Fine Arts, Boston
Pace Editions, Inc.
The Pace Gallery, New York
Reiss-Cohen, Inc., New York
Galerie Rosengart, Lucerne
Saidenberg Gallery, Inc., New York
Sindin Galleries, New York

## Private Lenders

Mr. and Mrs. Morton L. Janklow, New York
Owen Morrissey, New York
Mr. and Mrs. Mike Moses, New York
Mr. and Mrs. Raymond D. Nasher, Dallas, Texas
Marina Picasso, Geneva
Paloma Picasso-Lopez, Geneva
Angela Rosengart, Lucerne
Maya Ruiz Picasso, Paris
Mr. and Mrs. Daniel Saidenberg, New York
Javier Vilató, Paris
Xavier Vilató, Paris
Private Collections